MAKING SENSE
OF
CHILDREN'S DRAWINGS

MAKING SENSE
OF
CHILDREN'S DRAWINGS

John Willats

LEA LAWRENCE ERLBAUM ASSOCIATES, PUBLISHERS
2005 Mahwah, New Jersey London

Lawrence Erlbaum Associates, Inc., Publishers
10 Industrial Avenue
Mahwah, New Jersey 07430
www.erlbaum.com

Cover design by Kathryn Houghtaling Lacey

Cover art: Sally Willats (1967), age 6. *Costume Doll in the Bethnal Green Museum*, London. Collection of the Author.

Georges Braque, *L'Estaque: Viaduct and Houses,* 1908
© ADAGP, Paris and DACS, London 2004

Library of Congress Cataloging-in-Publication Data

Willats, John.
 Making sense of children's drawings / John Willats.
 p. cm.
 Includes bibliographical references and index.
 ISBN 0-8058-4537-2 (alk. paper)
 ISBN 0-8058-4538-0 (pbk. : alk. paper)
 1. Children's drawings—Psychological aspects. 2. Drawing, Psychology of. I. Title.

BF723.D7W55 2004
155.4—dc22 2004056419
 CIP

To Ruth and Bill

Contents

Preface ix

Chapter One: Introduction 1

PART I: STUDYING CHILDREN'S DRAWINGS

Chapter Two: Contradictions and Confusions 23

Chapter Three: In the Beginning 45

Chapter Four: The Early Years 57

Chapter Five: Where Do We Go From Here? 79

Chapter Six: Regions 98

Chapter Seven: Lines, Line Junctions, and Perspective 121

PART II: MENTAL PROCESSES

Chapter Eight: "Seeing in" and the Mechanism
 of Development 145

Chapter Nine: The Drawing Process 173

PART III: CHILD ART

Chapter Ten: Children as Artists 193

Chapter Eleven: Art Education 215

Chapter Twelve: Summing Up 232

Appendix	242
Glossary	245
References	250
Index	257

Preface

If I am unwise enough to admit in casual conversation that I am interested in children's drawings I usually meet with one or other of three responses. The first is to tell me that "young children draw what they know and older children draw what they see" or that "children see things differently from adults." This involves such difficult philosophical issues about the difference between knowing and seeing, and how we can know what it is that other people see, that I usually murmur sympathetically and leave it at that. The second is to tell me that young children are wonderfully creative in their drawings. As I believe this to be both profoundly true but in another sense rather doubtful, I usually offer some polite platitude and change the subject. The third response is to assume that I am interested in the clinical interpretation of the drawings of disturbed children. As I am rather skeptical of the value of such interpretations, I usually deny this, which brings the conversation to a close.

For all this, I am very grateful for at least one chance encounter. At the time I was teaching sculpture and drawing at Walthamstow School of Art and with my colleague Fred Dubery had just published our book called *Drawing Systems* (1972). We had written this for art students and it was the outcome of a sudden revelation. We needed to talk to art students about the spatial systems in pictures, and I realized that the drawing systems I had learned as an engineering student could be used to describe the spatial systems in pictures from other periods and cultures such as those used in Cubist paintings and Persian miniature paintings—systems that had hitherto remained mysterious and undefined.

Full of this discovery, I told someone who happened to be a psychologist about it. After listening patiently for some time he said, "Hmm, sounds to me like what Chomsky is trying to do with language." I confessed that I had

never even heard of Noam Chomsky, and he explained that he was an American linguist who was trying to describe the rules of language and who argued that it was these rules that enable us to use language creatively, "making infinite use of finite means." He also explained that psychologists had reached the conclusion that children learn a language not by copying adult speech but by acquiring increasingly powerful and complex language rules, and that the process of acquiring these rules was in itself a profoundly *creative* process. I was very impressed: this sounded very much like the way artists use the drawing systems in pictures. I went away determined to read Chomsky and to study children's drawings.

Within a few years I had managed to maneuver Chomsky, by correspondence, into a position in which he could hardly refuse to see me if I visited him at MIT. By this time he had become so much of a hero that I expected him to be like a saint in a Byzantine mosaic with gold rays emanating from him; instead, I found him to be quite an ordinary person, eating plums out of a paper bag. After listening to what I had to say he suggested that I should meet David Marr, also at MIT, who at that time was developing his revolutionary account of visual perception. I did later meet Marr, by which time I had already read his book on vision. Much of what I have to say about children's drawings, as well as the way I say it, is based on his work, and Marr became the second hero in my Pantheon.

By this time I had, with the help of Stuart Sutherland, head of Experimental Psychology at Sussex University, published my first paper in which I showed that as children get older they produce pictures based on increasingly powerful and complex drawing rules—rules very much like the ones that Dubery and I had described in artists' pictures. This really did seem like the equivalent of Chomsky's rules of language. By this time I was working full time on children's drawings and it was time to look for a Ph.D. supervisor.

With some trepidation I asked Sir Ernst Gombrich if he would take me on. He explained, very courteously, that he was about to retire but referred me to Richard Wollheim, Professor of Mind and Logic at University College, London. He couldn't have made a wiser choice, and Richard's account of representation in terms of "seeing in" has informed my account of pictures ever since—although I think he found my interest in children's drawings rather plebeian.

The final piece in the jigsaw puzzle was derived from work that had just begun in the field then known as artificial intelligence. This component was crucial because although the drawing systems provide a good way of describing children's drawings of rectangular objects such as tables and cubes they have little to say about drawings of "smooth" objects such as people and

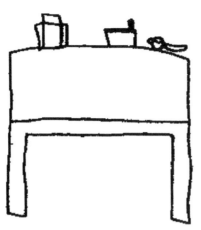

FIG. P.1. A child's drawing of a table, mean age 11.9. Taken from Willats (1977a, Fig. 9). Reprinted by permission of The Experimental Psychology Society, Taylor & Francis Ltd., http://www.tandf.co.uk/journals.

animals, nor do they explain the characteristic anomalies so common in children's drawings such as the strange drawing of a box apparently perched on the far edge of the table shown in Fig. P.1.

At this time work in artificial intelligence was showing that just as there are rules governing the spatial relations between objects in pictures (the drawing systems), so are there rules (the denotation systems) governing the relations between marks in the picture and corresponding features in the scene. My first paper had shown that young children use different drawing systems from adults and it now turned out that they also use different deno-

FIG. P.2. A drawing of a man by a 5-year-old boy. Collection of the author.

tation systems. The lines in the drawing of a man shown in Fig. P.2, for example, do not stand for the contours of the figure as they would do in an adult's drawing. Instead, they either stand for long volumes as in the legs and the nose, or act as the boundaries of round regions that stand for round volumes such as the head or head/body.

I shall argue that it is the acquisition of these drawing and denotation rules that underlies children's drawing development. I shall also argue that the way children use these rules is creative, in much the same way that their use of the rules of language is creative.

Much of the early work on children's drawings contains very valuable insights, but these accounts also contain many confusions and contradictions—partly because of the absence, when they were written, of an adequate account of visual perception and partly because the verbal tools necessary to describe representations of scenes and pictures, and to distinguish between them, were simply not available. Resolving these contradictions and confusions has only been made possible by advances in other fields and I owe a great debt to many people working in these fields. Of those known to me personally I would like to thank Elsbeth Court, Norman Freeman, Howard Gardner, Claire Golomb, John Kennedy, Connie Milbrath, Marjorie and Brent Wilson, Ellen Winner, and Dennie Wolf in psychology, Sue Malvern in art history, Patrick Maynard in philosophy, Peter Denny in linguistics, Frédo Durand in computer science, and Jan Koenderink in vision science, all of whose ideas have influenced my work. My special thanks are due to Alan Costall, John Matthews, and David Pariser. Not only have I profited greatly by their ideas, but they have given me active help and encouragement in the preparation of this book. I am also indebted to my niece Helen Erridge for her careful annotation of the drawings by her daughter Megan, and to the staff and children of the Infants School Somerton and the Montecliff Junior School Somerton who also provided me with drawings.

Finally, as with my previous book *Art and Representation* (Willats, 1997), my most grateful thanks are due to my wife Ruth and my son Bill. Ruth's experience as a professional editor has been invaluable to me in the preparation of earlier versions of my manuscript, and I am grateful to both Ruth and Bill for arguing with me, and for contributing many valuable and stimulating ideas.

Introduction

The message of this book is a simple one: children learn to draw by acquiring increasingly complex and effective drawing rules. In this respect learning to draw is like learning a language: children learn to speak, not just by adding to their vocabulary, but by learning increasingly complex and powerful language rules. And like learning a language, learning to draw is one of the major achievements of the human mind.

As with the early rules of speech, the drawing rules young children use are different from those used by adults. This is why drawings by young children look so strange. It follows that if we are to make sense of children's drawings we have to establish what these rules are and understand how and why they change as children get older. My hope is that parents and teachers will gain more pleasure from children's drawings if they understand these rules and, by understanding them, gain a clearer insight into what children are trying to do when they are learning to draw.

The account of children's drawings given here is different from those generally available. I make no apology for this because although children's drawings have now been studied for more than a century there is no generally accepted theory that can account for them, and existing theories are full of contradictions and confusions. The main reason for this is that all these theories have been derived, in one way or another, from theories of visual perception that now seem inadequate. As a result of new theories of perception developed during the 1970s and 1980s, it is now possible to see how we might begin to construct a new account of children's drawings that can not only explain the many strange features in children's drawings but also en-

able us to see how all the contradictions and confusions in previous theories have arisen.

In 1982 David Marr, working at MIT, published *Vision*, a book that revolutionized the study of visual perception. Although many of the details of his theory are still controversial, the broad outlines of his account of vision are now widely accepted. This new account of vision, which was set against the background of computing technology and information processing, was radically different from the optical theory of vision that had dominated theories of children's drawings since the end of the 19th century. I shall call this earlier account the camera theory of perception.

According to the camera theory, we receive and store our perceptions of the world in the form of internal images that resemble the kinds of images we get by taking a photograph. This leads naturally to a theory of picture production in which internal images are copied on to the picture surface, very much as the image in a camera is copied on to a print. This traditional theory was summed up by the psychologist J. J. Gibson (1978):

> Drawing is always copying. The copying of a perceptual image is drawing from life. The copying of a stored image is drawing from memory. The copying of an image constructed from other images is drawing from imagination. (p. 230)

Internal images of this kind are necessarily in perspective, and it is obvious that children's drawings do not fit comfortably into this theory. Not only are young children's drawings not in perspective, but they contain many other anomalies judged by the standards of photographic realism, including so-called transparencies and the lack of foreshortening. Explaining the presence of these features faced psychologists with a dilemma, which they attempted to solve in various ways. I describe some of their attempts in more detail in chapter 2, but by far the most common explanation was to say that although older children draw what they see, young children draw what they know. According to this account, very young children do indeed see the world in terms of perspectival mental images but by the time they begin to draw, this pure, innocent vision has become corrupted by knowledge, that is, by the concepts they form of objects and the expression of these concepts in language.

According to the copying theory of drawing, the anomalies in young children's drawings are simply faults: either because children lack manual dexterity or because they draw their concepts of objects rather than their appearance. These anomalies appear in children's drawings from the time they

first begin to draw until the age of 7 or 8 years. At this point, by a developmental process that is never fully explained, children are somehow able to get back to the state of visual innocence that had previously been repressed by knowledge. Against the background of the camera theory of vision, and its corollary in the form of copying theories of picture production, some account of children's drawings of this kind seemed unavoidable.

The problem with this account, however, is that it is not only very depressing in its mechanistic approach to picture making but it seems to run counter to our intuitions. There is a magic about children's drawings that makes them much more exciting, imaginative, and entertaining than either true photographs or the optically realistic academic paintings that were being produced at the end of the 19th century. At the beginning of the 20th century many art teachers, led by Franz Cizek in Austria and Marion Richardson in England, began to claim that the features in children's drawings that developmental psychologists had dismissed as faults were precisely those features that contributed to their magic. They were able to do this because many of these features seemed remarkably similar to those that were appearing in paintings and drawings by avant-garde artists such as Pablo Picasso, Henri Matisse, and Paul Klee. Moreover, they were supported in this view by many of the artists themselves. Picasso claimed that it had taken him his whole lifetime to learn to draw like a young child, and Klee declared that "the pictures that my little boy Felix paints are often better than mine" (quoted in Wilson, 1992, p. 18). As Fineberg (1997) has shown a number of avant-garde artists including Klee made collections of children's drawings and used motifs taken from them in their work.

Advocates of the new art teaching, as it came to be called, claimed that the magical quality of the drawings children produce showed that they had an innocence and purity of vision that the avant-garde artists had managed to retain, uncorrupted by bourgeois materialistic values and the outmoded conventions of Western academic painting. Thus, whereas the psychologists believed that the faults in the drawings that children produce up to the age of, say, 7 or 8 years are the result of their vision being spoiled by knowledge and language, the new art teachers believed that it was precisely these "faults" that demonstrated children's creativity and their purity of vision. It followed from this that the primary job of art teachers was to protect children for as long as possible from the corrupting values of conventional society and, in particular, to avoid any kind of overt teaching so that the child's creativity could develop naturally, "like a flower unfolding."

These two accounts of children's drawings are, of course, irreconcilable. From a theoretical point of view this is unsatisfactory, but the lack of any

credible and generally accepted theory of children's drawings has also had some unfortunate practical consequences. Psychologists have, perhaps rightly, not seen it as part of their job to give advice on teaching, and in any case if the change from intellectual to visual realism takes place inevitably as the result of maturation, teaching drawing is unnecessary. Within the standard psychological model the faults in children's early drawings are something they just have to grow out of. The new art teachers, on the other hand, saw any kind of teaching as positively harmful, but a teaching method that relies on an avoidance of teaching is ultimately indefensible. As a result we have an adult population who say, almost universally and truthfully, that they cannot draw.

However, we now have an opportunity, not of reconciling these contradictory accounts of children's drawings but of developing a new account that avoids most of these difficulties in the first place. This opportunity is provided by two recent developments, one in the field of visual perception and the other in the study of natural languages.

The old camera model has been replaced by a theory of vision in which internal representations of objects and scenes can take two possible forms. Marr (1982) called these *viewer-centered* and *object-centered* internal descriptions.[1] Viewer-centered descriptions provide us with an account of objects and scenes as they appear from a particular point of view, so that one object can be described as behind another, and a description of the top of a table, for example, might take the form of a trapezium. Viewer-centered descriptions of this kind are not, perhaps, so very different from the perspectival mental images of the older camera model, and we need them because they tell us where things are in relation to ourselves.

However, we also need to be able to recognize objects, and it would be uneconomic and impractical to do so by storing images of objects as they appear from all possible points of view and under all possible lighting conditions. Instead, Marr (1982) proposed that we need to be able store internal representations of the shapes of objects in the form of object-centered descriptions: descriptions that are given independently of any particular point of view. In an object-centered description of a table, for example, the top of a table would take the form of rectangle, and the positions of objects or parts of objects on the table would be described relative to the principal axes of the table rather than to the position of the viewer. Marr argued that the primary function of

[1]Marr (1982) used the word *description* to avoid implying that these internal representations necessarily take the form of "pictures in the mind." A representation of a picture or scene in a computer, for example, takes the form of characters in a file rather than a two-dimensional display.

the human visual system is to take the ever-changing viewer-centered descriptions available at the retina and use them compute permanent object-centered descriptions that can be stored in long-term memory. We then use these object-centered descriptions to recognize objects when we see them again from different directions of view or under new lighting conditions.

I shall show that most children's drawings (even those that look optically realistic) are derived from object-centered internal descriptions rather than from views. It might seem that this is only the old "young children draw what they know" in a new and more sophisticated guise, but this is not the case. The reason for this is that because object-centered descriptions are given independently of any particular point of view they must be three-dimensional. Thus, in learning to draw, children have to discover ways of mapping these three-dimensional internal descriptions of objects on to a two-dimensional surface, and they do this by acquiring increasingly complex and effective drawing rules.

Figure 1.1 shows the results of an experiment in which children of various ages were asked to draw a table from a fixed viewpoint. In terms of the camera theory of drawing, these results are inexplicable because only drawings of the types shown at Fig. 1.1g, and perhaps Fig. 1.1f, could be derived directly from the child's view of the table. They are, however, easy to explain if we say that these children were discovering increasingly complex and effective rules for mapping three-dimensional object-centered descriptions of the table onto the two-dimensional surface of the paper. In all these drawings horizontal lines in the picture are used to represent the horizontal edges of the table, and vertical lines in the picture are used to represent the vertical edges. But the problem these children were faced with was to find a way of representing edges in the third, front-to-back, direction. A few of the drawings were left unclassified because the spatial relations between the objects on the table and the table itself were incoherent (Fig. 1.1b). The rest of the drawings were classified in terms of the various projection systems (of which perspective is just one example), in which front-to-back relations in the scene are represented in different ways on the picture surface. In drawings of the type shown at Fig. 1.1c the front-to-back edges of the table were simply ignored. In drawings of the type shown at Fig. 1.1d the problem has been solved in a simple way: front-to-back edges in the scene are represented by up-and-down lines in the picture. But the problem with this solution is that one direction on the picture surface has been used to represent two different directions in three-dimensional space. As a result, drawings of this type tend to look flat and unrealistic. Nevertheless, drawings of this type were the most frequent of all the types of drawings produced in this experiment.

The children who produced drawings of the type shown at Fig. 1.1e managed to solve the problem by using a more complex rule: represent front-to-back edges by oblique lines. Of all the drawing systems used by adult artists in all periods and cultures this system (known as oblique projection) is probably the most frequently used solution to the problem. In this experiment, however, drawings of this type do not correspond to the view the children were asked to draw. In drawings of the type shown at Fig. 1.1f, naive perspective, the rule has been modified by saying that diagonal lines representing edges on the left of the table run up to the right, and lines representing edges on the right run up to the left (a system used by many 14th-century Italian painters). Some of the drawings of the type shown at Fig. 1.1g, which are in true perspective, may have been produced by using a rule in which the directions of the edges of the table as they appeared in the child's visual field are reproduced on the surface of the picture, but others may have been produced using the rule: Let the orthogonals (lines representing front-to-back edges in the scene) converge to a vanishing point. (It was the discovery of this rule that marked the beginning of Renaissance painting.) Without further experimentation, it is impossible to say which of these two kinds of rules the children were using. However, because drawings in true perspective accounted for only 6% of all the drawings produced in this experiment, it seems fair to say that the majority of the children were deriving their drawings from object-centered descriptions rather than from views.

It is clear from the results of this experiment that the older children used more complex rules than did the younger children and that as a result they were able to produce more effective representations. In this case, the drawings produced by the older children were more effective in two senses: they could more easily be recognized as drawings of a table, and they looked more like the view they were asked to draw.

Even within this experiment, however, the rules I have described are not adequate to account for all the features in these drawings. Why are the box and the radio in Fig. 1.1c shown side by side instead of one behind the other? Why are the objects in Fig. 1.1d apparently perched on the far edge of the table, and why is the box drawn in such a peculiar way? Moreover, drawing rules of this kind are not appropriate for drawing many of the objects that children want to draw, especially objects without straight edges such as animals and people. Discovering rules for drawing all these kinds of objects is a complex task for children, which is one of the reasons it takes children so long to learn to draw.

The other scientific revolution that makes this new account of children's drawings possible was pioneered by the American linguist Noam Chomsky. From roughly the beginning of the 20th century until the 1950s, linguists argued that children learn to speak by imitating adult speech, that is, by hearing adult words and sentences in repeated association with certain events or objects, committing them to memory and then reproducing them again in a similar context. This copying theory of language is not unlike the copying theory of drawing, and according to this theory, the errors in children's speech, like the errors in children's drawings, are just that: copying errors, and nothing more.[2] In 1959, however, in a classic paper in the journal *Language*, Chomsky showed that it was impossible to account for language in this way. Instead, he proposed that we learn a language by learning language rules. In addition, he proposed that using these rules is not a mechanistic response to external circumstances but is essentially creative, making "infinite use of finite means."[3]

In this new account of language the errors of speech that children make are not simply faults in copying but arise from the creativity that children bring to bear when they are learning to speak. To take just one example, my young son once referred to "a place where you keep guns" as an "engunment." In terms of the laws of word formation in English, "engunment" (like "entrenchment" or "embankment") is grammatical, and any native English speaker will understand what it means, but it happens not to be an English word. Instead of learning this word by imitating adult speech, my son had invented it to communicate what he wanted to say.

"Errors" of this kind provide crucial evidence for the rules that children use at different stages of development. A child who says "no a boy bed" is not copying adult speech but is using the simple rule: To make a negative, put "no" at the beginning of the sentence. Older children may use more

[2]According Bloomfield (1933), the "imperfections" in children's speech, such as "bringed," "wented," or "goed" are simply mistakes due to "distracting stimuli" or "a tantrum which disorders [the child's] recent impressions" (p. 31).

[3]As Cromer (1974) put it:

It would appear, then, that the child does not *learn* words, but that he invents them for the things he wants to communicate. Furthermore, imitation does not appear to be a mechanism of acquisition. This does not mean that these inventions are totally independent of the language he hears about him; they are closely related to it, but are nevertheless independent of it in important respects, the most important appearing to be the creativity which he brings to bear on the acquisition process, and this creativity has to do with the communication of concepts which he is cognitively able to handle. (p. 206)

FIG. 1.2. Typical drawings obtained when (a) 7-year-olds and (b) 9-year-olds were asked to color in their drawings of a cube. Courtesy of V. Moore.

complex rules, resulting in sentences such as "There no squirrels" or "I didn't see something." By studying errors of this kind, linguists have been able to describe the course of language development.

In part 1 of this book I give a detailed account of the drawing rules that children use at different stages of development, and much of the evidence for this account is drawn from the drawing "errors" that children make. Figure 1.2 shows typical drawings of a cube with a different color on each face produced by 7- and 9-year-olds. The children were first asked to draw the cube in pencil and then color in their drawings using a selection of felt-tipped pens. The older children, as we might expect, used just one color to fill in the square, resulting in a possible view of one face (Fig. 1.2b), but all the 7-year-olds filled in their squares with six colors, using either horizontal or vertical stripes (Fig. 1.2a).

I obtained similar results when I asked children of various ages to draw a die. The older children drew a square with just three dots in it, showing a possible view (Fig. 1.3c). The 6-year-olds, in contrast, drew single squares containing large numbers of dots (Fig. 1.3a), and one child drew a square containing all the dots on all the faces in sequence (Fig. 1.3b).

FIG. 1.3. Drawings obtained when children were asked to draw a die: (a) and (b) 6-year-olds and (c) 8-year-olds. Taken from Willats (1992c).

It seems impossible to dismiss the drawings by the younger children as the results of copying errors. Instead, these children seemed to be using a rule in which a square is used to stand for the volume of the cube rather than just one single face and so added the dots from all six faces. Thus, although the lines in Fig. 1.3c can be identified with particular edges, this is not the case with Figs. 1.3a and b. The smallest units of meaning in Fig. 1.3c, or picture primitives as they are called, are lines, but in Figs. 1.3a and b the picture primitives are not lines but regions, that is, areas of the picture whose only property is their overall shape. Lines are present in these drawings, but they only serve to define the outlines of the regions.

The drawings in Fig. 1.1 were classified in terms of various drawing systems. The drawing systems, such as oblique projection and perspective, map spatial relations in the scene into corresponding relations on the picture surface; that is, the drawing systems specify where the features such as lines and regions go. The drawing rules that children use at different ages give effect to these different drawing systems. Drawings in oblique projection, for example, are produced using a rule that says: Represent front-to-back edges by parallel oblique lines, whereas drawings in perspective are based on a rule that says that these lines should converge to a vanishing point.

However, describing children's drawings in terms of the drawing systems on which they are based is insufficient to explain all their features. To gain a full understanding of their drawings, we also have to be able to describe them in terms of the various *denotation systems* that children use. Whereas the drawing systems specify where the picture primitives go, the denotation systems specify what the primitives stand for, refer to, or denote. These two systems are not alternatives but instead complement each other.

There are three main kinds of denotation systems, based on points, lines, and regions as picture primitives. In photographs, and most Western paintings produced between the Renaissance and the 19th century, the picture primitives are blobs or dots, and these are used to stand for features such as the colors and intensities of light rays coming from the scene.[4] Perhaps the most common of all the denotation systems is line drawing, and in adult drawings and drawings by older children picture primitives in the form of lines can stand for a variety of scene primitives: edges (such as the edges of tables), contours (such as the contours of a person's face), and thin wire-like forms (such as strands of hair). The third kind of denotation system is less familiar and does not have a generally accepted name. In pictures based on

[4]Denotation systems of this kind are called optical denotation systems, but I do not say much about them here as children rarely use them. They are fully described in Willats (1997).

this system the pictures primitives are not dots or lines but regions, and, as I have suggested, the drawings of a colored cube shown in Fig. 1.2a and the drawings of a die shown in Figs. 1.3a and b appear to have been produced by using a denotation rule in which regions stand for whole volumes. Examples of adult pictures based on this system include early rock drawings and some cave paintings, and paintings and drawings by Klee, Matisse, and Picasso (Willats, 1997).

As with the drawing systems, children use different denotation systems at different ages, but it is not always easy to see that this is the case because the marks that children make nearly always consist of lines, even when the picture primitives they are using are regions. Here we come to what is perhaps the greatest difficulty in making sense of children's drawings, and this difficulty can be resolved only by making a distinction between the picture primitives that children use at different ages and the physical marks they use to represent them.[5]

As part of the process of acquiring a language children have to learn the basic units of which the language is composed, and these units change from whole sentence contours, to syllables, and finally to vowels and consonants. As in drawing, children tend to use smaller units of meaning as they get older. In addition, however, they also have to learn how these units are realized in sounds. The difference between units of meaning and the sounds children use to represent them is illustrated in this conversation between the psycholinguist Roger Brown and a small child:

> Brown had what has become a classic conversation with a child who referred to a "fis." Brown repeated "fis," and the child indignantly corrected him, saying "fis." After several such exchanges Brown tried "fish," and the child, finally satisfied, replied, "Yes, fis." It is clear that although the child was still not able to pronounce the distinction between the sounds "s" and "sh," he knew such a systematic phonological distinction existed. (Moskowitz, 1978, p. 96)

Moskowitz's remarks about the difficulty of determining the children's knowledge of the basic units of language from the actual sounds they make applies with perhaps even greater force to the study of children's drawings. In some drawings, such as the drawings by younger children shown in Figs. 1.2 and 1.3, it is apparent that the children were using regions rather than

[5]A similar distinction between phonology (the study of the basic units of language) and phonetics (the way these primitives are realized in sounds) has long been recognized in the study of language, but the importance of making a similar distinction between picture primitives and marks has only recently been recognized in the study of children's drawings.

FIG. 1.4. A "tadpole" drawing of a man by a 5-year-old boy. Collection of the author.

lines as picture primitives, but this is a rather special case. Take, for example, the difficulty of understanding what the marks stand for in children's "tadpole" drawings of people, such as the drawing shown in Fig. 1.4. All the marks in this drawing (with the exception of the two dots for eyes) are lines, and it is all too easy to assume that the picture primitives are therefore also lines and that these lines stand for the contours of forms, as they would in an adult's drawings. According to this interpretation, drawings of this kind simply represent badly drawn or unsuccessful views.

I shall argue in chapter 4, however, that this interpretation is incorrect and that drawings of this kind are based on rules that are fundamentally different from those used by older children or adults. I argue, for example, that the picture primitives in drawings of this kind are not lines but regions and that these regions represent body parts as whole volumes, very much as the squares drawn by the younger children shown in Figs. 1.2 and 1.3 represent the whole volumes of cubes. In this drawing the regions are not directly represented; instead, they are only implied, either in the form of areas enclosed by an outline, as in the case of the eyes and the head or head/body, or by single lines, as in the case of the arms and legs.

To gain a full understanding of children's drawings, therefore, we have to add descriptions of the *mark systems* on which they are based. The marks in a picture are the actual physical features that make the picture: the phosphors on a TV screen, the dots of ink in newspaper photographs, the blobs of paint in a Canaletto painting of Venice, the tufts of wool in a tapestry, the tesserae in a Roman floor mosaic, and so on. As a rule we do not pay much attention to these marks as such, although in some cases such as Impressionist and Pointillist paintings they may force themselves on our attention. Instead, we look through them to the more abstract picture primitives they represent. In

some cases, such as some of Picasso's line drawings in which the lines have a uniform thickness, there is a close resemblance between the marks and the picture primitives, but in other cases the relations between the marks and the picture primitives may be much less obvious. The marks in a sampler may take the form of individual stitches, but from them we infer the outlines of plants and animals, and cartoonists often leave out the most important parts of a drawing, leaving us to infer the picture primitives from the composition as a whole (Willats, 1997). For similar reasons young children's drawings can be difficult to analyze because they are often made up of regions that are not physically present on the picture surface but are defined only by their outlines. In many cases the relations between the marks and the picture primitives can be inferred only indirectly.

I have drawn attention to a number of similarities between children's drawing development and the acquisition of language, the most important of which is that learning to draw and learning to speak both depend on acquiring increasingly complex and effective rules. But in one respect at least there is a profound difference between drawing and language. Whereas in language the rules are conventional (i.e., they are arbitrary in nature and established by social conventions), in drawing they are derived from the laws of optics and the design features of the human visual system.

This difference between drawing and language has a number of important consequences. Perhaps the most obvious is that whereas no native English speaker can understand Japanese without tuition we have little difficulty in understanding Japanese paintings. It is true that there are many differences between Japanese paintings and typical Western paintings (the use of oblique projection rather than perspective, for example, and the lack of cast shadow and tonal modeling), but these are relatively superficial compared with the differences between English and Japanese as languages.

Another important consequence is that whereas children have to learn to understand language as well as to speak it, the ability to understand pictures seems to be innate. As part of the process of teaching children a language parents routinely show pictures to their children and ask them to name the objects they represent, but this depends on children being able to recognize objects in pictures without any special training. In a well-known experiment, Hochberg and Brooks (1962) studied a boy who had been prevented from seeing pictures until he was 19 months old. At the end of this period he was shown line drawings and photographs of various objects and in each case he was able to name them without any difficulty. Learning to produce drawings that are in any way comparable with those of a competent adult, on

the other hand, takes children a very long time. It seems that the processes by which we produce drawings and the rules we use in doing so must be very different from those we use to understand them.

Yet another difference between drawing and language is that children's language development is judged against the standards of normal adult speech. But it is difficult to see how we can use the same approach in judging children's drawing development. If we judge children's ability in drawing against that of most adults the standard is too low—most adults admit that they cannot draw. But if we judge children's drawings against those of adult artists, which artists are we to choose? Nineteenth-century Western painters? The artists of the early 20-century avant-garde? Or conceptual artists of the present day?

The way out of this dilemma is to rely on our intuitions about what constitutes an *effective representation*, and we can do this because in judging pictures we bring to bear the same visual pathways that we employ in the perception of real scenes. As a result, the experience we have when we look at pictures is fundamentally different from the experience we have when we listen to someone speaking or when we read a book. I have spoken of understanding drawings, but this is misleading. With most pictures it is not a matter of understanding them, in the way that we can be said to understand languages; instead, we have the vivid and irresistible experience of seeing the objects and scenes depicted in such pictures as if they were real. It is only with pictures that lie on the fringes of true representation, such as maps and engineering drawings, that we do not have this experience, and it is significant that we speak of "reading" pictures of this kind.

Following Wollheim's (1977) definition of what he called "central cases of representation" I define an *effective representation* as one in which something specific can be seen and recognized clearly and unambiguously. In most cases recognizing objects in pictures depends on recognizing their shapes: tables can be recognized in pictures irrespective of their color, but try to imagine what a drawing of a table would look like if it did not represent its shape! Moreover, we can see the shapes of objects in drawings even if we have never seen such objects before.

Figure 1.5 shows typical examples of drawings of an unfamiliar object, a model in the form of a cube with a smaller cube removed from one corner, produced by children ages 4 to 13. The drawings produced by the older children are clearly more effective as representations than those of the younger children. The object the children were asked to draw can be seen, clearly and unambiguously, in Fig. 1.5g, but this is not true of the drawings by the younger children.

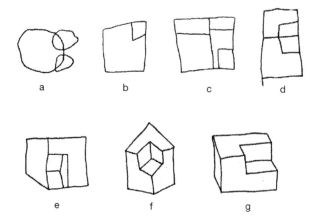

FIG. 1.5. Typical drawings of an unfamiliar object produced by children at different ages. Mean ages: (a) 5 years 6 months, (b) 7 years 2 months, (c) 8 years 10 months, (d) 10 years 4 months, (e) 10 years 9 months, (f) and (g) 12 years 2 months. Taken from Willats (1981, Figs. 1.3 to 1.8).

Because the ability to perceive objects and scenes in pictures is innate and (so far as we know) all adults have this ability in common, we can rely on our intuitions in judging whether a drawing does or does not provide an effective representation. But the ability to produce drawings is another matter, and I shall argue that it is the ability to produce drawings that are increasingly effective as representations that constitutes drawing development. To acquire this ability children must discover how to use the appropriate drawing rules.

The example shown in Fig. 1.5 is contrived: children are unlikely to produce spontaneous drawings of cubes with smaller cubes removed from their corners. Experiments of this kind are necessary, however, if we are to discover the drawing rules that children use at different stages of development. This experiment also shows that children can use these rules to draw objects they have never seen or drawn before, so they are not limited to producing stereotypical drawings of known objects, as some writers have argued. The ability to use a finite set of rules in novel situations was one of Chomsky's main arguments for the creative nature of language. As with children's speech, the "errors" in these drawings not only demonstrate the creativity they bring to bear in their attempts to draw an object they have never seen or tried to draw before but also provide evidence for the drawing and denotation rules they use at each stage of development.

In part 1 I provide descriptions of these rules. But how do children learn these rules, and what are the actual mental processes involved in making a

drawing? Here again, I draw on the experience we have of "seeing in," and our ability to judge pictures as effective representations on the basis of this experience. When we look at a drawing such as the one shown in Fig. 1.5g we do not simply see it as a collection of lines nor, of course, do we see a real three-dimensional object. What we do see is a paradoxical object, which appears to be three-dimensional but lacks many of the properties that objects have in real scenes. A step to one side, for example, does not change the appearance of the object in the picture, as it would do if the object were real. I refer to these paradoxical objects as pictorial images, and our experience of seeing them in pictures may be more or less vivid according to the drawing and denotation rules on which they are based.

Figure 1.5b is based on the rule: Represent the faces of objects by regions in the form of true shapes. This drawing provides a possible view of the object shown at Fig. 1.5g, but it is unsatisfactory as a representation because the pictorial image it provides is not very vivid, and it shows only two faces of the object. Children attempt to solve this problem in one of two ways: they either draw one face of the object and subdivide it, as in the drawing shown in Fig. 1.5c, or they draw one face (usually the front face) and add further faces around the edges. Drawings of this second type are known as fold-out drawings. The drawing in the top row in Fig. 1.6 provides an example in the form of a fold-out drawing of a cube.

Although fold-out drawings show more than one face they are even more unsatisfactory as representations than the earlier single-face drawings of cubes because they do not provide possible views and cannot, therefore, provide pictorial images. Children can see this for themselves and they adopt various strategies in an attempt to overcome the problem. One of these is to join the offending corners with lines, another is to draw the side faces as triangles, and yet another is to distort the shapes of the faces. These three solutions are shown in the drawings in the middle row in Fig. 1.6.

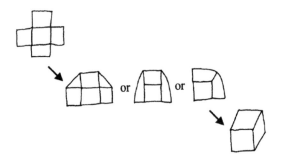

FIG. 1.6. The transition from fold-out drawings to oblique projection in children's drawings of a cube. Adapted from Willats (1984, Fig. 12).

None of these solutions provides a possible view of a cube, but many of them involve introducing diagonal lines and this, fortuitously, results in drawings that look much more three-dimensional. Eventually, children will realize this and start introducing diagonal lines deliberately. At this point it is only a small step to producing drawings in oblique projection, which do provide effective representations. To take this step, however, children have to adopt a new denotation rule (Use lines to represent edges) and a new drawing rule (Use diagonal lines to represent edges in the third dimension). Moreover, they also have to abandon the old denotation rule (Use regions to represent faces) and the old drawing rule (Use square regions to represent square faces). It is only by adopting new rules, and abandoning the old ones, that children can produce drawings that provide vivid pictorial images.

Development can thus be seen as the result of a series of interactions between production and perception and this interaction also plays a central role in the production of individual drawings. Children typically begin by drawing the front face of a cube as a square, and at this stage the drawing looks completely flat. Once a single diagonal line has been added, however, a three-dimensional pictorial image begins to appear and children can work within this image to complete the drawing. I have taken my examples from drawings of cubes, but this account of the interaction between making marks and seeing pictorial images in these marks can be used to describe the processes of production and development in drawings of all kinds of objects, including "smooth" objects such as animals and people.

I describe in part 1 the rules that enable children to produce drawings that are more effective as representations and in part 2 the mechanisms of development and the mental processes by which drawings are produced. But although learning how to represent the shapes of objects so that they can be recognized is an important goal, this is not the only function that pictures have. In part 3 I consider the extent to which children's drawings can be said to be expressive. Finding ways to make their pictures expressive has certainly been a major preoccupation for artists, and this is perhaps especially true of many of the avant-garde artists in the early 20th century. Many writers have claimed that young children's drawings are expressive in the same way and that, as with the paintings of avant-garde artists such as Matisse, this expression resides in their formal qualities of line, shape, and color rather than in their subject matter. How far is this claim justified?

Art educators such as Cizek and Richardson were able to make this claim because many of the anomalies in children's drawings are remarkably similar to those in the paintings and drawings of the avant-garde in which these anomalies were used for expressive reasons. To take just one example, the

subject matter of Giorgio de Chirico's *Mystery and Melancholy of a Street*, painted in 1914, is not especially remarkable. Nevertheless, this painting is very expressive in the sense of mystery and melancholy it conveys, and this expression is largely produced by the mixture of drawing systems on which it is based (Fig. 10.6). Linguists have suggested that a defining characteristic of poetry or poetic speech is its use of unusual or ungrammatical constructions for expressive purposes. Chomsky (1965) suggested that although sentences such as "The boy may frighten sincerity" and "Misery loves company" are ungrammatical, they can, in the right context, be interpreted metaphorically or allusively.

Children's drawings frequently contain mixtures of drawing systems that, at least superficially, look very like those in de Chirico's paintings. Chapter 10 provides other examples of expressive anomalies in artists' pictures that look very similar to the anomalies in children's drawings. The question is, do children use these anomalies intentionally, for expressive reasons? Cizek and his followers believed that they do, and saw "faults" as an essential part of the child's means of self-expression. However, it seems doubtful that children themselves see the anomalies in their drawings as expressive. What children look for in their drawings is realism, and what they want to produce are what I have called "effective representations." These anomalous constructions may look expressive to adults, but I believe that in almost all cases they arise as a by-product of the child's struggles to produce effective shape representations. From the child's point of view the faults in their drawings, once they recognize them, are just that: faults. As I suggest in chapter 8, it is the child's attempts to eliminate these faults in the interests of realism that provide the mechanism of development. Developing new rules and abandoning old ones require a supreme effort of creativity; but this is the creativity demanded by ordinary realistic drawing, not the creativity of artists such as Klee, Matisse, and Picasso.

Whether children's drawings are intentionally expressive, and whether they use anomalies deliberately for expressive reasons, would not matter very much if it were not for the fact that Cizek and his followers, and generations of art teachers after them, deliberately tried to restrict children's normal drawing development in an attempt to preserve their creativity. Their attempts were largely unsuccessful, but most children need the help of adults to progress beyond the early stages of drawing, and in the absence of such help, most simply give up. As a result, most adults say, with truth, that they cannot draw.

Children's drawings have thus been both overvalued and undervalued. Attempts to elevate children's drawings to the same level as the work of the

great 20th-century masters, and the misguided copying theories that reduced drawing to mechanical reproduction, have both diverted attention away from the very real creativity children need to bring to bear if ordinary drawing development is to take place. Ordinary development depends on children's discovering increasingly complex and powerful representational rules. If we are to make sense of child art and children's drawings, we have to understand what these rules are and what it is that children are doing when they are leaning to draw. That is what this book is about.

Part One

STUDYING CHILDREN'S DRAWINGS

Contradictions and Confusions

Listening to his father, who, canted over in his chair like a broken robot, was saying splenetically: "In children's art, you see, you get what you might call a clarity of vision, a sort of thinking in terms of the world as it appears, you see, not as the adult knows it to be. Well, this . . . this . . ."

—Kingsley Amis, *Lucky Jim*

Arthur B. Clark

Probably the most widely known theory of children's drawings is the one that says: Young children draw what they know and older children draw what they see. This is usually associated with the theory of intellectual and visual realism formulated by Luquet in 1913, but its origins go much further back: to Barnes (1894), Sully (1895), and a classic study by Clark (1897). Clark asked children of various ages to draw an apple with a hatpin stuck through it, turned through a small angle so as to present a slightly oblique view. The resulting drawings were then divided into three groups (Fig. 2.1). In the first, produced by children with an average age of about 8 years, were drawings that consisted of a rough circle for the apple with the pin drawn "clear across." In the second group, drawn by children with an average age of about 12 years, the pin was drawn "stopping on edges" so that the part of the pin hidden within the apple was not drawn but there was no effect of perspective. "Just such a drawing as a mechanic would make," Clark (p. 287) commented. The oldest group of children, ages 12 to 16, drew the pin "as it appeared," with part of the pin crossing one contour of the apple so as to give an effect of both perspective and foreshortening.

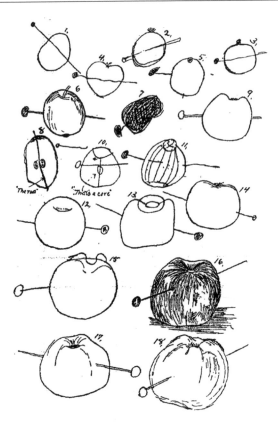

FIG. 2.1. Three types of drawing of an apple with a pin through it: "clear across the apple" as in 1, 2, 3, 4, and 10; "to the edges only" as in 9, 12, 13, and 15; "as it appeared" as in 16, 17, and 18. Taken from Clark (1897, p. 285).

Clark also asked children ages 6 to 16 to make drawings of a book lying cornerwise on a table. In contrast to the apple, which had a more or less smooth surface, the book was a roughly rectangular object, but like the apple it was presented in a foreshortened position.

These drawings are shown in Fig. 2.2. Most of the drawings by the youngest children show only one side of the book (no. 2) or the wrong number of sides (no. 14). In addition, most of these drawings show the book with its edges parallel to the sides of the page rather than in a slanting position. The older children, in contrast, drew the correct number of sides as well as attempting to show the book in the correct position from their point of view.

Finally, in an attempt to find out how fixed children were in their ways of drawing, Clark carried out a further test a few weeks later. Some of the children's drawings of the apple and the book were enlarged and shown to the

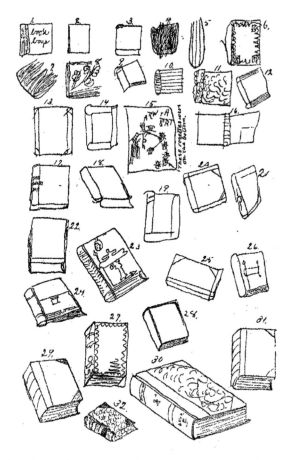

FIG. 2.2. Three types of drawing of a book presented in a foreshortened position.
Taken from Clark (1897, p. 288).

children. They were asked to choose the drawings that looked most like
those they had previously drawn and then to draw the apple and book again.
Clark found that that most of the children *chose* the best drawings but *drew*
them very much as they did the first time.

Clark then asked: "Why is it that the younger children do not draw things
as they see them?" His answer was that "they draw things as they are known
to be, not as they appear" (p. 287). The 6-year-old does not notice that part
of the pin is out of sight, or does not draw it so if he does, because he is try-
ing to show not appearances but facts: "The pin goes through the apple, and
he draws it so." Later, it occurs to the child to express the idea that part of the
pin is out of sight, so he does it in the easiest way by making a sectional

drawing. Finally, the oldest children "expressed the exact visual relations of the apple and pin as they appeared from their point of view" (p. 287). The reason children go through this protracted course of development, Clark suggested, is that "the child has had to pay penalties for mistaking appearances for facts, and has been rewarded for inferring the real use to him . . . hence, when he sees a thing he immediately thinks of its facts of form, or taste, or feeling—anything but its abstract visual qualities" (p. 287). As a result, he does not pay attention to the appearances of things from a single point of view until he learns to draw like an adult.

Karl Bühler

Bühler (1949) agreed with Clark that "the child draws from its knowledge" (p. 114) but gave a rather different reason for this phenomenon—or, rather, two different reasons. First, Bühler remarked that young children always draw in outline, rather than "drawing what they see," like a photograph. The obvious explanation, that outlines "are easiest to draw," has some truth in it, he thought, but is inadequate: the real reason is that the child "sees them differently, or, more correctly, its retinal images are quite different" (p. 113). In the light of modern theories of vision (Palmer, 1999) this explanation seems highly questionable, but as we shall see, the idea that children's drawings look different from those of adults because they *see* things differently has been very tenacious. However, Bühler deserves credit for pointing out that the fact that children draw in line rather than tone needs explaining, a point ignored by most other theorists.

Bühler's second explanation was more fundamental. The "root of this evil," as Bühler called it, lies in the "formation of concepts," which begins as soon as objects are named, "*and these take the place of concrete images*" (p. 114). Thus, the ultimate source of this "childish schematism" is in the acquisition of language: "*Language has first spoilt drawing, and then swallowed it up completely*" (p. 120). Like Clark, Bühler was drawing on an earlier suggestion by Sully (1895):

> The child's eye at a surprisingly early period loses its primal "innocence," grows "sophisticated" in the sense that instead of seeing what is really presented it sees, or pretends to see what knowledge and logic tell it is there. In other words his sense perceptions have for artistic purposes become corrupted by a too large mixture of intelligence. (p. 396)

Bühler illustrated his account with the drawings shown in Fig. 2.3.

FIG. 2.3. "Why does the child draw such curious outlines of things? Surely it sees them differently, or, more correctly, its retinal images are different" (Bühler, 1949, p. 113, Fig. 8). Images selected by Bühler from Ricci (1887) and Sully (1895).

Children learn to speak before they begin to draw, so it might seem difficult to test this theory. Bühler's answer was that there are two examples of types of realistic pictures produced by people in whose minds the "original talent for drawing has remained unspoilt" (p. 123): drawings by exceptionally talented children, and drawings and paintings by primitive peoples such as the Paleolithic cave painters and modern African bushmen. As an example of the first, Bühler illustrated some remarkably realistic drawings of a horse by an 8-year-old boy (Fig. 2.4). How delighted he would have been could he have seen the even more remarkable drawings of horses by Nadia such as the drawing shown in Fig. 7.13 (Selfe, 1977). Not only was Nadia autistic, with a spoken vocabulary consisting of some 10 single-word utterances, but the decline in her drawing ability coincided with the beginning of systematic attempts to teach her language. For Bühler, Nadia's drawings alone would have vindicated his theory, and many modern commentators have explained Nadia's drawings in terms of the theory of the "innocent eye" (Costall, 1997).

FIG. 2.4. Drawings by an 8-year-old boy. "Not from knowledge, but like a painter from concrete memory images" (Bühler, 1949, p. 121, plate 111).

Bühler also used examples of Paleolithic art to support his account of children's drawings (Fig. 2.5). This use of pictures from a distant golden age of art to explain the art of children was the result of the influence of what is called the theory of recapitulation. This theory, that the history of mankind as a whole can be discovered in the personal history of the child, originated in embryology but was abandoned in this field before the end of the 19th century. However, it remained popular in theories of children's art and art education until well into the 1940s.

The idea that children see things clearly and directly before their vision is contaminated by knowledge came to be know as the theory of the "innocent

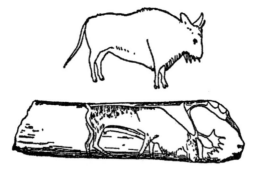

FIG. 2.5. Paleolithic animal drawings. Taken from Verworn (1907) and used by Bühler to support his theory of the innocent eye.

eye." For many centuries it was believed that the visible world is represented internally by a perspectival, depthless image: Costall (1993, 1994, 1997) called this supposed image the "sensory core."

The idea that perspectival images are corrupted by knowledge as the explanation for the "defects" in children's drawings was adopted by other theorists, and combined with the theory of recapitulation it not only provided an explanation for children's drawings but also for the remarkable paintings of the Neolithic cave painters and African bushmen. According to this theory, the use of perspective by older children does not develop at all; it is simply a return to an earlier golden age of vision that has been temporarily repressed. How and why older children overcome this repression remained unexplained.

Georges-Henri Luquet

The idea that children draw what they know rather than what they see was elaborated by Luquet (1913, 1927/2001) in his theory of "intellectual and visual realism." Luquet's account of drawing development was a good deal more complex than this suggests; what follows here is only a brief summary. Unlike Clark, Luquet did not carry out experiments and only rarely referred to those of other people, but he was an acute and thoughtful observer of his own and other children and many of the illustrations in his book *Le Dessin Enfantin* (1927/2001) are taken from drawings by his daughter Simonne.

Luquet divided children's drawing development into four stages: *fortuitous realism, failed realism, intellectual realism,* and *visual realism.* After an initial period of scribbling, the child begins to recognize meaningful objects in some of these scribbles: "The day comes when children notice a more or less vague resemblance between one of their traces and some actual object" (Luquet, 1927/2001, p. 88). They then regard this trace as a representation of that object, and give it a name, such as the "bird" drawn by an Italian girl, age 2 years 6 months, shown here as Fig. 2.6. Luquet called this first stage of drawing fortuitous realism.

FIG. 2.6. Fortuitous realism. Italian girl, 2 years 6 months. An unpremeditated trace is recognized as a bird, and the lines representing legs are then added to give greater verisimilitude. Taken from Luquet (1927/2001, Fig. 70).

In the second stage, failed realism, children know what they want to draw and can announce their intentions beforehand but are unsuccessful in producing what they want for two main reasons. The first is a lack of the necessary graphic control: "They are like novice violinists constantly hitting wrong notes" (Luquet, 1927/2001, p. 93). The second is a psychological difficulty: the limited and discontinuous character of the child's attention. "Children think of the details of an object in a certain order corresponding to the degree of importance they attribute to them, and they will continue to add them as long as their attention moves from those details which have already been drawn to a new one" (Luquet, 1927/2001, p. 94). At this stage, however, the task is often too difficult and their attention can easily wander because they are faced with a double task: "On the one hand, the task of thinking about the object that needs to be represented, and, on the other, the task of monitoring the graphic movements to produce this representation" (p. 94). Luquet illustrated this by the series of drawings of men by a 3-year-old boy shown in Fig. 2.7. This boy first started the figure on the left; this had a rudimentary body but initially no mouth or nose. In the next figure the nose and mouth were present but not the trunk. In the third drawing all these details are missing, but when asked "Is that all?" he replied, "It's finished," but then went back and added a nose and mouth to the first drawing. These kinds of imperfections in a drawing are characteristic of the stage of failed realism.

In the next stage, intellectual realism, children are able to realize their intentions, but their idea of realism is different from that of an adult. For an adult, if a drawing is to be realistic it must be "a kind of photograph . . . in short, the object has to be depicted in perspective" (Luquet, 1927/2001, p.

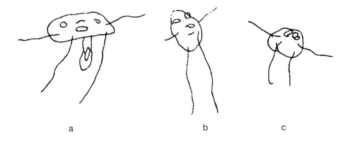

a b c

FIG. 2.7. Failed realism. Three consecutive drawings by a French boy, 3 years 6 months. The first drawing (with a hint of a trunk) initially lacked a nose or a mouth. In the second drawing these details were included. Then, after the third drawing that lacked these details but that the boy described as "finished," he went back and added them to the first drawing. Taken from Luquet (1927/2001, Figs. 85–87).

102). In contrast, the child's idea of a realistic drawing is that it must show all the details, whether or not these can be seen from any particular viewpoint, and each of these details must be given its characteristic form in accordance with what Luquet called "the principle of exemplarity." Drawings produced during this stage contain mixtures of viewpoints, transparencies, and what Luquet called "rabattement," in which parts of objects are folded down so as to show their most characteristic shapes.

Some transparencies, Luquet thought, can be explained as tacit corrections, such as the head visible under the hat in Fig. 2.8. But a great number of true transparencies are encountered, such as the one shown in Fig. 2.9 in which the furniture and people are shown within the house.

Figure 2.9 shows examples of both transparency and rabattement. All the objects in the house are shown as if the front wall of the house were transparent. In addition, the tabletop is folded up from the legs and the saucepan is folded down from the table (a similar but more elaborate example of a drawing of a table is shown in Fig. P.1). Figure 2.10 shows an even more striking example of rabattement containing mixtures of viewpoints. The horse is shown in a characteristic view from the side, but the figures, the wheels, and the hood are shown from the front, and the body of the carriage is shown in plan.

Like other writers, Luquet gave little space to a description of the final stage, visual realism. In this stage transparency gives way to the representation of occlusion; rabattement and a mixture of viewpoints give way to perspective; and exemplarity, in which each object is drawn in its characteristic

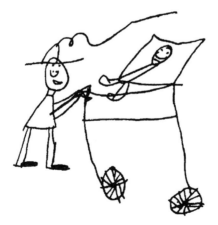

Fig. 2.8. Tacit correction rather than transparency. Jean Luquet, 6 years 10 months. The top of the head is visible under the hat. Taken from Luquet (1927/2001, p. 108, Fig. 104).

FIG. 2.9. Transparency and rabattement. Jean Luquet, 6 years 4 months. The contents of the house are shown as if the front wall was transparent. The tabletop is folded up from the legs, and the saucepan is folded down from the table. Taken from Luquet (1927/2001, p. 111, Fig. 108).

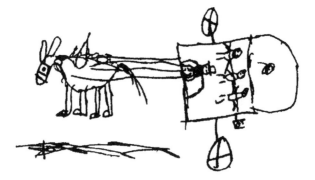

FIG. 2.10. Rabattement. The horse is shown from the side; the wheels, figures, and the hood are shown from the front; and the carriage itself is shown in plan, resulting in a mixture of views. Taken from Luquet (1927/2001, p. 112, Fig. 111).

shape, gives way to foreshortening. These transitions take place gradually, however, and have to struggle against entrenched habits. Moreover, visual realism is not firmly established once it has appeared, and the same drawing may contain a mix of intellectual realism and visual realism. In drawings of houses by children of many different nationalities, for example, furniture continues to be shown even when the inhabitants are only partially visible through the windows.

Luquet gives a rather confused account of the mechanisms of development and picture production. The transition from fortuitous realism to failed realism takes place when the child repeats a graphic image, like the drawing of a bird shown in Fig. 2.6, which has initially come about as the result of a chance resemblance. During the period of failed realism children not only repeat this image but try to improve it. A French girl 3½ years old, for example, having interpreted one of her traces as a bird added the beak, the eye, and the legs (cf. Fig. 2.6). At this stage children have the ability to improve a fortuitous resemblance intentionally, and by repeating these improvements they become more aware of this ability. Through repetition, and by adding characteristic details such as paws for a dog or whiskers for a cat, the child develops a repertoire for drawing a range of objects that is then available during the stage of intellectual realism. As Luquet pointed out, children who are entirely isolated could by this means begin to draw entirely by themselves. But in practice children see other adults producing pictures by drawing and are led to produce pictures themselves by imitation.

However, Luquet also offered an alternative account of intellectual realism in terms of what he called the internal model: the child's mental representation of the whole object. According to this account, children draw what they know in the sense of deriving their drawings from their knowledge of the object independently of any particular point of view: the knowledge that books, for example, have roughly rectangular faces and that carriages have round wheels. As we shall see, Luquet's idea of the internal model as a basis for drawing comes close to what Marr (1982) in his account of vision called an object-centered description, and Luquet's account of intellectual realism is now often interpreted in these terms. But what Luquet failed to explain was how this three-dimensional model was translated on to the two-dimensional picture surface: being three-dimensional it could not simply be copied on to the picture surface, although Luquet often wrote as if it could.

According to Luquet, children of all ages are trying to produce realistic drawings, but as they get older their idea of realism changes. Luquet saw intellectual realism not just as an imperfect version of visual realism but as an alternative way of representing the real world: "Visual realism is no less a

convention than intellectual realism. Intellectual realism allows children's drawings to be, in their representation of space, a kind of flat sculpture (though sculpture, unlike children's drawings, is not transparent). . . . It could thus be said to be a universal art, which at least merits serious attention before being dismissed" (Luquet, 1927/2001, pp. 156–157).

Jean Piaget

Piaget did not develop a separate theory of children's drawings of his own and was interested in them only to the extent that they provided evidence for his account of the development of the child's conception of space. *The Child's Conception of Space* (Piaget & Inhelder, 1956) was Piaget's major work on spatial representation and in it he claimed that the young child's internal representation of space, and thus his or her early drawings, are based on topological geometry rather than projective geometry. Drawings based on projective geometry represent objects from a particular point of view, whereas drawings based on topological geometry represent only the most elementary spatial relations such as touching, spatial order, and enclosure, which are intrinsic to the scene and independent of any particular point of view. Piaget accepted Luquet's account of intellectual realism but added his own account of the young child's conception of space, so that drawings containing transparencies representing enclosure such as the "egg with a duck inside" illustrated by Luquet (Fig. 2.11) were taken as evidence that children were using topological geometry as a basis for their drawings during this period.

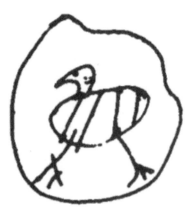

FIG. 2.11. Four-year-old Belgian boy, *An Egg With a Duck Inside*. Taken from Luquet (1927/2001, p. 100, Fig. 96).

Piaget attempted to test Luquet's theory of intellectual and visual realism by asking children of various ages to draw a stick presented to them in both foreshortened and nonforeshortened positions. He found that the younger children (below the age of about 7 or 8 years) used a line or a long region to represent the stick, whatever its position, whereas older children were able to represent foreshortening by a change of shape: a needle or pencil pointing directly toward the child was represented by a dot or a small circle. These results, Piaget concluded, demonstrated the truth of Luquet's theory: children draw sticks as long according to the principle of exemplarity, irrespective of the view they have of them.

It is difficult to tell from these accounts whether Piaget believed that the young child's internal representations of the world are based only on topological geometry or whether he believed that young children are able to form perspectival views of things but are unable to represent them in their drawings.

Brent Wilson and Marjorie Wilson

Most of the theories I have described so far assume that children's drawings are derived from some kind of internal image or mental representation: either the depthless perspectival images of the innocent eye or some kind of knowledge-based representation derived from language or cultural influences. The assumption has been that these internal images or representations are more or less universal and common to all periods and cultures, but Wilson and Wilson have challenged this assumption in a series of studies. They pointed out that if children's drawings unfolded through a series of universal stages the graphic productions of children coming from difference cultures ought to be essentially the same. They found, however (Wilson & Wilson, 1982), that the occurrence of the two-eyed profile in children's figure drawings (examples of which are shown in Fig. 2.12), which was as high as 70% in Italy in 1883, had declined to 5% in the United States in 1923 and by 1950, under the influence of the advent of cheap picture books and comics, had altogether disappeared. They also showed (Wilson & Wilson, 1977) that virtually every image drawn from memory by teenagers in the United States was derived, not from the individual imagination, but from popular printed media.

The Wilsons related their findings to the theory advanced by Gombrich (1988), in *Art and Illusion* that artists' pictures are almost always derived from pictures by other artists rather than from imagination or direct observation. According to this theory, the first crude approximations to pictures are gradu-

FIG. 2.12. The two-eyed profile. By 1950 the two-eyed profile had disappeared in the United States. Collected by Kerschensteiner, circa 1903, Germany. From Wilson and Wilson (1982, p. 22, Fig. 3).

ally shaped toward illusionistic, or at least realistic, representations by a process that Gombrich called "schema and correction." In the same way, according to Wilson and Wilson, children's drawings are derived from other pictures rather than from views of objects or from what they know about objects.

Thus, for Wilson and Wilson the developments we see in children's drawings do not reflect changes in their internal representations of the world but rather the child's attempts to improve his or her first crude schema by adopting corrections derived from the drawings of other children, or from picture books and the popular media. It is obvious that this account of drawing development has profound implications for art education and suggests a program radically different from that pursued by proponents of the innocent eye.

Norman Freeman

Freeman was the first writer to make a clear distinction between the mental processes that underlie the production of drawings and drawing development and the role played by graphic skills. Earlier writers such as Sully and

Bühler argued that mere lack of skill could not explain the failure (as they saw it) of young children to draw in perspective, "since it was clear to any attentive observer that children were not *trying* to draw in perspective" (Costall, 2001, p. x). Apart from Luquet's (1927/2001) account of failed realism, all the theories I have described so far correspond in drawing to what linguists would call competence theories in language. A competence theory describes the underlying knowledge of language possessed by a speaker or hearer, whereas performance describes the actual use of language in concrete situations. Freeman (1972) pointed out that we need to make a similar distinction between competence and performance in drawing because the drawings children actually produce do not necessarily reflect the young child's competence directly but may, like their speech, "show numerous false starts, deviations from rules, changes of plan in mid-course and so on" (Luquet, 1927/2001, p. 4). In practice, though, the difficulty is to decide whether a particular drawing error is a reflection of the child's' underlying competence (i.e., the child is using a different drawing rule from that used by adults) or whether this is a performance error arising from a "lack of graphic control" or the "limited and discontinuous character of the child's attention" (Luquet, 1927/2001, p. 93).

A long-standing problem in the study of children's drawings has been to explain the ubiquitous tadpole figures. Compared with conventional figures, the tadpole figures not only appear to lack a trunk but also often appear to lack either the arms or the legs (Fig. 2.13). As Freeman (1975) pointed out, various explanations have been offered. One is that the trunk is omitted because children at this age either do not know that people have bodies as well as heads, and arms as well as legs; another is that they do know but

a b

FIG. 2.13. Drawings of a man—(a) a conventional figure and (b) a tadpole figure—by two preschool children. Taken from Freeman (1975, p. 416, Fig. 1). Courtesy of N. Freeman.

think it is unnecessary to include them. In either case, the child may have a rule that says add the arms to the head, or alternatively, the child may have a rule that says add the arms to the trunk, but in the absence of a trunk the arms are added to the head by default. Yet another explanation is that the round region that adults see as the head represents the head and trunk taken together as a single shape, in which case the rule add the arms to the trunk is not violated. All these explanations assume that the tadpole drawings accurately reflect the young child's underlying concept of the human figure, that is, the child's competence. Freeman suggested instead that the omission of the trunk, and either the arms or legs, might be performance errors, arising from the child's "production problems in programming spatial layout" (p. 417).

To test this explanation Freeman asked children aged between 2 and 4 years to draw a man and then to complete a series of incomplete drawings, shown in Fig. 2.14, in which the relative proportions of the head and trunk were varied. The results were clear-cut. Almost no children who had initially drawn conventional figures attached the arms to the head in these incomplete figures, whatever the head–trunk radio. In contrast, nearly all the children who had initially drawn tadpole figures attached the arms to the body in the first of the series of incomplete drawings but to the head in the last of the series, with varying proportions in between.

Freeman argued that none of the competence explanations described previously could explain these results and suggested instead that the omission of the trunk and the arms or legs in tadpole figures was the result of a production error, that is, a "characteristic defect in an executive routine" (1975, p. 416). He proposed that for this group of participants, the production sequence would be head–trunk and then legs–arms, and that, as a result of executive errors, the second term in each sequence might typically be omitted, resulting in a drawing composed only of the head and legs. This explanation has come to be known as the serial order hypothesis.

FIG. 2.14. Incomplete drawings used by Freeman (1975) to test between competence and performance explanations for tadpole figures. Taken from Freeman (1975, p. 417, Fig. 2). Courtesy of N. Freeman.

Freeman's explanation of the appearance of the tadpole figures in the early years of drawing has not gone unchallenged (for a review, see Golomb, 1992), but whatever the truth of these various explanations might be, his experiment was important in two respects: it drew attention to the crucial importance of distinguishing between competence and performance in the interpretation of children's drawings, and it showed how experiments could be designed to test between alternative explanations.

Rudolf Arnheim

Arnheim's (1974) account of children's drawings is in many respects unique. First, he was one of the very few writers who have tried to describe children's drawings and adult pictures in the same terms. His account of depiction was derived from Gestalt psychology, a branch of perceptual psychology that flourished in the early years of the 20th century. The strength of Gestalt psychology lay in its attempt to describe the relationships between perceptual units, rather than just treating them as individual stimuli, and its philosophy can be summed up by saying that the whole is greater than its parts. The Gestalt psychologists attempted to formulate the laws that governed these wholes: laws such as those of proximity, good continuation, and common fate. Gestalt psychology and its immediate predecessors had a considerable influence on the artists of the 20th-century avant-garde. Braque, Klee, Léger, and Picasso all included motifs taken from perceptual psychology in their paintings, and in the 1920s Gestalt psychologists were invited to lecture at the Bauhaus when Klee and Kandinsky were teaching there (Teuber, 1976, 1980). Arnheim's achievement was to apply the principles of Gestalt psychology to the analysis of both children's drawings and artists' pictures.

Arnheim rejected the idea of picture production as a form of copying. Instead, he proposed that depiction is a graphic language governed by the rules of visual logic. His account of the tadpole figures, for example, contrasts strongly with Freeman's. For Arnheim, the tadpole is not an incomplete or defective representation of a person but a complete figure in which the head and body are not yet differentiated. Nothing is missing; instead, the undifferentiated structure of these figures is typical of an early stage of development. Further development does not depend on acquiring greater graphic skills, or seeing things more accurately, but on the progressive differentiation of forms within the graphic medium. The structures in children's drawings—and artists' pictures for that matter—are equivalents in this

graphic medium, not just transcripts of the visual image, and in the early stages of development reflect the child's limited graphic vocabulary.[1] Thus "the invention of the tadpole figure as a structural equivalent for the human being is an act of creative intelligence" (Golomb, 1992, p. 56). Finally, Arnheim was not interested only in the way children represent the shapes of objects. For Arnheim, all shape is semantic; that is, the shapes in pictures can be used to represent not only properties such as roundness and straightness but also qualities such as fragility, harmony, and discord (Arnheim, 1974; Golomb, 1992).

Contradictions and Confusions

Many psychologists and art educators have written about children's drawings, but I have picked out these writers because their accounts exemplify the most important theories. Taken individually, each of these theories seems plausible, but they cannot all be true because apart from Freeman's distinction between competence and performance most of them contradict each other. Moreover, nearly all these theories contain internal contradictions, so that with many writers it can be difficult to say what opinions they actually hold.

Which theory, if any, are we to choose? Most early writers assumed that adults see the world in terms of the perspectival mental image corresponding to, or directly derived from, the light falling on the retina, and that pictures are produced by copying this image onto the picture surface. According to this account, pictures by children produced during the stage that Luquet (1927/2001) called visual realism are unproblematic, and most writers devoted little attention to them. The great difficulty has been to explain why young children draw "such curious outlines of things" (Bühler, 1949, p. 113). The answer, according to Bühler (1949) and a number of other writers, is that young children draw what they know, but different writers have given different reasons why this should be the case. At one extreme, Luquet believed that intellectual realism constituted a genuine alternative to visual realism: both ways of drawing are valid, but young children choose to draw differently from adults. At the other extreme writers such as Sully (1895) and Bühler believed that children have no choice: their vision was corrupted by knowledge, and their drawings are simply defective, judged from an adult standpoint.

[1]It cannot be said strongly enough, or often enough, that *image-making, artistic or otherwise, does not simply derive from the optical projection of the object represented, but is an equivalent, rendered with the properties of a particular medium, of what is observed in the object* (Arnheim, 1974, p. 98).

Moreover, the expression "what children know" can and has been interpreted in a number of ways. For Clark (1897), young children draw what they know in the same sense that a mechanic draws what he knows; that is, both base their drawings on their knowledge of the three-dimensional shapes of objects irrespective of any particular point of view. Luquet (1927/2001) seemed at one point to have believed something very similar in his account of intellectual realism as "a kind of flat sculpture." On the other hand, in his account of the internal model, he seemed to be saying that children draw what they know in the sense of knowing a repertoire of graphic images. This repertoire consists of a vocabulary of types built up by successive modifications to forms originally derived from scribbles that happen to resemble known objects.

Wilson and Wilson (1977) took a similar position: children draw what they know in the sense of knowing how to draw something, but for them children's graphic models or stereotypes are derived, not from their own drawings but from the drawings of other children or, in the case of older children, from the popular media.

Alternatively, some writers seemed to have believed that the explanation for children's drawings lies in the fact that children *see* things differently from adults. Bühler (1949) said so in so many words: "Why does the child draw such curious outlines of things? Surely it sees them differently, or, more correctly, its retinal images are quite different" (p. 113). On the next page, however, he claimed that the "root of the evil" lies in "our mastery of language" (p. 114), which suggests that he seems to have believed that our mastery of language could change the retinal image.

Piaget also seemed to have believed that children see things differently from adults, but his account of children's drawings is equally confused. According to Piaget and Inhelder (1956), the young child's conception of space is based first on topological geometry and then, with increasing age, on projective geometry (corresponding to perspective); affine geometry (corresponding to oblique projection); and finally, Euclidean geometry (corresponding to orthogonal projection). This developmental sequence does not correspond to that actually observed in children's drawings of rectangular objects, as the experiment described in chapter 1 demonstrates (Willats, 1977a, 1977b). However, this is only one of the problems with Piaget's account of drawing because at another point in *The Child's Conception of Space* he said that children's inability to draw in perspective is not due to their inability to *see* things in perspective but instead results from "the lack of any conscious awareness or mental discrimination between different viewpoints" (Piaget & Inhelder, 1956, p. 178; Willats, 1992a). To make this con-

fusion still worse, Piaget's various explanations for the child's inability to draw in perspective seems completely at odds with his best known contribution to developmental psychology: his account of the young child's egocentrism (Morss, 1987; Willats, 1992c). According to this account, which also appeared in *The Child's Conception of Space*, the young child "appears to be rooted in his own viewpoint in the narrowest and most restricted fashion so that he cannot imagine any perspective but his own" (Piaget & Inhelder, 1956, p. 242). If we are to take this at all seriously it suggests that young children, *of all people*, ought to be able to draw in perspective.

Arnheim's (1974) account of children's drawings avoided the difficulties inherent in distinguishing between what children know and what they see, and is based on a more sophisticated account of visual perception: Gestalt psychology. His account of both children's drawings and artists' pictures as embodying a visual language, based on equivalents rather than copying, was far in advance of his time.[2] Arnheim was a visionary, and much of what I have to say is very much in the spirit of his description of drawing as a visual language. The weakness of Arnheim's position was that Gestalt psychology was only a passing phase in the development of modern theories of visual perception. Although many of its insights still find a place in modern accounts of vision, Gestalt theory is neither able to give a credible account of visual perception nor furnish the laws that Arnheim needed to flesh out his account of pictures as providing graphic equivalents for real or imagined scenes.

Vision and Pictures

To give a credible account of children's drawings we need an adequate account of visual perception, and most modern theories of perception are derived from or related to the theory of visual perception developed by

[2]Arnheim's philosophy is perhaps best summed up by Golomb (1992):

> Drawing is a uniquely human activity whose complex syntactic and semantic development can be studied systematically. It represents one of the major achievements of the human mind. While all symbolic forms testify to a universal attribute of the human mind, drawing presents the investigator with a special challenge. Perhaps, more than other symbol systems, representational drawing is a truly creative activity of the child, who invents or reinvents in every generation, and across different cultures, a basic vocabulary of meaningful graphic shapes. It is a remarkable feat since there are no real "models" available to the young child that might lend themselves to imitation. Unlike the spoken language, which offers a ready-made model for the child who is learning to speak, neither the natural nor the man-made environment provide the child with a comparable model for drawing. (p. 2)

Marr (Palmer, 1999). Marr began his account of vision by asking: "What does it mean to see?" His answer was that "Vision is the *process* of discovering from images what is present in the world, and where it is" (Marr, 1982, p. 3).

This is not just true of human vision. In some animals the two functions of vision, discovering where things are and what they are, are served by separate visual systems.

Jumping spiders, for example, have four pairs of eyes. The function of two of these pairs is to discover where things are, that is, in what direction they lie relative to the spider. This is their only function, and a fly, another spider, or a passing car will all provoke the same reaction. The third pair of eyes is dedicated to deciding *what* things are—whether the object in view is something to be eaten, mated with, or ignored (Land, 1990). (The fourth pair is more or less vestigial.)

In humans these two functions are served by a single visual system, although in the later stages they are processed by different visual pathways. To discover *where* things are in relation to ourselves, we need what Marr (1982) called viewer-centered descriptions, that is, information about where things are and how they look from a particular point of view. But to know what things are, we also need information in the form of what Marr called object-centered descriptions.

For the most part we recognize objects on the basis of their shapes (although in some special cases other properties such texture and color may also be important), and information about the shapes of objects can only come to us through the continually changing sensations available at the retina. But Marr pointed out that it would be impractical to use these continually changing sensations directly as the basis for vision. He therefore proposed that the primary function of the human visual system is to take these ever-changing sensations and use them as the basis of more permanent three-dimensional, object-centered shape descriptions that are independent of any particular point of view.

Marr also pointed out that all shape descriptions (and this includes pictures as well as internal mental images or representations) must have at least two design features. The first is a way of defining spatial relations. Spatial relations can be defined relative to the viewer in the form of viewer-centered descriptions or can be located in the objects themselves in the form of object-centered descriptions. The second design feature lies in what he called the primitives of the system (the smallest units of meaning). In a photograph or a Pointillist painting the picture primitives take the form of zero-dimensional or point primitives: blobs of paint or dots of pigment. But in a line drawing

the primitives take the form of one-dimensional lines, and in silhouettes the primitives may take the form of two-dimensional areas or regions.

Internal representations or images are also built from different kinds of primitives. The point sensations available at the retina are, of course, built up of point primitives. But the internal representation of a table held in long-term memory might be built up of scene primitives in the form of edges, or surfaces, or even whole volumes. For example, an object-centered description of a table might describe it as a slab standing on four sticks, and Marr argued that at the most fundamental level an object-centered shape description of a person or a table stored in long-term memory might actually take this form. Marr called such descriptions the 3-D model.

Thus the primary function of the human visual system is to construct permanent, object-centered shape descriptions built up of three-dimensional volumetric primitives out of the ever-changing, viewer-centered images made of point primitives available at the retina. These object-centered descriptions (the 3-D models) are then stored in memory, given names, and used to recognize objects when we see them again from a different point of view or under new lighting conditions.

Various kinds of internal descriptions or representations are thus potentially available as a basis for pictures. Indeed, Marr's concept of the 3-D model is not unlike what Clark (1897) was struggling to define when he said that children draw what they know in the way that a mechanic would do, or Piaget's (Piaget & Inhelder, 1956) description of young children clinging to the object in itself. Marr's contribution, however, was to make the nature of the 3-D model explicit. Picture production, then, is the process of mapping these various kinds of internal descriptions of objects and scenes onto the picture surface. This involves two kinds of transformations, which I call the *drawing systems* and the *denotation systems*. The drawing systems map spatial relations in the scene into corresponding spatial relations on the picture surface, whereas the denotation systems map scene primitives into picture primitives.

I argue that as children grow older they use different drawing and denotation systems at different developmental stages and that this is why children's drawings look so different from those of adults. I describe these drawing and denotation systems, and the representational rules derived from them, in the following five chapters.

In the Beginning

It used to be believed that when very young children are babbling they are simply making random noises, but we now realize that they are rehearsing the sound patterns they will use in later speech and that even in the womb children can recognize differences between the speech patterns of different languages. Similarly, it used to be believed that children who were scribbling were just making random marks, or at best rehearsing the motor movements they would need later on to make representational drawings (Kellogg, 1969). As a result, the study of representation in children's drawings used to begin with the study of the tadpole figures, the first obviously representational drawings to appear.

No one has done more to change our ideas about the significance of children's early mark making than John Matthews (1984, 1992, 1999). As a result of close and carefully documented longitudinal studies of his own three children, together with the analysis of recordings of the drawing process in very young children in both Europe and the Far East, Matthews has shown that representational drawing begins at a much earlier stage than had previously been thought and may be present at the very beginning of mark making.

Matthews (1999) identified three stages, or generations, in the development of mark making. First-generation structures are of three kinds and are shown in Fig. 3.1. They consist of horizontal patches or lines resulting from side-to-side arm movements, dots resulting from the child jabbing the mark-making instrument vertically onto the paper surface, and vertical patches or lines resulting from push-pull arm movements.

Even these very simple first-generation structures can be used to produce representations. At the age of 2 years 2 months, Ben laid a horizontal patch across a vertical patch and said, "This is an aeroplane" (Fig. 3.2a). This is an

a b

FIG. 3.1. First-generation structures: (a) horizontal lines resulting from side-to-side arm movements and dots resulting from up-and-down arm movements, (b) vertical lines resulting from push-pull movements. Taken from Matthews (1999, p. 21, Figs. 2 and 3). Courtesy of J. Matthews.

a b

FIG. 3.2. Ben, 2 years 2 months: (a) a horizontal patch of lines crosses a vertical patch, resulting in a cruciform shape that Ben called "an aeroplane"; (b) a few days later he painted an elliptical circuit, and while he was painting said, "This is an aeroplane." Taken from Matthews (1999, p. 34, Figs. 10 and 11). Courtesy of J. Matthews.

example of what Luquet (1927/2001) called fortuitous realism. Probably Ben did not set out with the intention of drawing an aeroplane, but the combination of the two marks suggested a meaning for the drawing and he gave this meaning a name. How does this come about? Obviously because the two elongated patches crossing each other at right angles suggests the shapes and spatial relations of the wings and fuselage of an aircraft. One long patch in the picture represents the wings of the aircraft and the other long patch represents the fuselage. Moreover, the spatial relation between these two patches of scribble in the picture corresponds to the spatial relations between the wings and fuselage of a real aircraft.

FIG. 3.3. While hopping a marker around the page, a 1½-year-old said, "Rabbit goes hop, hop, hop" and made these marks. After Winner (1986, p. 26). Courtesy of D. Wolf.

In this very early drawing it is the shapes of the marks that suggest the shape of the aeroplane, but not all early drawings represent shape. Perhaps just as common are drawings that represent events rather than shapes, that is, structures in time rather than space. Dennie Wolf at Harvard University observed a child age 1 year 6 months who took a marker and hopped it around on the page (Fig. 3.3), leaving a mark at each hop and saying as she did so, "Rabbit goes hop, hop, hop" (Winner, 1986).

A few days after he had drawn the aeroplane shown in fig. 3.2a, Ben made an elliptical circuit with a brush heavily loaded with dark blue, viscous paint and said as he did so, "This is an aeroplane" (Fig. 3.2b). As Matthews (1999) said, "In this painting he represents, not the shape of the aeroplane, but its movement" (p. 34).

Circular drawings belong to what Matthews (1999) called second-generation structures. These include continuous rotation, demarcated line endings, traveling zig-zags, continuous lines, and seriated displacements in time and space. Figure 3.4a shows Hannah, age 2 years and 7 months, making a continuous rotation in spilled milk, and Fig. 3.4b shows examples of these different kinds of structures.

The third-generation structures identified by Matthews (1999) include closure, inside–outside relations, core and radial, parallelism, collinearity, angular attachments, right-angular structures, and U shapes on a baseline. All these can be seen in Figs. 3.5a and b. Figure 3.5a, drawn by Hannah at the age of 2 years 5 months, illustrates the use of closure and the inside–outside relation. In Fig. 3.5b, drawn by a 3-year-old child from Singapore, the roughly horizontal lines radiating from the closed form on the left illustrate core and radial relations together with parallelism and collinearity. The E-shaped form to the top right shows right-angular relations, the A-shaped form to the right of this illustrates angular relations, and on the extreme right are two U shapes on a baseline.

a b

FIG. 3.4. Second-generation structures: (a) Hannah, 2 years 7 months, consciously ex-
periments with different kinds of lines—she can draw straight lines, but in this photo-
graph, drawing in spilled milk on a polyvinyl table cover, she makes a continuous rota-
tion; (b) continuous rotation, demarcated line endings, traveling zig-zags, and seriated
displacements. Taken from Matthews (1999, p. 25, Figs. 4 and 5). Courtesy of J.
Matthews.

a b

FIG. 3.5. Third-generation structures: (a) inside–outside relations; (b) core and radial,
parallelism, collinearity, angular relations, right-angular relations, and U shapes on a
baseline. Taken from Matthews (1999, p. 28, Figs. 7 and 8). Courtesy of J. Matthews.

As with the much simpler first-generation structures, these second- and
third-generation structures can be used for representational purposes. Fig-
ure 3.6 shows a drawing by Ben, now age 2 years 2 months, that combines a
number of these structures and uses them to represent both shape and
movement. This is based on the game: "Round and round the garden, like a
teddy bear, one step, two steps, tickly under there!"[1]

[1]"In this game, the adult sings the slow, suspenseful incantation, 'round and round the gar-
den,' while tracing a continuous, unbroken rotational course on the child's arm. Then, syn-
chronized with the words 'one step, two steps,' the movement is broken up into discreetly
spaced intervals as the adult's fingertips are 'walked' up the child's arm until they reach under
the child's armpit, at which point the termination of this movement is demarcated with an ex-
plosive tickle" (Matthews, 1999, p. 35).

FIG. 3.6. Ben, 2 years 2 months, "Round and round the garden, like a teddy bear." To the left, the continuous circular movement of "round and round the garden," to the right, the individual steps up the arm of the teddy. The end of the journey takes the form of an action representation showing the explosive tickle under the armpits. The shape of the teddy bear is also shown within the garden. Taken from Matthews (1999, p. 36, Fig. 12). Courtesy of J. Matthews.

In his drawing of this game Ben first drew a continuous ellipse, repre-senting going round and round the garden. Fortuitously, this also suggests the shape of the garden, and Ben drew a tadpole figure representing the teddy bear inside it. Then he drew the broken, discontinuous vertical lines in the center of the drawing representing the "steps" of the adult's fingers up the arm. Again fortuitously, these suggest a baseline or a path, and Ben drew three more tadpole figures standing on them, or perhaps these are successive views of the same figure. Finally, a patch of scribble at the end of the lines is an action representation of the explosive tickle. Action representations thus suggest shape representations, and these in turn prompt further shape repre-sentations in the form of the tadpole figures. A patch of scribble is used to represent the explosion, in contrast to the quieter action of the lines repre-senting movement round the garden and up the arm.

First-, second-, and third-generation structures can be defined in terms of two components: the shapes of the marks and the spatial relations be-tween them. There are, however, two different kinds of marks in these drawings: patches of scribble and distinct lines. At the most basic level the patches of scribble can be divided into *long patches* such as the long patches shown in Fig. 3.2a and the middle of Fig. 3.4b, and *round patches* such as the round patches shown in Figs. 3.2b and 3.4a. Similarly, the marks made by lines can be divided into *long lines* such as the lines radiating from the cores in Fig. 3.5a and *round areas* defined by a single, closed outline such as the cores themselves. In addition there are *dots* such as the dots in Fig. 3.1a. Alto-

gether, then, we can define five kinds of basic marks: long patches, long lines, round patches, round areas, and dots. Developmentally, patches precede lines and areas.

All these kinds of marks can be used for representational purposes. The very youngest children tend to use amorphous patches of scribble whose function is merely to mean "something there." In the dictated drawing shown in Fig. 3.7, for example, it is doubtful if the shapes of the scribbles standing for the eyes, hands, and shoes have any particular significance: these marks simply act as placeholders, saying, "Something there, but I don't know how to draw it." Even here, however, it could be argued that the more or less round patches used to represent the hands distinguish them from the long lines used to represent the legs.

In the drawing of a man by Megan, age 2 years 6 months, shown in Fig. 3.8, the significance of the shapes of the patches of scribble is much more apparent. A long patch is used to stand for the hair, and round patches stand for the eyes, nose, tummy, tongue, and feet. In addition, zig-zag lines are used to stand for the trousers, but apart from these zig-zag lines, all the other marks are scribbles.

FIG. 3.7. A dictated drawing of a man and a house, by a 2-year-old. "When someone dictates a list of body parts, even 2-year-olds can show them in their correct positions" (Winner, 1986, p. 26). The spatial order of the parts of the man are roughly correct, but the parts are not connected. The legs are represented by long lines, but most of the marks are place holders. After Winner (1986, p. 26). Courtesy of D. Wolf.

FIG. 3.8. Megan Erridge, 2 years 6 months, a drawing of a man. The spatial order of the parts is roughly correct, but the parts are not connected. The hair is represented by a long patch of scribble, and the eyes, nose, tummy, tongue, and feet are represented by round patches. The trousers are represented by zig-zag lines. Collection of the author.

In another drawing produced by Megan at the same age (Fig. 3.9) the marks are more varied and the representational system is more complex. These marks consist of a long line for the roof of the house, a round area enclosed by a line for the chimney, round marks intermediate between round areas and round patches for the windows and door, and a round patch of scribble for the door handle.

In another drawing done at the same time (Fig. 3.10), round areas enclosed by (more or less) single lines are used to represent the eyes and tongue, long lines represent the tabletop and the legs of the man, and within one eye is a patch of scribble, perhaps representing the pupil and iris. A zig-zag line is used to represent the teeth. The use of a long line to represent the tabletop is particularly interesting because tabletops are flat; that is, they can be thought of as either long or round. Perhaps, for a 2-year-old, a tabletop is more commonly seen edge on, or perhaps Megan wanted to use a different kind of mark to distinguish the tabletop from the eyes and the tongue.

However, it is not just the kinds of marks used in a picture that carry meaning but the spatial relations between them. In the dictated drawing shown in Fig. 3.7, the marks by themselves have very little meaning, but put

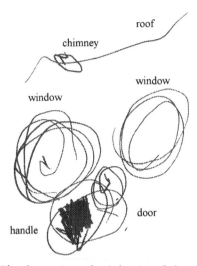

FIG. 3.9. Megan Erridge, 2 years 6 months. A drawing of a house. The spatial order of the marks is roughly correct, the chimney is joined to the roof, and the handle is enclosed by the door. The roof is represented by a long line, and the chimney, windows, and the door are represented by round regions. The handle is represented by a patch of scribble. Collection of the author.

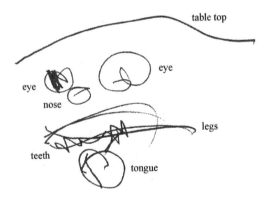

FIG. 3.10. Megan Erridge, 2 years 6 months. A drawing of a man and a table. The tabletop, a flat volume, is represented by a long line. The legs, as long volumes, are also represented by long lines, and the eyes, nose, and tongue are represented by long areas. The teeth are represented by a zig-zag line. Collection of the author.

together they suggest the figure of a man. Moreover, they do this because the *spatial order* of the marks in the drawing corresponds closely to the spatial order that the corresponding features would have in a standing man. The same is true (more or less) of Megan's drawing of a man shown in Fig. 3.8: at least the hair is at the top of the drawing and the feet are at the bottom.

The representation of spatial order seems to be the first spatial property to emerge. Perhaps surprising, the representation of relative *size* in these early drawings does not seem to be very important.

The next spatial relations to emerge are probably enclosure or inside–outside relations, and the join relation. The *enclosure* of one mark by another is shown in Fig. 3.5a, and this relation is put to use in Megan's drawing of a house (Fig. 3.9): here, the door handle, represented by a patch of scribble, is shown within the circular area representing the door. Ben's drawing (Fig. 3.6) shows a clearer example: the teddy bear is shown within the garden.

At about the same time the *join* relation begins to appear. In Fig. 3.5b the radial lines are joined to the cores, and Ben's teddy bear drawing shows this relation put to use: the legs are joined to the head/body and the figures are represented as standing on the path. In addition, this drawing includes an example of the representation of *spatial directions* in the scene. The garden and the path are, in effect, shown in plan, but because scenes are three-dimensional and pictures are two-dimensional this leaves children with the problem of representing the third dimension in the picture. In this case the figures standing on the path occupy the third, vertical dimension in the scene, intersecting the path at right angles, and Ben has chosen to show this by representing his figures as standing at right angles to the path. This means that side to side in this picture represents both side to side and up and down in the real scene.

In Megan's drawing of a horse and a tree, shown in Fig. 3.11, the connections between the parts of the horse are shown using the join relation. In addition, relatively smooth parts of the body such as the head and legs are represented by lines and an area enclosed by an outline, whereas more textured features, including the "fluffy bits" on the end of the tail and the hooves, eyes, nose, and teeth, are represented by patches of scribble. "Lots of leaves" on the tree are represented by a zig-zag line, and the vertical line in the center of the drawing shows the direction or action of the falling leaves.

Finally, in the tadpole drawing shown in Fig. 3.12 all these components are put together in an elegant and economical way and used to form a coherent representation: it is no longer necessary for the drawing to be annotated for us to recognize what it represents. The marks used are: long lines, the round area enclosed by a line, the round patches of scribble, and dots. The spatial relations represented are: spatial order, enclosure, the join relation, and spatial direction. Moreover, the marks and the spatial relations between them both reflect corresponding shape features in the scene. The long lines stand for long volumes in the scene: the legs and the nose. The round area

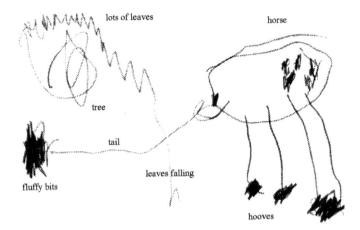

FIG. 3.11. Megan Erridge, 3 years 3 months. A drawing of a horse and a tree. Relatively smooth parts of the body are represented by lines and an area enclosed by an outline, and more textured parts such as the fluffy bits at the end of the tail and the hooves, nose, and teeth are represented by patches of scribble. Collection of the author.

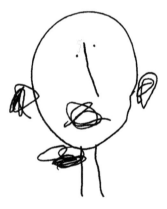

FIG. 3.12. *Drawing of a Man* by a boy age 5 years. The head or head/body is represented by a round region, the legs and the nose are represented by long lines, the eyes are represented by dots, and the ears and mouth are represented by patches of scribble. Collection of the author.

denotes the head or head/body as a round volume (or perhaps a view of a round volume; as we see in the next chapter these interpretations are controversial). The dots denote the eyes as small round features in the scene, and the round patches of scribble represent round features such as the ears and mouth that have a complex and irregular internal structure.

The shapes of the marks in the picture reflect the shapes of corresponding features in the figure of a man, but in addition spatial relations in this picture reflect corresponding spatial relations among these features. In terms of spatial order, the eyes are shown on either side of the nose and the ears on either side of the head or head/body. (Compare this with the dictated drawing shown in Fig. 3.7, in which the eyes are shown one above the other.) The eyes, nose, and mouth are all enclosed within the area of the head. The legs are joined to this area, a correct relationship if the area represents the head/body but only correct by default if the body is missing. (Perhaps the patch of scribble below this area represents the body, although this would be unusual.) Finally, in contrast to Ben's teddy bear drawing, side-to-side directions in the picture represent side-to-side directions in the scene, and vertical directions in the picture represent vertical directions in the scene. Front-to-back directions in the scene are not represented.

Thus, even in these early drawings the representational systems employed turn out to be complex. Even in these early pictures the drawing systems employed may vary from one picture to another. In Ben's teddy bear drawing (Fig. 3.6), for example, vertical directions in the scene are mapped into side-to-side directions in the picture, whereas in the tadpole drawing by a 5-year-old shown in Fig. 3.11, vertical directions in the scene are mapped into vertical directions in the picture. Some aspects of the early drawing systems are best described in topological geometry as Piaget and Inhelder (1956) suggested: the join, enclosure, and spatial order relations, for example. However, topological geometry cannot be used to describe either direction or relative size.

As with the drawing systems, the denotation systems employed by different children may differ and may also differ from one picture to another. Ben used a round patch of scribble to stand for the explosive tickle; a 5-year-old boy used a similar patch of scribble to stand for the mouth and teeth in his drawing of a man (Fig. 3.12); and a 6-year-old girl, whose drawing is shown in the next chapter (Fig. 4.1a), used lines to stand for both the mouth and the outlines of the teeth.

Even in these very early stages children are trying to discover the drawing and denotations systems they need to convey the ideas they want to express. The two systems are complementary. Random collections of marks cannot convey meaning effectively, even though each mark in isolation may have a meaning for the child. Equally, the drawing systems cannot exist in isolation. It is tempting, and perhaps not wholly misleading, to compare the mu-

tual relations between the drawing and denotation systems in pictures with the relations between syntax and vocabulary in language: the marks correspond to individual words or sounds, and the spatial systems correspond to the way these marks and sounds are put together.

As these drawings demonstrate, the nature of the representational systems used by young children are not always immediately obvious. In the following chapters I describe the systems children use as they get older, leaving the question of how and why these systems develop until part 2.

The Early Years

Her taste for drawing was not superior; though whenever she could obtain the out-
side of a letter from her mother, or seize upon any other odd piece of paper, she did
what she could in that way, by drawing houses and trees, hens and chickens, all
very much like one another.

—Jane Austen, *Northanger Abbey*

Perhaps children have become more skillful, or perhaps Catherine More-
land really was exceptionally poor at drawing, because Jane Austen's de-
scription of this 8-year-old's drawings would be more appropriate nowadays
for those of a 5-year-old. However, it is certainly true that young children's
drawings do tend to look very much alike. Once children get beyond the
scribbling stage their drawings typically consist of combinations of dots,
round areas enclosed by curved outlines, and more or less straight lines.
Even drawings of rectangular objects such as houses or cubes are often
drawn using a curved outline enclosing a round area.

Far and away the most common of these drawings are the so-called tad-
pole figures representing people. These figures typically consist of a line
surrounding a round area, often containing facial features, and straight lines
attached to the bottom of this round area representing either the arms and
legs, or both, as shown in Fig. 4.1. The defining feature of these tadpole fig-
ures is the apparent absence of any body or trunk, and in German these fig-
ures are known as *Kopffüssler*, or head-feet persons (Cox, 1992).

The apparent absence of a body in these tadpole figures has attracted a
good deal of research attention, and three main theories have been suggested
to explain it. The first is that these figures accurately represent the child's
knowledge or internal representation of the human figure, but that this

a b

FIG. 4.1. (a) *Drawing of a Man* by a girl, 6 years 6 months. The head, ears, and feet are represented by round regions; the arms, legs, teeth, and mouth by long lines; and the eyes by dots. Taken from Harris (1963, Fig. 59). (b) Adele Palmer, 3 years 6 months, *A Little Girl in a Hat.* The round regions intersecting the lines coming from the top of the head represent bunches of hair and two regions, one round and one elongated, represent the hat. Collection of the author.

knowledge is incomplete and immature either because the mental image, in the form of a view, is blurred (Eng, 1931) or because the child in some sense does not know that he or she has a body.

This explanation is fairly easy to test and has been shown to be wrong. Golomb (1992) tested children who normally drew tadpole figures in a number of ways, including asking them to tell her all the parts she would need to draw a person and asking them to construct a "puzzle-man" out of a number of flat wooden forms, to model a person out of Playdough, and to draw a person as she dictated the parts to them. The results were straightforward. Most of the children included a trunk in their list of parts, included a trunk in their models and constructions, and included a trunk in their figure drawings when the parts were dictated. On the basis of these studies, Golomb concluded: "The hypothesis of the print-out process and of the simple correspondence between an immature concept and a graphically simple drawing is no longer tenable. The old dictum that 'the child draws what he knows' has not been supported" (p. 40).

Cox (1992) and her coworkers carried out similar studies and came to similar conclusions. She found that children know about bodies and can locate them correctly on both real people and conventional drawings of the human figure. She also asked tadpole drawers to add the facial features, the

tummy, and the arms to their drawings if any of these parts had been left out. Two distinct types of figures were identified. In one, the head was drawn larger than the legs and in this case the tummy was located within the circular area and the arms were attached to this area (Fig. 4.2a). In the second transitional type of figure, the legs were drawn longer than the head and in these cases the tummy was placed between the legs, and the arms tended to be attached to the legs (Fig. 4.2b).

Thus, this first explanation for the apparent lack of a body in these tadpole figures seems to be wrong. The second theory that has been suggested is different in kind, and in developmental studies of language would be called a performance theory rather than a competence theory. This explanation is that the trunk and other features such as the arms are not missing as a result of lack of internal knowledge but are left out as a result of performance problems arising from difficulties in drawing or remembering these features during the drawing process.

As we have seen, this explanation was first suggested by Luquet (1927/ 2001): Children think of the details of an object in a certain order according to the importance they attach to them and will continue to add them to their drawings so long as their attention moves from one detail to another. But their attention can easily wander because of the difficulty of the task: they have to think about the object to be represented and at the same time monitor the graphic movements necessary to make the drawing. As a result, some details get left out.

Freeman (1975) attempted to test this suggestion, contrasting it with two competence theories. The first, described previously, is that these figures lack a body. The second, attributable to Arnheim (1974), is that the head and body are amalgamated so that the single closed, curved form in these tadpole

FIG. 4.2. "The 'head' contour of the tadpole figure may also stand for the body (a). Later, the body and arms are shifted to a lower part of the transitional figure (b)." Taken from Cox (1992, p. 34, Fig. 3.2). Courtesy of M. Cox.

drawings represents a global head/body shape. I have already described Free-man's experiment in chapter 2, but I will summarize it again here. In this ex-periment children between ages 2 and 4 years were first asked to draw a man. They were then asked to add arms to one or other of two series of in-complete figure drawings shown again here as Fig. 4.3. Freeman found that the children who drew tadpole figures added arms to whichever circle was the larger, regardless of whether this represented the head or the body.

Freeman (1975) suggested that these results could best be explained in terms of production errors. He observed that both children and adults nor-mally draw a man in a fixed sequence: head, trunk, arms, legs. In this experi-ment, however, most of the tadpole drawers drew the legs before the arms, and he concluded that for these children the production sequence would normally be head–trunk and then legs–arms. He then proposed that errors are prone to occur in the second element in each pair, so that tadpole draw-ers first draw the head but forget to draw the trunk, and then draw the legs but forget to draw the arms. This is often referred to as the serial order hy-pothesis.

Freeman's (1975) conclusions have been challenged by Golomb (1992), who found that although most children initially drew the human figure fol-

FIG. 4.3. Incomplete drawings presented for completion. In series (a) the overall size was kept constant, whereas in (b) one component was kept constant. Taken from Free-man (1975, p. 417, Fig. 2).

lowing a top-to-bottom sequence this did not necessarily end with drawing the legs; instead, children frequently backtracked to draw additional details such as facial features, arms and hair that had initially been left out. She also found that when children were asked to adopt a different drawing sequence, for example, by drawing the legs, the arms, or the tummy first, they had no difficulty in doing so and that "this deviation from a preferred sequence is not detrimental to their retrieval of parts from memory, nor need it impede their drawing performance" (Golomb, 1992, p. 45). Golomb also tested the body-proportion effect but without including the facial features in the incomplete drawings. She found, as Freeman had, that the children tended to add the arms to the larger circle, but she also found that some of the children added facial features to the larger circle, transforming it to a global head/body configuration (Fig. 4.4a), whereas others inverted the whole page, so that the smaller circle was at the top, and then added facial features to the smaller circle and arms to the larger circle (Fig. 4.4b). As Cox (1992) put it, the researcher may define the circle at the top as a head, but the child may not necessarily agree.

Thus, the apparent lack of a body in these tadpole figures cannot be explained in terms of lack of knowledge, nor can it be explained in terms of performance problems alone, although it is important to remember that performance factors must always play a part in any complete account of children's drawings. This leaves Arnheim's (1974) suggestion that the single circle stands for a simplified head/body combination as perhaps the most probable answer, although as we shall see there are problems with this explanation too.

a b

FIG. 4.4. What to do about disproportionate figures presented for completion. (a) This child added a head to normalize the figure. (b) This child inverted the figure and then added arms to the tummy. Taken from Golomb (1992, Fig. 30). Courtesy of C. Golomb.

The many attempts that have been made to explain the apparent lack of a body in the tadpole figures have diverted attention from what is really a much more fundamental question that applies not just to the tadpole figures but to all children's early drawings: the question of what the lines in these drawings stand for. As adults, we naturally assume that the outlines of the areas representing the head or head/body in these drawings stand for contours and that the single lines represent the arms and legs as thin, wire-like forms as they might do in adult drawings. However, this assumption is not necessarily justified, at least in terms of picture production. But if the lines in these drawings do not stand for contours, what do they stand for? An anecdote, for which I am indebted to Dennie Wolf of Project Zero, suggests that rather than standing for contours as they do in adult drawings, the lines in children's early drawings may define the boundaries of *regions* standing for whole *volumes*.

A young girl was asked to draw a ball, and she responded by producing a drawing in the form of a circle, similar to the drawing shown in Fig. 4.5a. This is, in fact, just what an adult would do, and without further evidence it would be natural to assume that the drawing represents a *view* of a ball and that the outline of the circle stands for what is called the *contour*: those points on the object where the line of sight just grazes the object's surface. However, this girl wanted to include the mold mark (the thin web of rubber left on the surface of the ball when the ball was made) in her drawing. Most adults would draw a curved line across the ball as shown in Fig. 4.5b, representing a view of this mold mark. Instead, this girl first drew a line outside the circle, saying as she did so, "I can't draw it here because it's not outside the ball" (Fig. 4.5c). Then (Fig. 4.5d) she began to draw a line inside the circle, but said, "I can't draw it here because it's not inside the ball." Finally

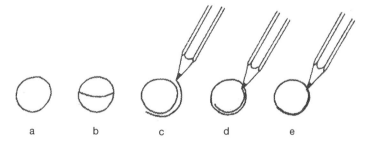

a b c d e

FIG. 4.5. A child's attempts to draw the mold mark on a ball: (a) the child's drawing of the ball, (b) the ball with a mold mark as an adult would draw it, (c) "I can't draw it here because it's not outside the ball," (d) "I can't draw it here because it's not inside the ball," (e) "And I can't draw it here because it won't show up. So I can't do it." From Willats (1985, Fig. 4.3). Courtesy of Cambridge University Press.

(Fig. 4.5e) she started to draw a line on top of the circle, but said, "And I can't draw it here because it won't show up. So I can't do it."

It is hard to avoid the conclusion that for this girl the circle stood for the volume of the ball as a whole, rather than a view of a ball. If this is the case, the line forming the circle must stand for the surface of the ball, dividing the inside of the ball from the outside, rather than representing its contour. And if this interpretation is correct, it makes sense to draw the mold mark where it belongs, on the surface of the ball, except that a line drawn here "won't show up." However, this sequence of drawings highlights two further questions that apply not just to the tadpole figures but to all children's early drawings. The first is: Why use a circular *line* to define an area that stands for a ball or the head of a figure rather than filling in the area with paint or pigment to make a silhouette? The second is: Why use a *circular* line to stand for a ball or the head in a tadpole figure? The answer to this second question might seem obvious, except that children also use circular lines to stand for rectangular objects such as cubes and houses.

Marks and Picture Primitives

"But I want to write a newthpaper, too," pleaded Violet Elizabeth.

William scowled so fiercely that his moustache fell off. He picked it up and carefully adjusted it again.

"Well, you're not *going* to," he said, with an air of finality.

Violet Elizabeth's blue eyes filled with tears. That was her first weapon. William, though he had no hopes of final victory, did not mean to be worsted by her first weapon.

"I c'write, too, I can," said Violet Elizabeth plaintively. "I c'write newthpaperth, too, I can. I'm a *good* writer, I am. I can thpell, too, I can."

"Well, you're not going to *thpell* here," mimicked William heartlessly.

　　　　　　　　　　—Richmal Crompton, *William in Trouble*

One of the major themes in the study of natural language is the distinction between the actual physical sounds of speech and the fundamental units, or primitives, out of which a language is built. Linguists use a special notation system to represent the sounds of language, and innumerable writers from Chaucer to Margaret Mitchell have tried to mark this distinction by using phonetic rather than conventional spelling. But unless (like William) we have some special reason for doing so we do not usually pay attention to the

actual sounds of speech: we only listen for the meaning. *Thpell* and *spell* sound very different, but they both mean the same word.

In the same way the actual physical marks of which a picture is composed do not necessarily correspond directly to the underlying units that carry the meaning. These units, or *picture primitives* as they are called, may be zero-, one- or two-dimensional. Examples of pictures based on zero-dimensional, or *point*, primitives are TV pictures, photographs, and Pointillist paintings, and here the primitives denote the intercepts of small bundles of light rays as they reach the eye or the camera from the scene. In line drawings the primitives are one-dimensional *lines*, and as Kennedy (1974, 1983) has pointed out, the lines in adult drawings can stand for a variety of scene primitives including edges; occluding contours; and thin wire-like forms such as hair, cracks, creases, and the boundaries between areas that differ in local tone or color. Finally, pictures can be based on two-dimensional primitives or *regions*. Examples of adult pictures based on regions as scene primitives include early rock drawings, Greek vase paintings of the geometric period, and Matisse's cut-paper silhouettes (Willats, 1997).

The marks in children's drawings are almost always lines, but this does not necessarily mean that the lines are the smallest units of meaning. For example, the convexities and concavities of the lines representing the outlines of the heads in the two tadpole figures shown in Fig. 4.1 do not necessarily reflect corresponding shapes in the heads themselves. The only thing that these lines are saying is that the shape of the head as a whole is round: that is, about equally extended in all three directions in space. It is therefore crucial to make a distinction between the marks in children's drawings and the picture primitives they represent. I argue that in children's early drawings the picture primitives are regions rather than lines, even though the physical marks that children use to define these regions are almost always lines.

If this is so, why do children use a circular line to define the outline of an area representing a region rather than filling in the whole area? In most adult pictures based on regions as picture primitives the regions take the form of silhouettes, in which the whole area representing the region is filled in with paint or pigment. Part of the reason might be that children are given pens or pencils to draw with, and pens and pencils make lines, but now that children use felt markers this argument loses some of its force. Another reason that might be given is that children are used to seeing adult pictures in the form of line drawings, but they probably see just as many pictures in which the areas are filled in, such as photographs or TV pictures. Moreover, children draw areas rather than lines in their early scribbles, so why do they change?

One reason is that children discover that using patches of scribble prevents them from showing details within the boundaries of regions: details such as the eyes, nose, and mouth in a figure drawing, or the windows and doors in a house drawing. In patches of scribble these details "won't show up." Figure 4.6 shows a drawing of Daddy by a 3-year-old girl. The eyes and the smiling mouth show up well against the blank area defined by a line that represents the head, but the small circular area in the center of the figure, intended to represent the tummy, can hardly be distinguished against the areas of scribble representing the pants, top, and trousers. As this drawing shows, there is a real advantage in using blank areas rather than patches of scribble if internal details are to be shown within regions.

A second reason for changing from a mark system based on patches of scribble to one in which the marks are blank areas enclosed by lines lies in the difference between picture production and picture perception. I have argued that the picture primitives in these early outline drawings are regions, but this is only true in terms of picture production. In terms of picture perception we interpret outlines in pictures as representations of the contours of smooth objects. The reasons for this are complex, but they seem to lie in the design features of the human visual system. In the early days of artificial intelligence attempts were made to extract line drawings from full gray-scale images by scanning photographs automatically, picking out abrupt changes in tone (so-called luminance steps) and then using lines to represent the

FIG. 4.6. Megan Erridge, 3 years 3 months. Most of the body parts are represented by patches of scribble, and as a result the small circular area representing the tummy "won't show up." The head, however, is represented by a blank area enclosed by an outline, and the eyes show up effectively against the blank background. Collection of the author.

points where these changes occurred. These early attempts were relatively unsuccessful (e.g., Marr, 1982, p. 61, Fig. 2.15) and resulted in line drawings that provided only poor representations. This seemed to bear out Gibson's (1971) contention that "there is *no* point-to-point correspondence of brightness or color between the optic array from a line drawing and the optic array from the object represented. There is some sort of correspondence, but it must be very different from the one defined" (p. 28). However, in 1990, Pearson, Hanna, and Martinez showed that it was possible to extract very successful line drawings from photographs using what they called a "cartoon operator" consisting of a feature detector picking out *luminance valleys*. These luminance valleys consist of bands of dark tone against a background of a lighter tone, and Pearson et al. showed that they correspond to changes in the optic array coming from contours.

In the light of these results Pearson et al. (1990) proposed that the early stages of the human visual system contain a feature detector, similar to their cartoon operator, that responds to luminance valleys and interprets these as the contours of objects. If this were the case, it would explain why outline drawings are so effective as representations. Line drawings in the form of dark lines on a white ground provide luminance valleys that closely resemble the luminance valleys resulting from contours, even though the array of light coming from these drawings is, overall, so different from that coming from a real scene. Thus, in terms of picture perception we naturally interpret lines in line drawings as representations of the contours of objects because the structure of the optic array coming from lines in pictures and contours in scenes is the same in each case. In silhouettes, however, the changes in tone at the boundaries take the form of luminance steps rather than luminance valleys, and this may be one reason silhouettes tend to be less effective as representations than line drawings. Moreover, there is every reason to suppose that the feature detector in the human visual system for detecting luminance valleys is hardwired, so that adults and children both interpret lines as representations of contours.

There are two further reasons children might change from using a mark system in which regions are represented by patches of scribble to a system in which the regions are represented by blank areas enclosed by lines. The first is that the outlines of patches of scribble tend to be very irregular, so that we do not readily interpret them as the contours of smooth forms. The patches of scribble representing hooves in Megan's drawing of a horse (Fig. 3.11), for example, are less effective as representations of round forms than are the areas enclosed by outlines representing feet in the drawing of a man shown in Fig. 4.1a. The second reason is that when they begin to draw, children use

pencils or felt-tipped pens to produce patches of scribble, and the marks in these patches of scribble may be more or less closely spaced. Where the marks are densely spaced these patches approximate to silhouettes, and here it is the irregularity of the outlines that prevent them from being effective as representations of smooth forms. In other cases the individual lines of pencils or markers are easily distinguishable, and in these cases the visual system tends to interpret the lines as representing surface contours, or textured areas such as patches of hair. Again, this may be inappropriate for the representation or more or less smooth body parts.

For all these reasons, mark systems based on patches of scribble are less effective in providing representations of smooth forms such as the heads, arms, legs, and trunks of figures. The truth of this can be seen by comparing the tadpole figures in Fig. 4.1 with the drawing of a man in Fig. 4.6. Only the head in Fig. 4.6, which consists of a blank area enclosed by a line, allows us to recognize this as a drawing of a man, whereas the tadpole figures shown in Fig. 4.1 are immediately recognizable as figure drawings, even though they contain fewer features. Thus, there are good reasons why children should change the mark system they use in these early drawings: areas defined by outlines are much more effective as representations of smooth forms than are areas filled in with scribble, and features such as the eyes, nose, and mouth show up much more clearly in outline drawings. Moreover, this change has an additional advantage. Because patches of scribble in a drawing tend to look like textured areas in the scene, using outline draw-

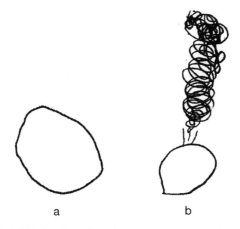

a b

FIG. 4.7. (a) A child's drawing of a cube, mean age 4 years 6 months. Taken from Willats (1981, Fig. 1.3). (b) Ben Matthews, 3 years 3 months, *A Drawing of a House* (detail of *Father Christmas on His Sleigh With Reindeer*). Taken from Matthews (2003, Fig. 53). Courtesy of J. Matthews.

ings to represent the contours of smooth forms has the advantage of freeing up areas of scribble to stand for areas of texture, as in the drawing of the smoke coming out of the chimney in Fig 4.7b.

Thus, one of the most profound changes that takes place in the early years of drawing development is the change from using patches of scribble as marks to using lines to define the outlines of regions. However, the fundamental units of meaning in these early drawings—picture primitives in the form of regions—are essentially the same in each case.

Extendedness

The second question raised by the previously described anecdote is: Why use a circle to stand for a ball rather than some other shape? The answer seems obvious: Because circles and balls are both round. But this does not explain why children also use circles to stand for rectangular objects (Fig. 4.7). Is it because children of this age are capable only of drawing circles rather than squares (perhaps as the result of performance problems), or is there some other reason?

As we have seen, tadpole figures are typically composed of a round region representing the head or head/body and either lines or long regions representing the arms and legs. Stern (1930) called these *natural symbols*.[1] Why? Presumably because the roundness of a circle or small round region reflects the roundness of shapes such as an eye or a head, and the longness of a line or a long region reflects the longness of shapes such as arms and legs. I refer to properties such as roundness, longness, and flatness as *extendedness*. Extendedness is the most basic of all shape properties and the first shape property children represent in their drawings, but not just in their drawings: extendedness also plays an important part in children's early speech in the form of what are called *noun classifiers*.[2]

[1]"We call these symbols 'natural' because their meaning does not first require to be learnt (as in the case of letters or mathematical signs) but directly occur to the child, and are used by him as a matter of course. Thus a long stroke is a natural symbol for an arm or a leg, a small circle for an eye or head" (Stern, 1930, pp. 369–370).

[2]As children begin to acquire language they are faced with the problem of mapping their knowledge of things into words, and they often do this very differently from adults. For example, most children learn the word *doggie* early on, but they apply this word, not just to dogs but to all sorts of other animals such as horses, cows, and sheep. This feature of children's early speech is known as overextension. The property most commonly used as the basis for these overextensions is shape, and the most common shape property picked out is what I have called extendedness, that is, saliency of extension in one, two, or three dimensions. Clark (1976)

The evidence from children's early speech and adult languages suggests that extendedness is what Rosch (1973) called a *real category*. Real categories are composed of a core meaning consisting of the clearest cases, surrounded by other cases decreasing in similarity. The example Rosch gave is that of color: pure blue shades off into green on one side and purple on the other. Rosch argued that the core meaning of such categories "is not arbitrary but is 'given' by the human perceptual system; thus, the basic content as well as structure of such categories is universal across languages" (p. 112). The same is true, I argue, of the representation of extendedness in children's early drawings. To begin with, children simply classify shapes as round or long, and their tadpole figures provide good examples of this. Later, children recognize finer distinctions—that the body of a horse is relatively elongated compared with the head but less elongated compared with the legs—and use intermediate shapes in their drawings as a way of representing these finer distinctions. To begin with, however, they only seem to recognize, and represent, the core cases of round and long.

Using words such as *round* and *circle* to describe the shapes of picture primitives can, however, be misleading. It is important to realize that the representation of the extendedness of an object has very little to do with the

gave various examples: *baw* [ball] was used by one child to stand for anything round, including apples, grapes, eggs, squash, and a bell-clapper. Another child used *tee* [stick] to stand for anything long, including a cane, an umbrella, a ruler, and old-fashioned razor, and a board of wood. *Mooi* [moon] was used to stand for all flat objects including cakes, round marks on windows, writing on windows and in books, round shapes in books, tooling on leather book covers, round postmarks, and the letter *O*. Another child referred to a roll of sellotape as *wheel*. Similar examples can be found in most other languages.

Although shape appears to be the most common basis for children's overextensions, Clark (1976) also gave instances of other properties that children pick out, of which the most important are size, texture, and movement: just those properties of objects that children pick out in their early drawings. Moreover, it is significant that "one notable absentee from the kinds of over-extension found in children's speech is color" (pp. 456–457), and as Luquet (1927/2001) pointed out, the representation of color plays a relatively minor role in children's drawings.

Extendedness also plays an important part in adult languages in the form of what are called *noun classifiers*. European languages are relatively impoverished in this respect, although words such as *lump* and *stick* in the expressions "a lump of wax" or "a stick of wax" act like shape classifiers. Most other languages, however, have much richer systems for describing shape. Both Clark (1976) and Denny (1978) cited a study of 37 Asian languages made by Adams and Conklin (1973) in which they speak of round, flat, and long as being basic semantic primes. Denny described the extendedness variable in relation to Tarascan, Algonquian languages, Athapaskan languages, Eskimo, Toba, Bantu languages, Ponapean, Tzeltal, Trukese, Malay, Iban, Burmese and Gilbertese, and concluded that "it seems reasonable to say that extendedness is a widespread and perhaps universal principle of noun classification" (Denny, 1978, p. 101).

shape of its surface or with the shapes of its edges or corners.[3] Thus, when, as is common, a young child represents an object such as a house or a cube using a closed circular form, this is not because the child does not realize that houses have flat walls any more than children cannot tell the difference between dogs and cows when they refer to cows as "doggies." What Ben was representing in the drawing of a house shown in Fig. 4.7b was its most fundamental volumetric shape property: its extendedness. What this drawing is saying is that a house is a lump. Only later will secondary shape properties, such as having flat faces, be represented.

Regions and Volumes

I have argued that in these early drawings, such as the tadpole figures and Ben's drawing of a house, children use round or long regions to represent the volumes of objects rather than views of objects. But what evidence is there for this? I have suggested that when children produce drawings of rectangular objects such as cubes or houses in the form of more or less round regions they are representing these objects as round volumes or lumps. That is, these children are representing the extendedness of the volumes of these objects, irrespective of the shapes of their edges and surfaces. But it might equally well be argued, on the basis of these drawings alone, that these children are representing the extendedness of their projections in the frontal plane or visual field. A view of a cube, for example, can take the form of a square if the cube is seen directly from the front, or an irregular polygon if it is seen at an oblique angle. Thus, from whatever direction a cube is viewed, its shape, in the form of its projection in the frontal plane, can be described as round if we neglect the shapes of its edges. In the drawings shown in Fig. 4.7 children are representing the most basic shape properties of these rectangular objects—their extendedness—and in both cases these shapes are round rather than long, but without further evidence there is no way of telling whether these drawings are derived from volumes or views.

In chapter 2, I describe two experiments in which children were asked to draw rectangular shapes in form of cubes. In the first (Moore, 1986) chil-

[3]This is also true in language. A regular, smooth, round object such as a ball can be classified as a lump but so can cubic objects such as houses or irregular objects such as potatoes. Denny (1979a) gave an example from Japanese, which has a particularly rich system of shape classifiers: "For example, *ko* (3D) cannot mean 'round' since it is used for square-cornered objects such as a child's block and an empty box, as well as rounded objects. Also *mai* (2D) would be the correct classifier for clothing whether it is flat or wrinkled" (p. 321).

dren ages 7 and 9 years were asked to draw from a model cube that had a different color on each face and then color in their drawings. In the second experiment children ages 6 to 12 years were asked to draw from a model die. In the first experiment many of the children produced drawings in the form of a square, but whereas the 9-year-olds used only one color to fill in the square, all the 7-year-olds filled in their squares with six colors, using either horizontal or vertical stripes. A typical example of one of these drawings is shown in Fig. 4.8a. In the second experiment the older children who produced drawings of a die in the form of a square drew the square with just three dots in it, showing that they were drawing just one face. The 6-year-olds, however, typically produced drawings with the square filled in with large numbers of dots, and one 6-year-old produced a drawing containing all the dots on all the faces in sequence as shown in Fig. 4.8b.

These children were older than those whose drawings are shown in Fig. 4.7, and their drawings took the form of squares rather than more or less circular regions. Nevertheless, the results strongly suggest that these 6- and 7-year-olds were using a square to stand for the whole volume of a cube rather than just one face. To use Marr's (1982) terminology, these children were deriving their drawings of cubes from three-dimensional volumetric object-centered descriptions rather than from views.

Light and MacIntosh (1980) used a different approach to discover whether young children base their drawings on object-centered descriptions or on views. In their experiment they presented 64 children (mean age = 6 years 10 months) with two identical views of scenes that consisted of a model house and a transparent glass beaker. In one view, however, the house was inside the glass, whereas in the other view it was behind the glass.

Apart from one child who refused to draw either arrangement, all the children produced what Light and Macintosh (1980) called *unified drawings* for the inside glass condition, as shown in Fig. 4.9a. However, almost half

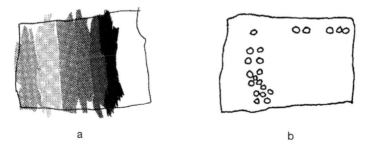

a b

FIG. 4.8. (a) A drawing by a 7-year-old of a cube having a different color on each face. (b) A drawing of a die by a 6-year-old. Taken from Willats (1992, Figs. 52 and 53).

a b

FIG. 4.9. A typical pair of drawings obtained when 6- and 7-year-olds were asked to draw a model house in the "inside glass" and "behind glass" conditions. The view the children had of the scene was the same in each case. At (a), however, the model house was represented within the region representing the glass, whereas at (b) it is represented outside the glass. Taken from Light and MacIntosh (1980, Fig. 1). Courtesy of P. Light.

produced separate drawings for the behind glass condition as shown in Fig. 4.9b. These results suggest that about half of these children, those who produced drawings of the type shown at 4.9a for both conditions, were drawing views of the scene. In contrast, the children who produced drawings of type a for the "inside glass" condition but type b for the "behind glass" condition were apparently basing their drawings on object-centered descriptions.

In viewer-centered descriptions of these scenes the house would be described as appearing within the glass in each case; therefore, children who were basing their drawings on viewer-centered descriptions would produce similar drawings for each of the two conditions. However, in an object-centered description of the inside glass condition the model house is inside the glass, whereas in an object-centered description of the outside glass condition the house is outside the glass, and the difference in the drawings shown at Figs. 4.9a and b clearly reflects the difference in these two descriptions.

The results of these three experiments suggest that up to about the age of 6 or 7 years many children base their drawings on object-centered descriptions rather than views. The results of the first two experiments also suggest that these object-centered descriptions are based on three-dimensional volumes rather than faces as scene primitives and that drawings of the type shown in Fig. 4.8 are therefore based on a denotation system in which regions denote volumes.

Burton (1997) developed a computer program called ROSE in which he attempted to model the drawing process used by young children. This pro-

gram is based on the hypothesis that young children's drawings are derived from object-centered descriptions in which the scene primitives are volumes. In Burton's own words:

> ROSE's output process is inspired by Willats's (1985) description of denotation systems in which "regions" (closed forms) in a drawing denote 3D volumes.
>
> ROSE attempts to produce relationships of topology, size and proportion between the closed forms in a drawing that are equivalent to those of the perceived volumes of the input. All the relationships ROSE endeavours to preserve are object-centered rather than viewer-centered. (p. 302)

Figure 4.10b shows an example of a drawing of a horse derived from the three-dimensional object-centered description shown in Fig. 4.10a.

Figure 4.11 shows further examples of drawings produced by ROSE, including a tree, a house with a person inside, various animals including a horse and a cow, and two people holding hands. The house and the tree appear on a baseline, as they would in children's drawings, and the house with the person inside is an example of enclosure resulting in a transparency. Figure 4.12 shows a 3-D model of a man, the resulting drawing produced by ROSE, and a drawing of a man by a child age 2 years 11 months.

In the drawing shown in Fig. 4.12b the scene primitives of the 3-D model shown at Fig. 4.12a are represented by more or less round regions, and these

a b

FIG. 4.10. (a) A three-dimensional object-centered description of a horse, as an example of the kind of description from which the drawings in ROSE were derived. The scene primitives of the description consist of volumes in the form of cylinders of varying proportions, similar to those described by Marr (1982) in his account of the 3-D model, together with the topological relations between the primitives in three-dimensional space. (b) The drawing derived from this three-dimensional description. The picture primitives are regions whose proportions vary according to the proportions of the scene primitives from which they are derived. The topological relations between the regions in the drawing reflect the topological relations between the parts of the 3-D model. Adapted from Burton (1997, Fig. 2).

FIG. 4.11. Drawings produced by ROSE showing a tree, a house with a chimney and a person inside, various animals including a horse and a cow, and two people holding hands. Taken from Burton (1997, Fig. 3).

FIG. 4.12. (a) A 3-D model of a man as an input to ROSE. (b) The corresponding drawing produced by ROSE. (c) A drawing of a man by a child, 2 years 11 months. Taken from Burton (1997, Fig. 4).

may be compared with the shapes of the regions used to represent the head and body of the child's drawing shown in Fig. 4.12c. With the exception of one arm, long volumes or sticks in the 3-D model of the man are represented in ROSE's drawing by long regions, however, rather than being represented by lines as they are in the child's drawing. One other difference between the drawing produced by ROSE and children's drawings is that ROSE's drawings of people and animals lack facial features such as the eyes, nose, and mouth, although the program could be easily altered to overcome this. Nevertheless, there are obvious similarities between the drawings produced by ROSE and children's early drawings, and this suggests that the account I have given of young children's drawings—that they are derived from volumetric object-centered internal descriptions rather than from views—is plausible. As Burton (1997) said:

> Since the computer is not analogous to the mind, ROSE does not simulate a
> child's activity and as such does not prove or disprove the theoretical models

on which it is based. However, successful implementation of a program demonstrates a theory's plausibility. (p. 302)

The drawings produced by ROSE resemble the drawings that children produce just after the tadpole stage rather than the earlier tadpole figures that lack, or appear to lack, a body. Moreover, in tadpole figures long volumes such as the arms and legs are typically represented by lines rather than long regions, and the long regions occasionally used to represent the legs in tadpole figures are unusual. For comparison, Fig. 4.13 shows the tadpole figure shown in Fig. 4.1a alongside a drawing of a man produced by a boy who has just passed the tadpole stage. In this later drawing the head and body are represented separately, and the arms, legs, and feet are all represented by long regions rather than lines.

In their early drawings children represent only round and long volumes. Round volumes such as the head are represented by round regions, but long volumes are typically represented by lines rather than long regions. This may be because the contrast between lines and round regions represents the difference between lumps and sticks in the strongest possible way. At a slightly later stage, children make finer distinctions among the proportions of the various body parts, and to represent these differences they have to vary the proportions of the picture primitives; to do this they have to use regions rather than single lines. Differences of this kind can be seen in the drawing of a man produced by ROSE shown in Fig. 4.12b and the drawing

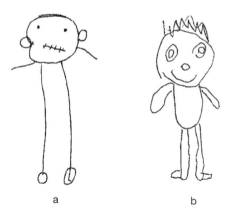

a b

FIG. 4.13. (a) A tadpole figure in which the body appears to be missing and in which long volumes such as the arms and legs are represented by lines. Taken from Harris (1963, Fig. 59). (b) A developmentally later drawing of a man in which the body is represented, and the arms and legs are represented by long regions. Taken from Cox (1992, p. 48, Fig. 4.2). Courtesy of M. Cox.

of a man shown in Fig. 4.13b. In both these drawings the relative proportions of the heads, bodies, and legs all vary, and to make these finer distinctions children have to change to a denotation system in which long regions are used to represent long volumes whose proportions vary in their degrees of extendedness.

However, this still leaves us with the problem I raised at the beginning of this chapter: Why do children's tadpole figures appear to lack a body? As we have seen, the apparent lack of a body in the tadpole drawings cannot be explained in terms of lack of knowledge, nor can it be explained in terms of performance problems. This seems to leave Arnheim's (1974) proposal that children use a round region to stand for the head and body combined as the most plausible solution, but there are still difficulties with this. Logically, this would mean that the child's internal representation of the head and body are amalgamated, at least for the purposes of drawing, into a single scene primitive in the form of a lump.[4]

However, it seems difficult to apply this explanation to more complex tadpole figures, such as the tadpole drawing shown in Fig. 4.13a. This figure contains round regions representing the ears and feet but still lacks a body. Why should children have separate internal representations for the ears and feet but still amalgamate the scene primitives representing the head and the body? It might be possible to save Arnheim's (1974) explanation by saying that children initially have a very simplified way of representing the figure in the form of a round region with lines radiating from it, and that this way of drawing a man persists as a stereotype in their later drawings, even when further details such as the ears and feet are added. In fact, Luquet (1927/2001) suggested something of the kind in terms of what he called *type constancy*.[5]

Perhaps this combination of Arnheim's (1974) account of the tadpole figures with Luquet's (1927/2001) *conservation du type* provides the answer, al-

[4]In a program similar to that used by ROSE, for example, this could be done by saying that the head and body in the 3-D model are to be treated as a single scene primitive rather than being treated separately. This would result in a drawing consisting only of a round region with lines radiating from it, similar to the very early tadpole figures; to this extent Arnheim's (1974) suggestion seems plausible.

[5]"The conservation of type first appears in the form of the first drawing of a certain motif. . . . A clear example is provided by the first drawings of a man which remain cast in the same mould over a rather long period. These are distinguished by the absence of a trunk, so that the arms, if they are shown, have to be attached either to the legs or more often to the head. Primary conservation is all the more remarkable in the case of such 'tadpole' men since the type thus conserved clearly conflicts with reality; only the effect of habit could prevent the child from noticing such striking imperfections for so long" (Luquet, 1927/2001, p. 31).

though it seems rather untidy. This very untidiness, however, does have the merit that it illustrates the importance of the need to include both performance factors and competence factors in any full account of children's drawings.

In this chapter I have described three features of children's early drawings: (a) the change from a mark system based on patches of scribble to a system based on the use of lines, (b) the employment of a denotation system in which regions as picture primitives are used to represent volumes as scene primitives, and (c) the role of the extendedness principle in representing the shapes of these primitives.

The effectiveness of the different mark systems children use depends largely on performance factors. The performance factors that determine the nature of the marks are very different from those that determine the nature of the sounds in children's speech. There are, however, some striking similarities between the competence factors in children's early speech and children's early drawings. The complementary relation between the drawing systems and the denotation systems can be compared to the relation between vocabulary and syntax, and the representation of extendedness appears to play an important role in both language and drawing. But perhaps the most striking similarity lies in the creativity that children bring to bear in each case. Figure 4.14 shows a drawing of a man with a saw reproduced in Arnheim (1956). The vocabulary of picture primitives employed in this drawing is extremely limited and consists only of round regions, long regions, lines, dots, and patches of scribble. The extendedness of these regions represents the extendedness of the features they represent, regardless of the

FIG. 4.14. A child's drawing of a man with a saw. Taken from Arnheim (1956, p. 141). Courtesy of The Regents of the University of California.

shapes of their edges or surfaces: perhaps the most striking instance of this is that the triangular shapes of the teeth of the saw are represented by round regions rather than triangles. In spite of the extreme simplifications of form imposed by this very limited vocabulary, however, this child was able to produce a most vivid representation of the scene, making, as Chomsky (1972) said of language, "infinite use of finite means" (p. 21).

Where Do We Go From Here?

> ... And at least you know
> That maps are of time, not place, so far as the army
> Happens to be concerned—the reason being,
> Is one which need not delay us. Again you know
> There are three kinds of trees, three only, the fir and poplar,
> And those that have bushy tops to ...
>
> —Henry Reed, *Judging Distances*

Representing Disks and Slabs

The drawings described in chapter 4 are based on a simple denotation rule: Use round regions to stand for lumps and long regions to stand for sticks. The term *lump* is used here to describe objects such as heads and houses that are about equally extended in all three dimensions in space, and the term *sticks* is used to describe objects such as arms and legs that are extended in only one dimension. The marks used to represent these picture primitives are either single lines or areas enclosed by outlines. Single lines, or long areas, are used to stand for long regions, and round areas are used to stand for round regions. In addition, small round regions (represented by small areas or dots) are often used to stand for small objects such as eyes that are not significantly extended in any direction. But this leaves out of account a whole class of objects that are neither round nor long, but *flat*. This class includes objects such as the tabletops, hat brims, hands, and wheels. I refer to objects of this kind as *disks* or *slabs*, depending on whether they are more or less round or rectangular. After the very earliest drawings, one of the things that

children have to discover is how to represent objects that are flat, as well as objects that are round, long, or small.

As Stern (1930, pp. 369–370) said, "A long stroke is a natural symbol for an arm or leg, a small circle for an eye or head," but it is not quite so easy to see what might be a natural symbol for a flat shape. A round region is a natural symbol for a round lump such as a head, not only because lumps are round in themselves but because they appear round from whatever direction they are viewed. On the other hand, although sticks, such as arms or legs, are both long in themselves and will appear long from most directions of view, there are two special views (the two end views) from which they will appear round. Nevertheless, a long region seems much more natural than a small round region as a way of representing a stick. Not only does a long region reflect the fact that sticks are long in themselves, but it also corresponds to the most probable view of a stick. In the absence of other clues to its identity (such as the context), a small round region in a drawing is always more likely to be seen as representing a small lump than a foreshortened view of a stick. Thus, although a round region in a picture may show a true view of a stick, it does not provide an effective representation.

However, it is not obvious whether a disk ought to be represented in a drawing by a round region or a long region: a long region disguises the fact that that disks are round in three-dimensional space, whereas a round region disguises the fact that disks are flat. Moreover, it is not immediately obvious whether the most likely view of a disk is a round region or a long region. Consequently, although children will always use a round region to stand for a head and long regions to stand for the arms and legs, they may choose either round regions or long regions to stand for flat features such as the hands or feet, as shown in Fig. 5.1.

a b

FIG. 5.1. Two figure drawings showing alternative ways of drawing the hands and feet. The heads are represented by round regions and the arms and legs by lines in each case, but in drawing (a) the flat shapes (the hands and feet) are represented by round regions, whereas in drawing (b) the flat shapes are represented by long regions. Taken from Willats (1987, Fig. 2). Drawing (b) is reproduced courtesy of Dennie Wolf.

Because there are no natural symbols for disks or slabs it is not always easy for children to find ways to represent them. We normally see round regions as lumps and long regions as sticks, but being able to recognize slabs or disks in a drawing often depends on the context in which they appear (Willats, 1992b). In Fig. 5.2, for example, we can see that both the brim of the hat and the wheels of the pram are flat shapes even though they are represented in different ways.

In the absence of an appropriate context, however, it is not easy to see disks or slabs in children's early drawings. Figure 5.3 shows two drawings of tables. In Fig. 5.3a, a drawing by Megan, the tabletop is represented by a round region, and in Fig. 5.3b, a drawing by Ben, the tabletop is represented by a curved line. It is not easy to identify either of these as a drawing of a table. We tend to see the round region in Megan's drawing as a lump, so that the drawing looks more like a jellyfish than a table. Once we know this drawing is intended to represent a table, however, it is not difficult to see the round region as the top and the lines as legs. Unlike Megan's earlier drawings, this drawing does not have to be annotated for us to make sense out of it, but we do have to know what the drawing as a whole is intended to represent. Similarly, we would not naturally see Ben's drawing as a drawing of a table with things on it—it looks more like a drawing of a hair band (i.e., a bent stick). Again, we have to be told that this is a drawing of a table before we can see a table in it.

FIG. 5.2. Jean Luquet, 6 years 10 months, *A Woman Pushing a Pram*. The drawing contains two representations of disks, in the form of the wheels of the pram and the brim of the hat. The wheels are represented by round regions and the brim of the hat by a long region, but in this drawing the context tells us how these different picture primitives, both representing disks, ought to be interpreted. Taken from Luquet (1927/2001, p. 108, Fig. 104).

a b

FIG. 5.3. Two drawings of tables: (a) a dictated drawing of a table by Megan Erridge, 2 years 9 months; (b) a drawing of a table by Ben Matthews, 3 years 3 months. Megan's drawing looks more like a jellyfish (i.e., a lump with sticks dangling from it), whereas Ben's drawing looks more like a hair band (i.e., a bent stick). We can only see tables in these drawings when we are told what they are intended to represent. Drawing (b) is taken from Matthews (2003, Fig. 52). Courtesy of J. Matthews.

Shape Modifiers

One way in which children can make their drawings more effective as representations is by using regions of different shapes. It would be easier to recognize Megan's drawing as a representation of a table, for example, if she had used a rectangular region rather than a round region to represent the tabletop. We might think that children would have no more difficulty in drawing square or rectangular regions than they do in drawing round regions, but this does not seem to be the case, and there is some evidence to suggest that children may regard extendedness and secondary features such as "having flat sides" or "having corners" as separate shape properties. When Piaget and Inhelder (1956) asked children between ages 3 and 5 years to copy drawings of squares and diamonds, they found that some of the children represented both figures by round regions, but added little ticks or "hats" to represent the corners. Hayes (1978) obtained similar results when she asked 3-year-olds to copy squares and diamonds; some of these variations are shown in Fig. 5.4. Figure 5.4a represents the extendedness of a square by a round region, whereas the radial lines may represent either sides or corners. Figures 5.4a, b, and c similarly represent the extendedness of a diamond, whereas the sharp corners are represented by radial lines or patches of scribble.

Hayes (1978) also asked a girl of 3 years 6 months to copy a square under two conditions. In Fig. 5.5a the girl had watched the experimenter draw a square using discontinuous strokes, and in Fig. 5.5b the experimenter had

a

b c d

FIG. 5.4. Drawings produced when 3-year-olds were asked to copy squares and dia-monds. (a) A copy of a square. The closed form represents the extendedness of the square and the radial lines may represent either sides or corners. (b), (c), and (d) Copies of a diamond. The closed forms represent the extendedness of the diamond and the corners are represented either by radial lines (b) or patches of scribble (c) and (d). Taken from Hayes (1978, Figs. 8 and 9).

a b

FIG. 5.5. Two drawings of a square produced by a girl, 3 years 6 months. Before draw-ing (a) the girl watched the experimenter draw a square using discontinuous strokes. Before drawing (b) she watched the experimenter draw a square in one continuous movement. Taken from Hayes (1978, Fig. 10).

drawn the square in one continuous movement. The first drawing (5.5a) showed that this girl possessed the necessary manual skill to draw a square and that she understood the idea of copying. After she had produced the sec-ond drawing (5.5b) the girl was asked to identify the parts of her drawing, which she did by pointing to the radial lines representing the sides ("These are the side bits" and "For going up and down") and the corners ("There for stiff things").

Although drawings of squares of the type shown in Fig. 5.5b are relatively rare, these observations suggest that for at least some children the primary property of "extendedness" and the secondary shape properties of "having straight sides" and "having corners" are represented separately.

In English, these two shape properties are combined in single words; a *disk* combines the idea of being flat with the idea of being round, and a *slab* combines being round with being rectangular. In some languages, however, the two shape features are represented separately, very much as the two shape features of "being round" and "having corners" are represented separately in the drawings of diamonds shown in Fig. 5.4.[1]

I have already suggested that the first and most basic shape property of an object that children represent in their drawings is its extendedness. It is in this sense that a round region provides a graphic equivalent for a round object such as a head, and a long region provides a graphic equivalent for a long object such as an arm or a leg. But to produce drawings that are more effective as representations children have to find a way of representing secondary shape properties such as having flat sides or having corners. Adding radial lines to round regions, as in the drawing shown in Fig. 5.5b, is not an effective way of doing this, and most children find more direct graphic equivalents that correspond to possible views, although they are not derived from them. The solution they find, in the case of rectangular objects such as cubes or houses, is to use straight lines to stand for the secondary shape property "having flat sides." I refer to features of drawings that represent secondary shape properties of this kind as *shape modifiers* (Hollerbach, 1975).

Figure 5.6 shows a simple but highly effective painting by Arfan Khan, a boy age 7 years 5 months, of *A House With a Huge Snowdrift*. Up to a point, the drawing provides a possible view of the front face of the house, but it has a curious feature that is common in children's drawings: the windows are set into the corners of the facade. This makes no sense as a view of a house, but if the square into which they are set represents the volume of the house rather than the facade, and the straight lines represent the property "having flat sides," the windows are drawn where they belong, attached to the sides of the house. It would be even more logical to draw the windows on these straight lines, rather than just touching them, but then they "wouldn't show up." There is a parallel here with the girl who wanted to draw the mold mark

[1]In Cree, for example, an Amerindian language, *wawiye-* refers to all round shapes such as a round, flat tomato or a cookie, but the perfectly round shape of a coin would be expressed by *weweni-wawiyeya* (it is truly round, i.e., circular; Denny, 1979b), whereas a hemisphere would be *apittaw-wawiyeya* (it is half-round).

FIG. 5.6. Arfan Khan, 7 years 5 months, *A House With a Huge Snowdrift*. Taken from Willats (1991, Fig. 16.8). Collection of the author.

on the ball shown in Fig. 4.5: she wanted to draw the mold mark where it belonged, on top of the circle representing surface of the ball, but rejected this solution because it "wouldn't show up." The idea that the square represents the whole volume of the house is reinforced by the way the snowdrift is painted. Topologically the snowdrift surrounds the house; therefore, the region representing the snowdrift is shown surrounding the house in the picture.

Figure 5.7 shows the results of another copying task. Crook (1985) asked thirty-one 5-year-olds to copy the drawing shown in Fig. 5.7a. In Fig. 5.7b each house is drawn separately and only the extendedness is represented; that is, the two houses are drawn as lumps, represented by round regions. In Fig. 5.7c the two houses are shown joined, but in the house on the left the top two windows are shown joined to the top corners, suggesting, as in the painting by Arfan Khan, that the squares represent whole volumes. In Fig. 5.7d the facades correspond to possible views, as shown in the model drawing, but each facade is drawn separately. Thus, none of these three drawings is a copy of the model drawing: instead, each child has found his or her own graphic equivalent for the three-dimensional scene depicted in the original drawing.

I have suggested that in these drawings of houses the straight lines bounding the square facades are not views of edges but act as shape modifiers, in this case modifying the basic shape property of extendedness by the

a b

c d

FIG. 5.7. Three of the drawings produced by thirty-one 5-year-olds who were asked to copy the model drawing shown at (a). None of these drawings is copies in a true sense; instead, each child has found his or her own graphic equivalent for the model drawing. Taken from Crook (1985, Fig. 14.1). Courtesy of C. Crook.

modifier "having flat faces." The same principle can be found running through children's drawings of all kinds of other objects, including objects having smooth surfaces such as people and animals. Figure 5.8 shows three drawings, typical of those produced by 4- and 5-year-olds, when children from ages 4 to 9 years were asked draw from a three-dimensional model of a kangaroo (Reith, 1988).

Reith (1988) divided the drawings produced by his participants into eight classes. The first class, which he called *scattered schematic forms*, consisted only of separate circles and line segments, each representing parts of the kangaroo in isolation. The second class contained drawings similar to those shown in Fig. 5.8 and were made up of what he called *linked schematic forms*. These drawings differ from those in the first class in several respects. The most obvious difference is that the forms are linked instead of being represented separately; that is, the drawing system contains the join rule, so that parts that are joined in the model are shown joined in the drawing. The denotation system in these linked schematic forms drawings is more complex. Whereas drawings in the first class contained only lines and circles, these drawings also contain long regions, such as those used to represent the tail and ears in Fig. 5.8c. In addition, both the round and long regions in these drawings have been modified to represent additional shape properties beyond those of "being long" and "being round." In drawing Fig. 5.8a the

a b c

FIG. 5.8. Drawings of a 3-D model of a kangaroo, typical of those produced by 4- and 5-year-olds and described by Reith (1988) as being made up of "linked schematic forms." Taken from Reith (1988, Fig. 2).

shape of the region representing the body of the kangaroo as a round form or lump has been modified, using a shape modifier that might be character- ized as "being pear-shaped" or "being pointed." Similarly, the regions repre- senting the ears and the pouch are not just long but are subject to the shape modifier "being pointed at one end." The drawing shown in Fig. 5.8b con- tains only round regions and lines but contains a patch of scribble acting as the modifier "being textured." The modifiers used in Fig. 5.8c are similar to those in Fig. 5.8a, but in addition the lines representing the mouth and the edge of the pouch are subject to the modifier "being bent."

Shape modifiers in drawings represent what are called *nonaccidental shape properties* in the scene (Biederman, 1987). Nonaccidental shape properties are those shape properties of objects that are likely to be reflected in views. The most basic of these is extendedness. For example, any view of an object that can be represented in the scene by a long volume, such as a poplar tree, is likely to take the form of a long region, although there is one improbable viewpoint, from directly above, from which a poplar tree will appear round. In the quotation at the beginning of this chapter, "poplar trees" is a good ex- ample of one of Rosch's (1973) clearest cases, used by the British Army to define one category of trees. The second category, trees "that have bushy tops" includes all trees that take the form of lumps (or perhaps lumps on sticks) such as oaks. But there is one further category, that of fir trees, that is defined by applying the shape modifier "being pointed at one end" to the more basic category of poplar trees.

Once past the tadpole figure stage children seem to use the same ap- proach in their drawings as the British Army, adding shape modifiers such as

a b

FIG. 5.9. (a) Robert Gondris, 5 years, a drawing of a man. (b) Boy, 6 years 8 months, *A Man With a Hat*. The brim of the hat is shown touching the head rather than partially occluding it.

"having flat sides," "being bent," "being pointed," and "being textured" to the three basic categories of "being round," "being long," and "being flat." In this way their vocabulary of picture primitives can be much enlarged and as a result their drawings can be made much more effective as representations.[2] Figure 5.9a shows a drawing of a man by a 5-year-old boy. The basic picture primitives are round regions, long regions, lines, and dots, but the shape modifier "being forked," has been applied to the long regions used to represent the arms in order to represent the hands and fingers. In Fig. 5.9b, drawn by a 6-year-old boy, the modifier "being bent" has been applied to the arms and legs, and the body and hat are shown with straight sides. The hat brim is drawn using a line representing a long region. Notice that this is *touching* the head rather than occluding part of it. If the shape of the head represents a round volume rather than a view, this makes good sense: the brim of a hat touches the surface of the head rather than cutting through it.

Shape modifiers can be applied to picture primitives representing two-dimensional scene primitives such as faces and one-dimensional scene primitives such as edges, but some of the most intriguing examples of the use of

[2]If the role of the drawing systems in pictures can be compared with the role of syntax in language, and the role of the denotation systems with the lexicon, the role of the shape modifiers in pictures might be compared with the role played by adjectives in language.

shape modifiers appear in children's drawings when they are applied to whole volumes.

The two drawings of apples shown in Fig. 5.10 are taken from the experiment by Clark (1897) described in chapter 2. In both drawings the pin is drawn "clear across," as Clark put it, suggesting that the children who produced drawings of this type were representing the apple as a whole volume, so that the pin is, quite logically, shown passing through this volume. In Fig. 5.10a the shape of the apple is represented by a round, circular region, representing the apple simply as a lump; that is, the drawing is based on a denotation system in which a round region is used to denote a round volume. The overall shape of the second drawing is also round, but the outline has a dent at the top, representing the dent in the top surface of the apple. Figure 5.10b, then, is based on a denotation system in which a round region is used to denote a round volume, but with the addition of the shape modifier "having a dent."

The same shape modifier can also be applied to drawings of rectangular objects. Many years ago I carried out an experiment in which I asked children ages 4 to 13 years to make drawings from a familiar object (a model cube), together with a number of unfamiliar objects including a model of a cube with a smaller cube removed from one corner. A number of writers had suggested that children's drawings are based on known stereotypes, and if this is the case children should have great difficulty in drawing unfamiliar objects, that is, objects they have never drawn before and for which they have no stereotypes. If children base their drawings on drawing rules, however, and are able to apply these rules to new objects, they can be expected to draw unfamiliar objects in the same way, and with about the same level as competence, as they draw familiar objects. This experiment (Willats, 1981) was designed to test between these two hypotheses.

a b

FIG. 5.10. Children's drawings of an apple with a hat pin stuck through it. In (a) the apple is represented simply as a round volume or lump. In (b) the apple is still represented as a lump, but with the addition of the shape modifier "having a dent." Taken from Clark (1897, Fig. 1).

In an earlier experiment (Willats, 1977a, 1977b) I had asked children to draw pictures of a table. One little boy told me very solemnly that he could draw ladies in crinoline dresses and Alsatian dogs, but he couldn't draw tables, which certainly suggested that this child at least had known stereotypes for drawing them. However, even this little boy was eventually persuaded to draw the table, and I found that the drawing systems the children used followed a developmental sequence in the order: orthographic projection, vertical oblique projection, oblique projection, and perspective. In the second experiment I found that the children were able to use the same drawing systems, at about the same ages, for drawing both the cube and the unfamiliar objects. However, I was puzzled by some drawings produced by the youngest children, and it was the attempt to describe the spatial systems in these drawings that eventually led to the concept of the role played by the denotation systems in children's drawings.

Figure 5.11a shows the model cube the children were asked to draw. In Fig. 5.11b the denotation rule is: Use a round region to denote a lump. In Fig. 5.11c a shape modifier has been added, and the rule becomes: Use a round region to denote a lump and add the shape modifier "having flat sides." These are the kinds of drawings one would expect from children of this age. Figure 5.12, however, shows some examples of the drawings the children produced to represent the unfamiliar object. In Fig. 5.12b the denotation rule is: Use a round region to denote object a as a lump and add the shape modifier "having a dent." In Fig. 5.12c the denotation rule is: Use a round region to denote object a and add the shape modifiers "having a dent" and "having flat sides."

The shape modifier "having a dent" has as its counterpart the modifier "having a bump." Figure 5.13 shows a child's drawing of a man in which the basic round region representing the head is modified by bumps representing the nose and chin. As Wilson and Wilson (1982) pointed out, children's

a b c

FIG. 5.11. Children's drawings of a cube. In (b) only the extendedness of the cube is represented; that is, the cube is represented as a lump. In (c) the shape modifier "having flat sides" has been added.

<div align="center">

a b c

</div>

FIG. 5.12. Children's drawings of an unfamiliar object in the form of a cube with a smaller cube removed from one corner. In (b) the extendedness of this object is represented together with the shape modifier "having a dent." In (c) the extendedness of the object is represented together with two shape modifiers: "having a dent" and "having flat sides."

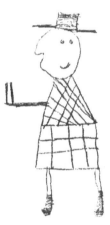

FIG. 5.13. A drawing of a man showing the use of the shape modifier "having a bump" to represent the nose and chin. Collected by Thorndike circa. 1913 and illustrated in Wilson and Wilson (1982, Fig. 2).

drawings of this type were common at the beginning of the 20th century but are now exceedingly rare. This suggests that although the principle of adding the shape modifier "having a bump" may be derived from innate properties of the visual system (cf. Fig. 8.10), children may or may not use this shape modifier in their drawings of heads, depending on the drawings they see around them.

As a final example of the use of shape modifiers, Fig. 5.14 shows a drawing of a horse by a 5-year-old girl. In an earlier drawing by the same girl (Fig. 11.6) the body and the legs were represented by lines, and the head was represented by a round region. In this drawing, produced about a year later, the body and legs are both represented by long regions. The ears are also repre-

FIG. 5.14. Heidi, 5 years, *A Drawing of a Horse*. The head and neck are represented to-gether using a single long region with the addition of the shape modifier "bent at right angles."

sented by long regions, but with the addition of the shape modifier "pointed at one end." The head and neck are represented by a single long region, to-gether with the shape modifier "bent at right angles."

I have argued that all the children's drawings shown in this chapter are based on a denotation system in which either long or round regions denote long, round, or flat volumetric scene primitives. But is this really the case? Many of them look convincing as views, so how do we know that they are de-rived from volumetric object-centered internal descriptions? In the case of single drawings this must nearly always be a matter of judgment rather than certainty, but we do often have some clues. For example, in the drawings of apples shown in Fig. 5.10 the pin is drawn clear through, and this strongly suggests that these drawings are based on volumetric scene primitives. In drawings or paintings of houses, similar to the *House With a Huge Snowdrift* shown in Fig. 5.6, the fact that the windows are shown joined to the corners suggests that the outlines of the house represent its surface and that the region they enclose therefore represent the whole volume of the house.

Although analyzing finished drawings is usually a matter of judgment there is one certain way of deciding whether drawings are derived from views or from object-centered descriptions, and that is to ask children to make drawings of the same objects from different directions of view. If chil-dren respond appropriately to the change in viewpoint, this shows that they are drawing a view, but if children produce the same drawing whatever the viewpoint, this strongly suggests that they are deriving their drawings from object-centered internal descriptions.

In one experiment of this kind (Willats, 1981) 64 children ages 6 to 12 years were asked to draw a model die shown to them in four different views.

FIG. 5.15. The apparatus used in an experiment in which children ages 6 to 12 years were asked to draw a model die presented to them in four different views. Taken from Willats (1981, Fig. 10.1).

Each child was seated at a table having a section that could be moved up and down, as shown in Fig. 5.15, and the die was placed either face on or edge on from the child's point of view. The die could thus be presented in four views: face up, face down, edge up, and edge down. Each child was then asked to draw all four views.

Figure 5.16 shows drawings typical of those produced by the 12-year-olds, representing, appropriately, all four views. Figure 5.17, however, shows drawings typical of those produced by the 6-year-olds. I shall never forget the look of pity mixed with contempt that one 6-year-old turned on me when I asked him to draw yet another view. His look said, as plainly as possible, "I've drawn it three times already, how many drawings do you want?" It was quite clear that these children were basing their drawings on object-centered internal descriptions that were independent of any particular point of view, and the denotation rule on which these drawings are based is: Use square regions to denote volumes with flat faces.

In a second experiment of this kind (Willats, 1992a) children were asked to draw a model figure of a man similar to that used by Marr to illustrate the

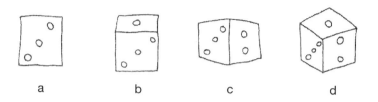

FIG. 5.16. Drawings of four views of the die typical of those produced by 12-year-olds. Taken from Willats (1981, Fig. 10.2).

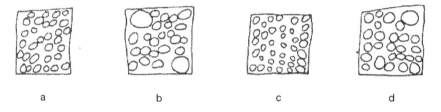

a b c d

FIG. 5.17. Drawings of four views of the die typical of those produced by 6-year-olds. Taken from Willats (1981, Fig. 10.2).

kind of shape that might be used to store a description of "a human" in long-term memory (Marr, 1982, Fig. 5.10). The model figure was 34 cm (13½ in.) high and had arms in the form of cylinders (or *sticks*) that could be rotated about the shoulders so that they could be seen either from the side or end-on from the child's point of view. The arms held a plate (in the form of a *disk*), and this could also be rotated so that it could be seen either from the top or from the side. Thus, both the arms and the plate could be presented to the children in both foreshortened and nonforeshortened positions. Figure 5.18, by a 12-year-old boy, gives a good idea of the shape of this model figure. The object of the experiment was to test children's ability to represent foreshortening and, in particular, to test whether they were more willing to represent a foreshortened view of the disk than a foreshortened view of the sticks. Piaget and Inhelder (1956) had asked children to draw sticks (a needle or a pencil) in foreshortened and nonforeshortened positions and found that the younger children used a line or a long region to represent them, whatever their orientation. Lines or long regions are natural symbols for sticks, and as Piaget said, when children draw they "cling to the object in itself" (p. 178). However, because there are no natural symbols for disks, and children routinely switch from using circles to using lines to represent them (as in the children's drawings of hands and feet in Fig. 5.1 at the beginning of this chapter), we might expect that they would be more willing to draw disks as either round or long regions than to draw sticks as small,

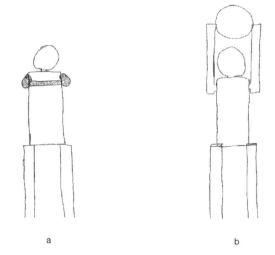

a b

FIG. 5.18. A pair of drawings of a model figure of a man holding a plate, by a boy, 12 years 1 month. The foreshortened positions for the arms and the plate are shown highlighted. Taken from Willats (1992a, Fig. 7).

round regions. This indeed proved to be the case, and I discuss the results of this experiment in a later chapter. However, because children were asked to draw these objects from different points of view this experiment also provided a way of finding out which children were basing their drawings on object-centered descriptions and which were drawing views.

If children are basing their drawings on object-centered internal descriptions they can be expected to produce the same kinds of drawings of objects, whatever the view presented to them; by definition, object-centered descriptions are given independently of any direction of view. As might be expected from the results of the experiment in which children were asked to draw a die, very few of the 4-year-olds in this experiment changed their drawings of the arms or the plate, whatever view they had. Twenty-four of the thirty-two 4-year-olds produced no changes of shape for either the arms or the plate. Of those who did change their drawings, two children made a partial change in their drawings of the arms (i.e., they made them shorter), but no child drew the arms as dots or small round regions. Only three children changed their drawings of the disk from a round region to a long region, and two children, one of whom produced the drawing shown in Fig. 5.19, used a partial change of shape to indicate the foreshortening of the disk. These results showed that nearly all of the 4-year-olds were basing their drawings on object-centered descriptions; that is, they were drawing the whole volumes of objects rather than any particular view.

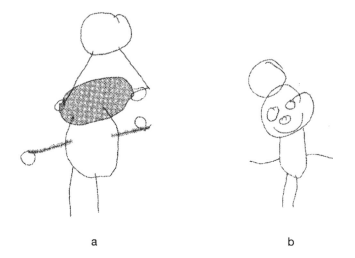

a b

FIG. 5.19. A pair of drawings by a girl, 4 years and 6 months. The plate shows a partial change of shape whereas the arms show no change of shape. Taken from Willats (1992a, Fig. 2).

To sum up, the mark system used by Jean Luquet in his drawing of *A Woman Pushing a Pram* shown in Fig. 5.20b is substantially the same as that used by the 6-year-old in her *Drawing of a Man* shown in Fig. 5.20a. Round areas defined by an outline are used to stand for round regions (the heads of the figures in both drawings), and single lines are used to stand for long regions (the arms and legs in Fig. 5.20a and the brim of the hat and the legs of the pram in Fig. 5.20b). The main difference between these two drawings is

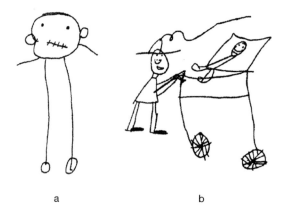

a b

FIG. 5.20. (a) Girl, 6 years 6 months, *A Drawing of a Man*. (b) Jean Luquet, 6 years 10 months, *A Woman Pushing a Pram*. Taken from Luquet (1927/2001, Fig. 104).

that Jean has also used long outline areas to stand for long regions (the arms and legs of the woman).

The denotation system in drawing Fig. 5.20b differs from that shown in Fig. 5.20a in two respects. Round regions are used to denote round volumes and long regions are used to denote long volumes as before, but flat volumes (the brim of the hat and the wheels of the pram) are also represented, using either long or round regions. In addition, the rectangular shape of the body of the pram is represented by using the shape modifier "having flat sides" and the shape of the body of the woman is represented using the shape modifier "being pointed."

The drawing system used in these two drawings is essentially the same. Objects or parts of objects that are joined in the scene are represented by regions that are joined in the picture, and in both drawings features such as the eyes and mouth are shown enclosed within the outline of the head.

Regions

In the previous chapter I described drawings by children based on a denotation system in which regions denote volumes. The shapes of the regions in these drawings reflect the extendedness of the volumes they denote, so that long regions are used to stand for long volumes and round regions are used to stand for round volumes. Flat volumes, such as disks or slabs, may be represented by either long or round regions, depending on the context. In addition, the shapes of these regions may be subject to shape modifiers such as "being pointed," "being bent," or "having flat sides." The drawing systems in pictures of this kind are typically based on topological geometry and may or may not provide possible views.

Once they are past the scribbling stage children use this basic denotation system to represent all kinds of objects irrespective of their surface shapes. They do, however, begin to use different shape modifiers according to whether the objects they draw have smooth surfaces or plane faces. The surfaces of objects such as people and animals can be regarded as smooth, and children continue to use smooth convex outlines to represent the shapes of the various parts of the body, but features such as the legs or arms may be represented using the shape modifier "being bent," as in the drawing shown in Fig. 6.1a. In their drawings of houses, however, children apply the shape modifier "having flat sides" to represent the shape property "having flat faces," as in the drawing shown in Fig. 6.1b. The fact that in this drawing of a house the windows are joined to the corners suggests that this drawing is still based on a denotation system in which the square region represents the volume of the house as a whole. The combination of straight and curved outlines in the drawing of the glass beaker in which the model house is en-

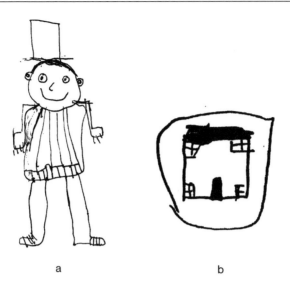

a b

FIG. 6.1. (a) Most of the body parts in this figure are represented using separate re-
gions but the arms and hands, and the legs and feet, are represented together using the
shape modifier "being bent." Collection of the author. (b) The model house is repre-
sented by a round region subject to the shape modifier "having flat sides." The combi-
nation of straight and round outlines in the drawing of the glass beaker in which the
model house is enclosed is perhaps intended to represent the contrast between the
shape of the rim of the glass and the curved sides. Taken from Light and Macintosh
(1980, Fig. 1). Courtesy of P. Light.

closed is perhaps intended to represent the contrast between the shape of the
rim of the glass and the curved sides.

Both these drawings are based on a denotation system in which the re-
gions denote volumes, but in the next stage of development different deno-
tation systems are used for different kinds of objects. Objects that have flat
faces, such as houses, are now drawn using the denotation system: Regions
denote faces.

Within this system the faces of rectangular objects can be shown as true
shapes. However, this system cannot be used to draw smooth objects be-
cause such objects do not have plane faces; therefore, in drawing smooth ob-
jects, children continue for some time to use a denotation system in which
regions denote volumes. Initially, the body parts of objects such as people
and animals are drawn separately using long or round regions with curved
outlines, as in Fig. 6.1a. Drawings of this type look unrealistic, however, be-
cause they suggest that there are abrupt discontinuities between the various
parts of the body. To overcome this disadvantage children resort to a tech-
nique called *threading*. This smoothes out the discontinuities in the outlines,

but it also acts as a shape modifier, so that "having a smooth outline" in the picture begins to represent the shape property "having a smooth surface." Gradually, the shapes of the regions begin to resemble true views, and the denotation system children use to draw smooth objects changes to: Regions denote regions in the visual field.

Thus, for a time the developmental pathways children follow to draw different kinds of objects diverge. Eventually, these pathways come together again when children learn to use a denotation system in which lines rather than regions are used as picture primitives.

Single-Square Drawings

Children's drawings based on a denotation system in which a single square is used to stand for one face of an object such as a house or a cube are common. Nicholls and Kennedy (1992), in an experiment in which nearly 900 children were asked to draw a cube, found that the type of drawing most frequently produced by children up to the age of 8 years was what they called *single-square*. There is, however, no way of telling from their results whether these single squares represented just one *face* of the cube, or whether (as was most probably the case with many of the younger children) this single square represented the cube as a *volume*. However, the results obtained by Willats (1981), in which 64 children ages 6 to 12 years were asked to draw a die from four different points of view, suggest that by the age of about 6 years most children are beginning to draw faces rather than volumes. Six of the sixteen 6-year-olds drew a single square to represent the die, regardless of the view they had of the die. Two of these children produced single-square drawings containing large numbers of dots, and one child produced drawings consisting of dots taken from all the faces in turn. These drawings appeared to represent the volume of the cube as a whole. The other three 6-year-olds, however, drew single-square drawings with the correct number of dots on them representing just one face, similar to the drawing shown in Fig. 6.2.

FIG. 6.2. A drawing of a die representing one face of a cube. Taken from Willats (1981, Fig. 10.2).

Similarly, in Fig. 6.3 the windows of the house are set within the facade rather than being joined to the corners, and in this drawing the single square probably does represent the front face of the house rather than its volume. Drawings of this kind resemble what architects would call *orthogonal projections* (Fig. 6.4).[1]

To determine the projection systems that children use at different ages, I asked children ages 5 to 17 years to draw a scene from a fixed viewpoint (Willats, 1977a). This scene is shown in Fig. 6.5 and consists of a table with three objects on it: a box, a radio, and a saucepan. Each child was tested separately, and Fig. 6.5 shows the scene as it appeared from the child's point of view. (From this point of view one of the back legs of the table was hidden by a front leg. Nevertheless, all the children produced drawings showing four legs.) The drawings produced by the children were then classified in two ways. Drawings in which the side edges of the table were not repre-

[1]This drawing system is commonly employed for engineers' and architects' working drawings because the faces of objects are represented as true shapes. However, orthogonal projection, like all the other projection systems (oblique projection, isometric projection, perspective, and so on) can be defined in two ways, depending on whether we are concerned with picture perception or picture production (Willats, 2003). Definitions of the projection systems given in terms of what is called *primary geometry* are usually more useful for describing picture perception, whereas definitions in terms of secondary geometry are more useful for describing the processes of picture production. In terms of primary geometry, orthographic projection is the system in which the projection rays (representing light from the scene) are parallel and intersect the picture plane at right angles. The primary geometry of this system is shown in Fig. 6.4.

Because the projection rays are parallel in this system, pictures in orthogonal projection approximate to views of objects or scenes taken from an infinite (or at least very great) distance; therefore, there is no change of scale with distance as there is with pictures in perspective. In addition, every object is seen as if from eye level, so that, for example, the seat of the chair shown in Fig. 6.4 is represented by a single line. Edges parallel to the projection rays (such as the side edges of the seat of the chair) are not shown. The ground plane is represented by a single line, which may coincide with the bottom edge of the picture, as it does in the drawing of the house shown in Fig. 6.3. Finally, because pictures in this system provide possible views, objects or parts of objects that are obscured by other objects closer to the viewer must be omitted from the picture (by a process that is known in computing as *hidden line elimination*, or HLE).

In terms of picture production, however, orthogonal projection is often more usefully defined in terms of *secondary geometry*—the geometry of lines and regions on the surface of the picture. In this system, the shapes of faces of objects that are parallel to the picture plane are represented as true shapes, so that the back of the chair shown in Fig. 6.4 is represented by an identical shape in the drawing. Pictures of whole scenes, containing several objects, can be made up using single regions to stand for the front face of each object, and such pictures can also approximate to orthogonal projections.

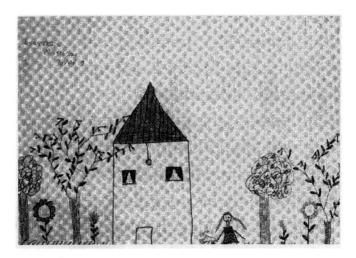

FIG. 6.3. A drawing of a house by a 9-year-old Greek girl. The single square represents the front face of the house. Taken from Golomb (1992, Fig. 159). Courtesy of C. Golomb.

FIG. 6.4. The primary geometry of orthogonal projection. The projection rays are parallel and intersect the picture plane at right angles. Taken from Dubery and Willats (1983, Fig. 8).

sented were judged to be in orthogonal projection. The other drawing systems were judged by measuring the angles that the lines representing the side edges of the table in their drawings made with the horizontal and comparing these with the corresponding angles of these edges in their views of the scene as shown in Fig. 6.5.

FIG. 6.5. Children ages 5 to 17 years were asked to draw this scene from a fixed view-point, and their drawings were classified in terms of the drawing systems they used and their representation of occlusion. Taken from Willats (1977a, Fig. 1).

The children's drawings were also classified according to the way each child represented the points of occlusion visible in the scene, that is, the points in the child's view of the scene where the edge of one object on the table just disappeared behind another. There were six of these points in the child's view of the scene, and these are numbered 1 to 6 in Fig. 6.5.

Each child's drawing was assigned to one of six classes of drawing systems. A few drawings by the youngest children were judged to belong to Class 1, *no projection system*. These drawings were, in effect, based on topological geometry rather than projective geometry. In most of them the spatial order in which objects were portrayed was roughly correct but the objects were represented separately rather than standing on the table, and there was no representation of occlusion. The rest of the drawings were found to fall into five classes: *orthogonal projection, vertical oblique projection, oblique projection, naive perspective,* and *perspective*. Only drawings belonging to the first two of these classes—orthogonal projection and vertical oblique projection—are described in this chapter, whereas drawings in the three remaining projection systems are described in chapter 7. Most children were unable to represent the points of occlusion correctly until the age of about 11 years.

Figure 6.6 shows two drawings of tables, both classed as being in orthogonal projection, in which the front faces of the tables, the box, and the radio are all represented by single faces. The side edges of the table are not represented, and the top face of each table is represented by a single line. However, these drawings appear to be based on different denotation systems. In Fig. 6.6a the legs of the table, the front edge of the table, and the

a b

FIG. 6.6. Drawings of tables classed as being in orthographic projection. In (a) each face is drawn as a true shape, and the objects are represented side by side, avoiding any occlusion of one object by another to preserve these true shapes. Taken from Willats (1977a, Fig. 2). In (b) the radio is drawn in front of the table to partially occlude the box, thus introducing a T-junction at the point of occlusion. Taken from Willats (1977b, Fig. 3).

front faces of the box and the radio are all drawn as true shapes, but the box and the radio are drawn separately, side by side, thus avoiding any representation of occlusion that would destroy the integrity of the shape of the region representing the front face of the box. This suggests that this drawing is based on a denotation system in which regions denote faces.

In Fig. 6.6b one point of occlusion (no. 4 in Fig. 6.5) is correctly represented. This introduces a T-junction, suggesting that this drawing is based on a denotation system in which the smallest units of meaning are lines and line junctions rather than whole regions. Thus, although both these drawings correspond, more or less, to views in orthogonal projection, they appear to be based on different denotation systems.

Fold-Out Drawings

Drawings in which each region denotes the single face of an object are popular with children, but they suffer from the drawback that they only show one face. Children try to overcome this limitation by adding more faces, but when they do this they find it difficult to get the faces, edges, and corners of rectangular objects to join up properly.

In Willats (1981), in which children were asked to draw a die presented to them from four different viewpoints, several of the 8- and 10-year-olds pro-

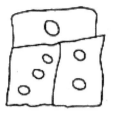

FIG. 6.7. A fold-out drawing of a die, typical of those produced by 8- and 10-year-olds for the condition in which they could see three faces. Taken from Willats (1981, Fig. 10.2).

duced drawings similar to that shown in Fig. 6.7 for the condition in which they could see three faces. Drawings of this kind are known as *fold-out* drawings. Each region represents a single face, and the shapes of the faces are, as far as possible, shown as true shapes. In this drawing the top face is represented by a rectangle rather than a square, probably in an attempt to keep at least the areas of the faces more or less equal. The defining feature of these drawings is, however, that right angles, representing the square corners of the faces, are preserved in the drawing. Nicholls and Kennedy (1992) found that these fold-out drawings were, after single-square drawings, the next most frequent type of drawings produced by 8-year-olds.

Phillips, Hobbs, and Pratt (1978) asked 7-year-olds and 9-year-olds to copy the drawing of a die shown in Fig. 6.8a in which three faces are visible, together with a two-dimensional pattern of similar complexity shown in Fig. 6.9a. They then judged the drawings the children produced as either "correct" or "incorrect." They found that nearly all the children (81% of the 7-year-olds and 90% of the 9-year-olds) copied the pattern correctly, and typical examples of copies that were judged to be correct are shown in Fig. 6.9b. Almost half the 9-year-olds (41%) copied the drawing of the die correctly, and typical examples of their correct copies are shown in Fig. 6.8b. In

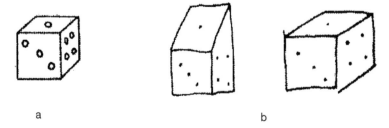

a b

FIG. 6.8. Nearly half of the 9-year-olds (41%) copied the drawing of a die shown at (a) correctly. Typical examples of correct copies are shown at (b). Taken from Phillips et al. (1978, Table 1 and Fig. 3). Courtesy of W. Phillips.

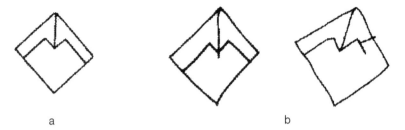

a b

FIG. 6.9. Nearly all of the 7-year-olds (81%) and 9-year-olds (90%) copied the pattern shown at (a) correctly. Typical examples of correct copies are shown at (b). Taken from Phillips et al. (1978, Table 1 and Fig. 3) Courtesy of W. Phillips.

contrast, nearly all the 7-year-olds (85%) copied the drawing of the die incorrectly. Typical examples of the drawings judged to be incorrect are shown in Fig. 6.10b.

Thus, although nearly all the 7-year-olds copied the pattern correctly, most of these children made incorrect copies of the drawing of the die. As Phillips et al. (1978) said, "It is astonishing to see a child copy drawings of cubes using only squares and rectangles but copy similar designs not seen as cubes quite accurately. It is particularly astonishing when the child is looking continuously at the drawing being copied" (p. 27).

The results cannot be explained by saying that squares and rectangles are simply easier to draw than regions with oblique outlines because most of the 7-year-olds were able to copy the patterns containing such regions accurately, nor can the results be explained by saying that fold-out drawings are in some sense stereotypes that children of this age have for drawing cubes. I repeated this experiment, but as well as asking the children to copy a drawing of a die I also asked them to copy a drawing of an unfamiliar object: a cube with a smaller cube removed from one corner. For comparison, I also asked them to

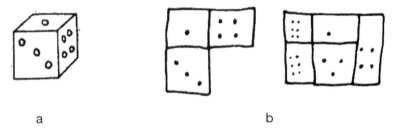

a b

FIG. 6.10. Nearly all of the 7-year-olds (85%) copied the drawing of the die incorrectly, even though almost all of these children were able to copy the pattern correctly. Typical examples of drawings of the die judged to be incorrect are shown at (b). Taken from Phillips et al. (1978, Table 1 and Fig. 4). Courtesy of W. Phillips.

copy a pattern of equal complexity. The results (Willats, 1981) confirmed the finding by Phillips et al. (1978) that children copy pictures of solid rectangular objects less accurately than patterns of equivalent complexity, but the results also showed that this same effect occurs for pictures of an unfamiliar object. This shows that the effect is not the result of children using a stereotype in the form of a "graphic motor schema" as Phillips et al. had suggested.

The explanation for the results obtained by Phillips et al. (1978) is that the 7-year-olds looked at the drawing of the die shown in Fig. 6.8a in which three faces are shown, saw it as a three-dimensional shape, and redrew it in terms of the drawing and denotation systems they currently possessed. Similarly, some of the 8- and 10-year-olds in the experiment in which children were asked to draw a real die looked at the die in the edge-down condition, saw three faces, and represented each face by a square or rectangular region. The denotation system underlying these fold-out drawings is: Regions denote faces, and the drawing system is: Join regions in the picture that represent regions that join in the scene.

Unfortunately, applying this drawing rule results in fold-out drawings in which the edges and corners cannot be made to join up properly and that cannot therefore provide possible views. Children apply these rules to all kinds of objects having plane faces. Figure 6.11 shows a fold-out drawing of

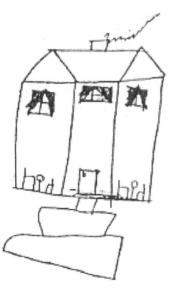

FIG. 6.11. A fold-out drawing of a house. The front and two sides are, as far as possible, shown as true shapes. This drawing also shows transparencies. Taken from Cox (1992, Fig. 6.2). Courtesy of M. Cox.

FIG. 6.12. Simonne Luquet, 6 years 6 months, *A Drawing of a Railway Station*, used by Luquet as an example of rabattement. Taken from Luquet (1927/2001, Figs. 118 and 119).

a house in which the front face and two side faces are all included, and the garden, or perhaps the front steps, are folded down from the front face. This drawing also contains transparencies in the form of the people inside the house. As so often happens with children's drawings, this feature represents, as it were, the fossilized remains of an earlier system in which the regions represented volumes.

As with the single-square drawings, children also apply this fold-out principle to drawings of whole scenes. Luquet (1927/2001) referred to this feature as rabattement (*rabattre* means to fold over or turn down), and Fig. 6.12 shows a typical example in the form of a drawing of a railway station by his daughter Simonne.[2]

Stopping at the Right Moment

The problem with drawings of this kind is that because all the faces of the objects are drawn as true shapes they contain mixtures of viewpoints and cannot therefore provide possible views. One way out of this dilemma, at

[2]Luquet (1927/2001) said of this drawing:

> In a drawing of a station, the main building and the two buildings at its side are folded out on to the ground, so that their vertical axes form a right angle as their facades do in reality; and the street light which stands in front of the central building and the central building itself are drawn upright, but the tram, which is parallel to the side buildings is turned on its side just as they are. (p. 114)

FIG. 6.13. Children's drawings of a cube, classed as being in (a) vertical oblique projection and (b) horizontal oblique projection. Drawing (b) may show one side foreshortened. Typical of drawings produced by children between ages 8 and 9 years. Taken from Willats (1981, Fig. 1.6).

least for relatively simple objects, is to stop drawing at the right moment. Figure 6.13 shows two drawings of a cube, each consisting of two squares. Both these drawings are still, in a sense, fold-out drawings, but because they show only two faces of the cube, either side by side or one above the other, both provide possible views. Developmentally, drawings of this type are more advanced than fold-out drawings. Nicholls and Kennedy (1992) found that the mean age for children drawing fold-out drawings of cubes was 8 years 2 months, whereas the mean age for the two-square drawings was 8 years 7 months.

In terms of primary geometry, drawings of this kind correspond to views of objects or scenes in what Dubery and Willats (1983) called *vertical oblique projection* and *horizontal oblique projection*. Figure 6.14 shows the primary geometry of vertical oblique projection applied to a chair. In this projection system the projection rays intersect the picture plane at an oblique angle in the vertical direction, hence, the name. In terms of secondary geometry, faces in both the vertical plane (such as the back of the chair) and the horizontal plane (such as the seat of the chair) are shown as true shapes.

As with the fold-out drawings, children can also apply this drawing system to their drawings of unfamiliar objects. Figure 6.15 shows two drawings of a cube with a smaller cube removed from one corner classed as being in vertical oblique projection. Figure 6.15a is perhaps best described in terms of secondary geometry. All the faces are drawn as true shapes, and this results in what is called a *false attachment* in the center of the drawing, where the convex edge of the main shape just coincides with the concave edge of the smaller concave shape. As a result, the drawing looks flat. Figure 6.15b, in contrast, looks much more three-dimensional. This is partly because the false attachment in

FIG. 6.14. The primary geometry of vertical oblique projection. The projection rays intersect the picture plane at an oblique angle in the vertical direction, and both the vertical and horizontal faces of objects are represented as true shapes. Taken from Dubery and Willats (1983, Fig. 27).

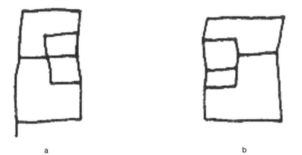

a b

FIG. 6.15. Children's drawings of a cube with a smaller cube removed from one corner, classed as being in vertical oblique projection. In (a) the faces are shown as true shapes, whereas (b) may show foreshortening. Drawing (a) contains a false attachment in the form of a false T-junction, whereas drawing (b) contains one true T-junction. Taken from Willats (1981, Fig. 1.6).

the center has been avoided and partly because the very slightly oblique lines in the drawing suggest edges in depth. Figure 6.15b is thus probably best described as a genuine view in vertical oblique projection.

Figure 6.16 shows a drawing of a table and chair used by Luquet (1927/ 2001) to illustrate rabattement. Only the front and top faces of the table are

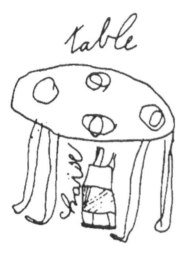

FIG. 6.16. Jean Luquet, 7 years 6 months, *A Table and Chair*, used by Luquet to illustrate rabattement. The table is in vertical oblique projection whereas the chair is a fold-out drawing. Taken from Luquet (1927/2001, Fig. 115).

shown; therefore, this drawing provides something approximating to a view in vertical oblique projection. The chair looks odd, but if the two legs and the ground line at the bottom are removed it corresponds to a drawing of a chair in vertical oblique projection, similar to the drawing of the chair shown in Fig. 6.14 but upside down. Possibly Jean Luquet drew the chair upside down to show it facing the table and then added more legs and a ground line in an attempt to show it the right way up, or possibly he drew it the right way up in the first place and then added the two far legs. As a result, this drawing looks like a fold-out drawing.

Figure 6.17 shows two other drawings of a table, taken from Willats (1977a). Figure 6.17a is probably best regarded as a fold-out drawing in which regions are used to denote faces as true shapes. As in the drawing of the table classed as being in orthogonal projection shown in Fig. 6.6a, the box and the radio have been shown side by side to avoid the representation of occlusion, and the box is a true fold-out drawing. Figure 6.17b is perhaps a little closer to showing a possible view, and the far legs of the table are shown at a smaller scale, as if in perspective. However, the box and the radio have again been separated out instead of showing one behind the other. (The drawing of the box is probably based on a stereotype.)

Vertical oblique projection has its counterpart in the system known as *horizontal oblique projection*. As with many of the drawings in vertical oblique projection, drawings in this system are often best regarded as fold-out drawings

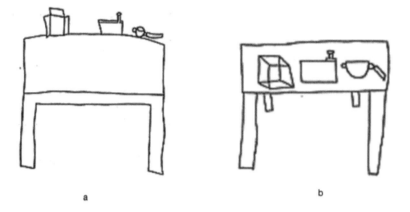

FIG. 6.17. Children's drawings of a table classed as being in vertical oblique projection. In terms of secondary geometry, the denotation system is one in which regions are used to represent the true shapes of faces. Taken from Willats (1977a, Fig. 9).

but with only two faces shown side by side, resulting in a possible view. In the drawings of tables shown in Figs. 6.16 and 6.17, only the two most important faces are shown: the top and front faces. The side faces, being less important, can safely be left out. In drawings of houses, however, it is the front and side faces that are important, and in drawings of houses in horizontal oblique projection, the front face and one side face are shown side by side.

Figure 6.18 shows one such drawing by a 9-year-old Greek girl. As is common in such drawings, the edge of the roof on the right is carried up vertically from the side of the house in an attempt to draw the roof as a true shape.

Threading

The terms *single-square*, *fold-out*, and *two-square* drawings are all applied to drawings of objects having plane faces such as cubes, tables, and houses. Most of the single-square drawings and all the fold-out and two-square drawings are based on a denotation system in which regions denote faces. Developmentally, these types of drawings represent an advance on the earlier system in which regions are used to stand for whole volumes. But whereas the denotation system in which regions denote volumes can be applied to all kinds of objects, whatever their surface shapes, the denotation system in which regions denote faces can only be applied to objects that have plane faces. As a result, objects that have curved surfaces cannot be drawn using this system. How can children represent the shapes of such objects?

FIG. 6.18. A drawing of a house in horizontal oblique projection by a 9-year-old Greek girl. The drawing approximates to a possible view, although the roof is, as far as possible, drawn as a true shape. Taken from Golomb (1992, Fig. 159). Courtesy of C. Golomb.

Many naturally occurring objects such as fruit, people, and animals have curved surfaces that vary smoothly in three dimensions. Objects of this kind are sometimes referred to as smooth objects, and the surfaces of wholly smooth objects have two primary shape properties. The first is that such surfaces vary continuously without abrupt discontinuities such as wrinkles, puckers, or creases (Huffman, 1971). The second is that there are three and only three types of smooth surfaces: *convex* surfaces, such as the outside of an egg; *concave* surfaces, such as the inside of an egg; and *saddle-shaped* surfaces that are convex in one direction and concave in the other.

In practice, of course, the surfaces of fruit, people, and animals often do have discontinuities such as wrinkles, puckers, and creases. Moreover, objects made of cloth may have smooth surfaces but they also have smooth edges, and like smooth surfaces, the shapes of these edges cannot be reproduced directly on the picture surface. Thus, the shapes of smooth objects can be very complex, and representing their shapes in pictures presents a formidable drawing problem.

In early figure drawings each part of the body is represented by a separate region, as shown in Fig. 6.19a, and for the most part the outlines of these regions are convex. As a result, the places where these regions join are repre-

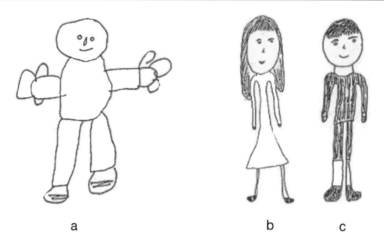

<div align="center">a b c</div>

FIG. 6.19. Threading. At (a) each body part is represented by a separate region. At (b), by an 8-year-old girl, the trunk and arms are represented by regions with a continuous outline. Taken from Cox (1992, Figs. 4.3 and 4.4). Courtesy of M. Cox.

sented by abrupt discontinuities in the outlines, a feature that looks unrealistic. In the next stage of development, children overcome this difficulty by joining the regions using continuous outlines, a feature sometimes known as *threading* (Goodnow, 1977). In the drawing shown in Fig. 6.19b, for example, continuous outlines are used for the neck, shoulders, arms, and trunks of the figures (Cox, 1992, p. 49).

"Having smooth outlines" may be regarded as a shape modifier representing the shape property "having a smooth surface" in the same way that the shape modifier "having straight sides" is used to represent the property "having flat surfaces" in drawings of rectangular objects. To use Arnheim's (1974) terminology, the use of smooth outlines provides a graphic equivalent for representing smooth surfaces. The shapes of the regions enclosed by these outlines, however, are still governed by the extendedness principle, so that the heads of the figures are represented by round regions, the arms and legs by long regions, and the torso of the girl by a long region with the addition of the shape modifier "narrow at the top." The picture primitives in these drawings are thus still essentially regions, even though these regions are now joined together rather than being represented separately.

Similarly, in the drawings shown in Fig. 6.20, the picture primitives are still essentially regions rather than lines. The hat in Fig. 6.20a is touching the head rather than partially occluding it, and in Fig. 6.20b the fingers are only touching the hat and the spoon. Nevertheless, both figures are represented using continuous outlines that are beginning to suggest contours.

a b

FIG. 6.20. (a) By a girl age 8 years 10 months. (b) By a boy age 11 years 3 months. At (a) the hat is touching the head rather than partly occluding it, and at (b) the fingers are only touching the hat and the spoon, suggesting that both drawings are still based on regions as picture primitives. Nevertheless, both figures are represented using continuous outlines that are beginning to suggest contours. Collection of the author.

All the outlines defining the regions in Fig. 6.19a are convex, but in the figure drawings shown in Figs. 6.19b and 6.20 some of the outlines are concave. In Fig. 6.19b the small convex outlines representing what would be the armpits of the boy and the girl are the result of using a continuous outline to join the arms to the bodies, and the larger concave outlines of the girl's dress are probably fortuitous: the region representing the torso has been smoothly enlarged toward the bottom so that it does not overlap the arms. In the figures shown in Fig. 6.20 the concave outlines on the inner sides of the arms are the result of representing the arms as long, bent regions and it is the shapes of these regions that carry meaning rather than the shapes of the outlines. Nevertheless, the presence of concave outlines in all these figure drawings is, developmentally, something new.

Koenderink (1984) proved a general rule that holds for all views of smooth objects: convexities in the contour correspond to convex surface patches and concavities in the contour correspond to saddle-shaped surface patches. Fully concave surface patches cannot be represented. As we shall see, this rule has important implications for the way we interpret line drawings. For example, the concave outlines of the girl's dress in Fig. 6.19b may have come about fortuitously, but in terms of picture perception the draw-

ing looks realistic. Instead of seeing the trunk simply as a long volume, as we do in Fig. 6.19a, we see the shape of this dress as being like a cone with concave sides. A more sophisticated and perhaps more deliberate use of a concave outline to represent a saddle-shaped surface appears in the drawing of a horse by Heidi shown in Fig. 6.21. I have already illustrated one of Heidi's drawings, shown in Fig. 5.14, in which the body, legs, and head/neck are all represented by separate regions, and although the head and neck are represented together, the outlines are either convex or straight. In the drawing shown in Fig. 6.21, however, the body, legs, head, and neck are all defined within a single outline, smoothly curved for the most part and containing two well-defined concavities: one below the neck and the other representing the saddle-shaped surfaces of the top of the body and the saddle itself. This continuous outline still connects well-defined regions, and the legs in particular are still represented as long volumes using long straight regions. Nevertheless, drawings of this kind are beginning to approximate to possible views of smooth objects in the form of *silhouettes*.

In silhouettes, as shown in Fig. 6.22, the outlines correspond to what are called the *occluding contours* of the objects they represent. These contours represent lines joining the points where the line of sight just grazes the surface of an object and thus correspond to the outlines of objects in what is called the *visual field*.

The marks in the silhouette shown in Fig. 6.22 consist of areas filled in with paint or pigment, and there are no lines as such. Nevertheless, the picture primitives in this picture are lines rather than regions because the detailed shapes of the outlines carry information about the shapes of the various objects represented. For example, the convex surface of the cup on the

FIG. 6.21. A drawing of a horse by Heidi, 6 years. The legs are still drawn as long regions, but the saddle-shaped back of the horse's back is correctly represented by a concave region. Taken from Fein (1984).

FIG. 6.22. Charles (Karl) Christian Rosenberg, *Lady Taking Tea*, c. 1795. Painting on glass, 14.0 cm × 16.6 cm. Courtesy of the Holbourne Museum and Study Centre, Bath, England.

extreme left of the painting is represented by a convex outline, and the saddle shape of the back of the chair is represented by a concave outline. In an attempt to show the concave shape of the upper surface of the saucer held by the lady, the artist has represented this surface by a concave outline, but this is not realistic. As Koenderink (1984) has shown, concave surfaces cannot be represented in line drawings.

In contrast, I have suggested that although the marks in Heidi's drawing of a horse shown in Fig. 6.21 are lines, most of the shape information is carried by the shapes of the regions. The outlines of the shapes of the long regions representing the legs are not significant, and although this drawing contains lines within the bounding contours, these do not correspond to the contours of solid shapes but only to internal details such as the edges of the saddle and the horse's mane. For these reasons this drawing is perhaps best described as being based on a denotation system in which regions in the picture denote regions in the visual field. Nevertheless, this drawing is beginning to approximate to a silhouette in which the convex outlines represent convex surfaces and the concave outlines represent saddle-shaped surfaces.

A simpler example of a drawing based on a denotation system in which regions in the picture denote regions in the visual field is provided by a drawing of an apple with a pin stuck through it. In a group of drawings by younger children in Clark's (1897) study, the pin was drawn clear through the apple, suggesting that the region representing the apple denoted its whole volume. In another group of drawings, by older children, of which

FIG. 6.23. A drawing of an apple with a pin stuck through it. The pin is occluded where it passes through the apple, and at first sight this looks like a line drawing showing a view of the apple and pin. However, the concave surface at the top of the apple could not be represented in a true line drawing. This drawing is probably best thought of as being based on a denotation system in which the round region representing the apple denotes a round region in the visual field, with the addition of the shape modifier "having a dent." Taken from Clark (1897, p. 285).

Fig. 6.23 provides an example, the part of the pin inside the apple is omitted from the drawing. The shape of the outline of the apple approximates to a silhouette, but the concave surface at the top of the apple could not in fact be represented in a line drawing. Consequently, this drawing is probably best thought of as being based on a denotation system in which the region representing the apple is intended to denote a region in the visual field, but with the addition of the shape modifier "having a dent."

Foreshortening

Most of the drawings described in this chapter are based on a denotation system in which regions are used as picture primitives. In drawings of rectangular objects the regions denote faces, whereas in drawings of smooth objects the regions denote, first, the volumes of objects, linked by threading, and then, as in Heidi's drawing, regions in the visual field. Using regions as primitives in this way enables children to produce drawings that at least approximate to possible views, but these denotation systems still have serious limitations. The first is that because the shapes of the regions cannot be changed it is difficult to represent the partial occlusion of one object by another. Children seem reluctant to alter the shapes of the regions they use to represent the faces of objects, and as a result they draw each face separately in its entirety. This can be seen clearly in the drawing of a table in orthogonal projection shown in Fig. 6.6a and the two drawings in vertical oblique

projection shown in Fig. 6.17. In all three of these drawings the box and the radio are separated out and shown side by side. In the drawing shown in Fig. 6.6b, the radio is shown partly occluding the box, but as a result the box is now represented not by a rectangular region but by an L-shaped region. Thus, although in this drawing the faces of objects are mostly represented by regions, the denotation system is beginning to change to one in which lines are used to represent edges. Similarly, in the threading drawings of the boy and girl shown in Fig. 6.19 there is no representation of occlusion, and even in Heidi's drawing of a horse shown in Fig. 6.21 there is only one tentative and insignificant representation of partial occlusion where the body of the horse overlaps one of the front legs. The representation of occlusion is the strongest of all depth cues in pictures; therefore, the avoidance of the representation of occlusion in these drawings tends to make then look flat.

Because children are reluctant to change the shapes of the regions representing the faces of objects with plane faces they are unable to solve the problem of representing more than two faces at a time. This results in the fold-out drawings, and however hard they try, they cannot get the faces, edges, and corners to join up properly. At the most, they are prepared to use rectangular regions to stand for square faces, as in the drawing of a die shown in Fig. 6.7, but they cannot, at this stage, bring themselves to change the shapes of the regions by introducing oblique lines. Thus, the problem of representing all three faces of an object, in systems such as oblique projection or perspective, can only be solved by using lines rather than regions as picture primitives.

Finally, using regions as picture primitives makes it difficult to represent the foreshortening of long objects such as arms and legs satisfactorily. Figure 6.24 shows a pair of drawings produced by a 7-year-old girl in an experiment (Willats, 1992a) in which children were asked to draw sticks (the arms of a figure) and disks (a plate) in both foreshortened and nonforeshortened positions. Representing disks in the foreshortened condition (i.e., from edge on) does not present much of a problem because representing a disk by a long region is just as good as using a round region, although neither solution is very effective. In the event, about two thirds of the children in this age group used a round region to represent the plate when it was shown face on and a long region to represent it when it was shown edge on. Representing foreshortened views of sticks within a system based on regions as picture primitives is, however, another matter. Fewer than one fourth of the 7-year-olds in this experiment were willing to use small round regions to represent arms when they were shown end on, and some of these children were clearly dissatisfied with this solution. One girl, whose drawings are shown in Fig. 6.24,

FIG. 6.24. A child's attempts to represent foreshortening: a pair of drawings by a girl, 7 years 7 months. Regions are used to represent both the arms and the plate, and changes of shape are used to represent foreshortened views (the drawings produced for the fore-shortened conditions are highlighted). This girl was reluctant to use round regions to represent the arms in the foreshortened position, and after finishing the drawing pointed to the small circles and said, "Those are his arms!" Taken from Willats (1992a, Fig. 5).

pondered for some time before using two small circles to represent the arms, and when she had finished looked up at me, pointed to the circles, and said, "Those are his arms!"

The results of this experiment show that the difficulty that children have in representing foreshortened views of sticks is not the result of any difficul-ties that they might have in *seeing* objects in foreshortened positions, as Piaget and Inhelder (1956) argued. If this were the case, they would encoun-ter the same difficulties in representing foreshortened disks as they do in representing foreshortened sticks. Instead, the difficulties arise from the limitations of the representational systems that children use at this stage of development. Nor do children have any difficulties in seeing one object in front of, and partly occluding, some other object. Thus, the difficulties chil-dren have in representing partial occlusion and foreshortening arise from their use of denotation systems based on regions as picture primitives, and this limitation can only be overcome by adopting a denotation system in which lines rather than regions are used as picture primitives.

Lines, Line Junctions, and Perspective

> *How cunningly imagined is the device by which objects so varied in size as an orange and an island can be depicted within the narrow compass of a porcelain plate without the larger one completely obliterating the smaller or the smaller becoming actually invisible by comparison with the other!*
>
> —Ernest Bramah, *Kai lung's Golden Hours,*
> *The Story of Wong Ts'in and the Willow Plate Embellishment*

In chapter 1, I stressed the importance of distinguishing between the marks in children's drawings and the picture primitives that these marks stand for. Picture primitives, the units in pictures that carry meaning, are represented in pictures by physical marks such as lines of ink or pencil, blobs of paint, or the lines of stitches in a sampler. Except in unusual circumstances, however (as when we view an Impressionist painting from up close), we do not normally pay attention to the marks but see through them to the picture primitives for which they stand. In much the same way we rarely pay attention to the actual sounds people are making when they speak because we only listen to their meanings. The dimensions of the marks used in pictures may in practice be different from the dimensions of the primitives they represent. For example, the one-dimensional lines in a picture may be realized physically using small pieces of mosaic or knots of wool—marks that are, in themselves, zero-dimensional. Conversely, marks in the form of one-dimensional lines in a picture may be used in hatching to represent zero-dimensional optical features, such as the continuously varying tones in the cross-sections of the light rays coming from areas of tonal modeling or cast shadow. Sometimes the picture primitives represented may not be present

at all but are only implied by marks. In the 18th-century silhouette shown in Fig. 6.22, for example, the marks are areas of paint but the meaning of the picture lies in the shapes of the lines enclosing these areas, even though there are no lines that are physically present.

In the earliest drawings, described in chapter 3, this distinction may be somewhat artificial; the lines and patches of scribble in these drawings can be understood as standing directly for objects or actions. But in the next stage of development, described in chapter 4, a dramatic change takes place in the nature of the marks children use. Instead of using patches of scribble to denote objects or parts of objects, children use areas bounded by lines, and to make sense of these drawings it is essential to realize that these bounded areas stand for regions, which in turn denote volumes in the scene. The detailed shapes of the lines in the tadpole figures, for example, have little significance; it is only the shapes of the regions that carry meaning—long regions being used to denote the long volumes of arms and legs, and round regions being used to denote round volumes such as the head or head/body. This change in the mark system from patches of scribble to areas bounded by lines leaves children free to use patches of scribble to stand for textured features such as hair or smoke. In practice, it may be difficult to decide in individual cases whether the outlines carry meaning or whether they are only accidental. In general, however, making sense of children's drawings in these early stages depends on realizing that the lines in their drawings do not denote edges and contours, or thin, wire-like forms, as they would in adult drawings, but only define the boundaries of regions as picture primitives.

This use of lines as marks and regions as picture primitives persists for a long time. At first, round and long regions are used only to denote round and long volumes. In the next stage of development, described in chapter 5, shape modifiers are added to the regions to represent properties such as "being bent," "being pointed," or "having flat sides," so that objects such as cubes or houses are no longer represented by round regions but by square or rectangular regions. At about the same time, either long or round regions may be used to denote flat volumes, such as a wheel or the brim of a hat.

The next major change to take place, at least so far as the representation of rectangular objects is concerned, lies in the use of regions as picture primitives to denote faces rather than volumes. This results in the fold-out drawings, described in chapter 6, in which each region denotes a face and represents its true shape. The mark system, however, remains the same, and lines are still used only to define the boundaries of regions. In these fold-out drawings individual line segments cannot be identified with particular edges. This poses a problem because within this denotation system the

edges and corners of rectangular objects cannot be made to join up properly. Nor can this denotation system be used for representing smooth objects such as people, animals, and fruit because these objects do not have flat faces. To represent objects of this kind children are obliged to retain an earlier denotation system, in which the regions denote volumes, but they compensate for its shortcomings by adding more and more shape modifiers. Developmentally, the most important of these is the shape modifier "having a smooth outline" to represent the shape feature "having a smooth surface." This results in the so-called threading drawings in which the outlines of the individual parts flow smoothly into one another instead of being drawn separately as they are in the tadpole figures and their immediate successors. In drawings of this kind the detailed shapes of the lines bounding the regions are still of secondary importance, and even in a drawing such as Heidi's horse (Fig. 6.21) it is the shapes of the regions that carry most of the meaning. However, because such drawings are beginning to approximate to views, we can say that in drawings of this kind the regions denote regions in the visual field.

Eventually, these drawings of smooth objects come to resemble the outlines of true silhouettes, and at this point both the mark systems and the denotation systems undergo radical changes. The marks in these drawings are still lines, but instead of serving just as the boundaries of areas, these lines come to stand for lines as picture primitives. At the same time, the denotation system changes and the lines as picture primitives come to stand for contours. At first, only the bounding contours of smooth objects are drawn, but then the contours of surfaces within the outline are added, and this involves the introduction of two new kinds of picture primitives: the line junctions. In drawings of smooth objects, T-junctions are used to denote points of occlusion, where one form overlaps another, and end-junctions are used to denote the points where contours end within the outlines of the image.

The mark systems and denotation systems in drawings of rectangular objects also change. The lines, as marks, now stand for lines as picture primitives, and these lines now denote edges. This leaves children free to distort the regions denoting faces and so solve the problem of the fold-out drawings. This change has a profound effect on the drawing systems children are able to use. Single-square drawings of cubes and houses correspond to views in orthogonal projection, and two-square drawings of cubes and tables may correspond to views in horizontal or vertical oblique projection, but in reality such drawings are still based on topological geometry and represent only such spatial relations such as enclosure, the join relationship, and spatial order. By changing to a denotation system in which lines denote edges, chil-

dren can use lines to represent edges in the third dimension, and this enables them to produce drawings in genuine projection systems such as oblique projection and perspective that show objects from a general direction of view.

In this chapter I describe the developmental changes that come about as the result of using lines rather than regions as picture primitives. Figure 7.1a shows a photograph of the model kangaroo used in an experiment (Reith, 1988) designed to test children's ability to draw contours. Figure 7.1b shows this photograph reduced to a silhouette, with the area enclosed by the outlines of the photograph filled in with ink.

Although the marks in this silhouette are areas of tone, the picture primitives are lines, and the shapes of these outlines carry detailed information about the surface shapes of the model kangaroo. In Fig. 7.2a these picture primitives are represented by lines as marks. The shape information carried by these lines is exactly the same as that carried by the outlines of the silhouette. The convex line representing the contour of the upper part of the back of the kangaroo represents the convex surface of the model at this point, whereas the convex lines at the top of the figure represent the smooth edges of the ears. The concave line representing the lower part of the back and its junction with the tail shows that at this point there is a saddle-shaped surface patch. However, although the filled-in silhouette shown in Fig. 7.1b and the outline silhouette shown in Fig. 7.2a carry the same shape information, the outline silhouette looks less realistic. Notice that the shapes of the regions in these silhouettes are not very informative.

a b

FIG. 7.1. (a) A photograph of the model kangaroo used by Reith (1988) in his experiment on the use of contour lines in children's drawings. (b) This photograph reduced to a silhouette, in which the boundaries represent the bounding contours in a view of the scene. Taken from Reith (1988, Fig. 1).

a b

FIG. 7.2. (a) Lines representing the boundaries of the silhouette. (b) A child's drawing of the model shown in Fig. 7.1a (perhaps taken from a different vantage point) classified by Reith (1988) as showing a simple global contour. Taken from Reith (1988, Fig. 2).

Figure 7.2b shows a child's drawing of the kangaroo, assigned by Reith (1988) to the class he called *simple global contour*. Describing drawings of this kind Reith commented that:

> The drawing consists of a single closed figure formed by modulated segments placed end to end. The subject treats the model as a single volume instead of dividing it into parts. He centers on its outer contour which he follows with his eyes as he draws. (p. 90, Fig. 2)

Although this drawing is much cruder and much less appealing than Heidi's drawing of a horse, and less convincing as a representation, it does correspond to an outline silhouette in which the lines denote the contours of the figure, whereas in Heidi's drawing the picture primitives are still, effectively, regions. Even without Reith's observation that "he centers on its outer contour which he follows with his eyes," we would still be inclined to describe this as an outline silhouette because the shapes of some of the regions enclosed are not very meaningful: the shapes of the lower part of the body, for example.

Figure 7.3 shows two drawings of the same model belonging to the class defined by Reith (1988) as *contours with added and embedded schematic forms*.[1] By

[1]Reith's (1988) rationale for giving this name to drawings in this class is as follows:

> Although much of the drawing consists of modulated forms following the contour of the model, many of the parts and details are represented by schematic forms. These are either added on the outside or the inside of the contour lines, or are embedded within them. The subject tries to reproduce the model's visual appearance but tends to use schematic forms to represent familiar parts. (pp. 91–92)

a b

FIG. 7.3. Children's drawings of the same model classified as showing contours with added and embedded schematic forms. Taken from Reith (1988, Fig. 2).

schematic forms, Reith meant the kinds of regions that make up the tadpole figures and their immediate successors, that is, convex regions, which may be subject to shape modifiers such as "being bent" but are not linked to other parts of the body by threading. For example, in Fig. 7.3a we can think of the body and tail of the kangaroo as forming a silhouette, but one back leg has been added separately, embedded within the contour, and one arm has been added inside the main contour. Similarly, in the drawing shown in Fig. 7.3b the head and body are represented together in silhouette, but the legs and arms have been added separately.

Developmentally, Reith's (1988) description of these drawings makes good sense: schematic forms representing individual body parts have been added to the basic silhouette. In formal terms, however, I prefer to describe these two drawings as containing mixtures of true and false *line junctions*. The names for these junctions were introduced by workers in the field of artificial intelligence such as Clowes (1971) and Huffman (1971), who wanted to give precise descriptions of line drawings of both smooth objects and rectangular objects so that they could be analyzed automatically by computers.[2]

Drawings of more complex objects may include additional types of junctions. For example, line drawings of objects with smooth edges (such as drapery) may also contain merge-junctions where the contours of folds join edges. Figure 7.4 shows a line drawing of a piece of cloth in which e and f

[2]As Huffman (1971) showed, line drawings of solid objects with smooth surfaces contain two and only two types of line junctions: T-junctions and end-junctions. According to Huffman, these junctions constitute the "alphabet" of a simple picture language in which the T-junctions denote points of occlusion (the points in the view of an object where the contour of one object just disappears behind another object), and the end-junctions denote the points where contours end within the outer boundaries of the drawing.

FIG. 7.4. Types of line junctions in drawings of a smooth surface with edges. a and b indicate merge-junctions where contours merge into edges, e and f indicate end-junctions denoting the points where the contours of folds end within the form, and T indicates T-junctions denoting points of occlusion. Taken from Huffman (1971, Fig. 16).

mark the end-junctions, a and b mark the merge-junctions, and a T marks the T-junctions. The single and double arrows are used to show on which side of a line the occluding surface lies. Going around the drawing in the direction of an arrow, the occluding surface lies on the right-hand side.

Huffman (1971) showed that there are definite rules governing the ways these line junctions may and may not be connected if pictures containing them are to provide views of possible objects. He compared these rules with the grammatical rules in natural languages. For example, the sentence "The dog bit John" is a grammatical sentence in English, whereas the sentence "The bit John dog" is not grammatical.

Similarly, line drawings in which the line junctions are not connected according to the rules described by Huffman (1971; i.e., drawings that contain what he called "forbidden configurations") do not provide pictures of possible objects. Figure 7.5 shows one such drawing, representing what Huffman called "an impossible object." Huffman explicitly likens such drawings of impossible objects to nonsense sentences, but the rules they break are not arbitrary (as they are in natural languages) but are derived from the laws of optics and the nature of the physical world. One important rule, for example, is that a line cannot normally have more than one meaning along its length. The drawing shown in Fig. 7.5 breaks this rule because the central, continuous line representing a smooth edge has an occluding surface to one side at one end and another occluding surface to the other side at the other end. In the real world this would be impossible. Locally, we interpret the two merge-junctions on either side of the drawing as representing the edges of a smooth, shell-like form, but the configuration of lines and T-junctions

FIG. 7.5. A line drawing of an impossible object. The drawing breaks the rules for pictures of smooth objects with edges because the central continuous line changes its meaning along its length. Taken from Huffman (1971, Fig. 18).

in the center of the drawing contradicts this interpretation, so that overall the drawing represents an impossible object.

Similarly, the child's drawing of the model kangaroo shown in Fig. 7.3b, repeated here as Fig. 7.6, contains a mixture of possible and forbidden configurations. For example, the line at the bottom of the figure that represents the contour of the lower part of the body and the leg on the left changes its meaning at the point marked by an asterisk. Going along this line from left to right, the presence of the T-junction before the asterisk shows that the occluding surface must lie to the left of the line. Once past the asterisk, however, the presence of the two T-junctions marking the points where the leg occludes part of the pouch shows that the occluding surface now lies to the right of the line. Similarly, at a point marked by the asterisk at the top of the figure, the line representing the contour of the head changes its meaning at a

FIG. 7.6. A child's drawing containing at least two forbidden configurations of line junctions marked by asterisks. The line at the bottom left of the figure changes its meaning as it moves around the lower part of the body to the leg, and a line at the top of the figure changes its meaning as it moves from the head to the arm where four lines meet. Adapted from Reith (1988, Fig. 2).

point just below the T-junction, and the merge-junction is anomalous. Thus, although the shapes of the contours in this drawing are realistic, the combination of line junctions is not, so that the drawing as a whole represents an impossible object.

Figure 7.7 shows two drawings in Reith's (1988) final class, which he called *complex contour with embedded parts*. Figure 7.7a is almost correct in terms of the combinations of line junctions, but the merge-junction in the center of the figure is suspect, and the contour of the right leg touches the contour of the lower part of the back, resulting in a false attachment. Both these anomalies are marked with asterisks. In Fig. 7.7b, however, all the lines and line junctions are used correctly, so that although the actual shapes of the parts are clumsy, the drawing is convincing as a picture of a smooth object. The merge-junction at the top of the figure, for example, correctly represents the point where the edge of the ear joins the contour, and the two end-junctions representing the points where the contours of the nose and muzzle end are also realistic. Reith did not give mean ages for his classes, but his Fig. 3 shows that drawings of this kind were typically produced by 8- and 9-year-olds.

The drawings of kangaroos illustrated by Reith (1988) were drawn from a model, but the two drawings shown in Fig. 7.8 were drawn from either memory or imagination. Both these drawings contain T-junctions, notably in Fig. 7.8a where the T-junctions denote the points where the hand partly occludes the brim of the hat. Both these drawings also contain end-junctions where the arms meet the body, although these may be largely fortuitous and simply represent the ends of the lines separating the arms from the body. The combination of a T-junction and an end-junction halfway

a b

FIG. 7.7. Children's drawings of the model kangaroo classified as complex contour with embedded parts. (a) The merge-junction in the center of the figure is suspect and there is a false attachment to the left of the figure (these anomalies are marked by asterisks). (b) All the combinations of lines and line junctions are correct, so that this drawing convincingly represents a possible object. Adapted from Reith (1988, Fig. 2).

a b

FIG. 7.8. (a) A drawing of a man with a hat by a girl age 10. (b) A drawing of a pirate by
a girl age 10 years 10 months. Figure 7.8a contains two correct T-junctions representing
points of occlusion where the fingers overlap the hat. Both drawings contain end-
junctions where the arms meet the body, although these may be largely fortuitous, sim-
ply representing the ends of the lines separating the arms from the body. The lawful
combination of a T-junction and an end-junction halfway down the arm on the right of
Fig. 7.8b is probably also fortuitous.

down the arm on the right of drawing Fig. 7.8b is correct, and does suggest
the three-dimensional shape of the sleeve at this point, but is probably also
fortuitous.

In contrast, all the configurations of line junctions in the drawing of a
man by a talented 8-year-old girl shown in Fig. 7.9 are both convincing and
correct. The visible contour at the end-junction where the right leg of the
figure meets the body is slightly concave and represents the contour of a sad-
dle-shaped surface at this point.[3] As a result this provides a much more real-
istic representation than that provided by the straight line ending in an end-
junction where the legs meet the body in Fig. 7.8a.

[3]Koenderink and van Doorn (1982) showed that visible contours must always end in a law-
ful manner: the visible contour must be concave at its ends and the corresponding part of the
rim must lie in a saddle-shaped surface patch.

FIG. 7.9. A detail of a drawing by Kate, 8 years. All the configurations of line junctions are correct. Reproduced from *Patterns of Artistic Development in Children* by Constance Milbrath, 1998, Fig. 4.13, New York: Cambridge University Press with author's permission.

Foreshortening

Using line junctions correctly enables children to solve nearly all the problems associated with representing smooth objects. One major problem concerns the representation of foreshortening. This cannot be solved effectively within a denotation system in which regions are used to represent volumes or regions in the visual field because within this system the extendedness of the regions used as picture primitives has to reflect the extendedness of the volumes or regions in the visual field they denote. The 7-year-old girl who produced the drawing shown in Fig. 6.24, and pointed doubtfully at the small circles representing the arms of the model in the foreshortened condition, was well aware of this problem. These round regions represented a true view of the foreshortened arms but could not provide an effective representation. Figures 7.10 and 7.11 show how this problem can be solved by the use of lines and line junctions as picture primitives. In Fig. 7.10 the arms are in a fully foreshortened position, so that the regions representing a foreshortened view are round rather than long. However, the appropriate use of merge-junctions, where the edges of the ends of the arms meet the contours of the sides, ensures that we see the arms as being long in the scene.

Figure 7.11 shows a different solution used by an 11-year-old. Here, the regions defined by the outlines are long rather than round, but the oblique lines used to represent the contours of the arms show us that the arms lie at

a b

FIG. 7.10. A pair of drawings by a boy, 12 years 1 month. The arms are drawn using merge-junctions to represent the points where the contours of cylinders representing the arms meet the edges of the ends of the cylinders. Both the arms and the plate are shown fully foreshortened. Taken from Willats (1992a, Fig. 7).

a b

FIG. 7.11. A pair of drawings by a boy, 11 years 10 months. The drawings of the arms and the plate both contain merge-junctions where the contours of the cylinders meet the edges. The arms are shown partially foreshortened and the plate fully foreshortened. Taken from Willats (1992a, Fig. 6).

right angles to the body of the figure; that is, they are in a foreshortened position with respect to the figure.

The use of lines and line junctions rather than regions as picture primitives thus provides a powerful and effective way of representing foreshortening. Figure 7.12 shows how this denotation system was used by a talented 9-year-old girl in her drawings of dogs.

Finally, Fig. 7.13 shows one of Nadia's drawings of horses, produced at about age 6. (Nadia was an autistic child with exceptional drawing ability.) What is so remarkable about her drawings is not so much that they are in perspective but that she was able to use a denotation system in which lines

a b

FIG. 7.12. Details showing foreshortened views of dogs, taken from *Self-Portrait With Dogs* by Joanne Hudson, 9 years. In (a) the muzzle is foreshortened and in (b) the body is foreshortened. Courtesy of Doreen and Frank Hudson and Longman Education.

FIG. 7.13. Nadia, about 6 years, *A Drawing of a Horse* (detail). Reprinted from Selfe (1977, Fig. 20), with permission from Elsevier.

denote contours, and T-junctions and end-junctions denote points of oc-
clusion. By using this system she was able to represent foreshortening very
effectively.

Concave Surfaces

Another drawing problem that the use of lines and line junctions as picture
primitives can solve is the representation of concave surfaces. Clark (1897)
gave children the task of drawing an apple, an object with a smooth surface
that is mainly convex but has a concave dent at the top. The younger chil-
dren, who used a denotation system in which regions were used to represent
volumes, solved this problem by drawing a round region with a dent at the
top, using a continuous outline to define the shape of this region. Although
this results in the convincing representation of an apple shown in Fig. 6.23, a
drawing of this kind does not provide a possible view because, as Koen-
derink (1984) has shown, the contours of concave surfaces cannot be di-
rectly represented in line drawings. A drawing illustrated by Clark (Fig.
7.14a) suggests that at least one of the children in his experiment was aware
of this problem. The contour of the apple is, correctly, represented by a
wholly convex line, but two more lines have been added in an attempt to
represent the shape feature "having a dent." In contrast, Fig. 7.14b shows a
true view of the apple in which the two end-junctions are joined by a con-
cave line representing the saddle-shaped surface where the convex surface
of the main body of the apple changes to a concave dent.

a b

FIG. 7.14. (a) A correct view of the outer contour of the apple represented by a wholly
convex line, but two more lines have been added in an attempt to show the shape fea-
ture "having a dent." (b) A true view of the apple in which the two end-junctions are
joined by a concave line representing the saddle-shaped surface where the convex sur-
face of the main body of the apple changes to a concave dent. Taken from Clark (1897,
p. 285).

Rectangular Objects

Lines and line junctions also play an important role in children's drawings of rectangular objects. Drawings of rectangular objects include four and only four types of line junctions: L-junctions, Y-junctions, arrow-junctions, and T-junctions. All these junctions are present in the drawing shown in Fig. 7.15a. On the extreme left there is an arrow-junction at the top and an L-junction at the bottom, and in the middle left there is a Y-junction. All these junctions denote corners. Finally, there is a T-junction in the center of the drawing where the front face partially occludes a concave edge. Huffman (1971) likened these junctions to the alphabet of a simple picture language, and as with line drawings of smooth objects, there are rules governing the ways these junctions may and may not be connected to produce pictures of possible objects.

Whether a drawing represents a possible or impossible object, or whether the drawing is ambiguous, depends on the way these rules are used, very much as the way the rules of grammar are used decides whether a sentence is unambiguous, ambiguous, or meaningless. Thus, "The dog bit John" is unambiguous but "The police were ordered to stop drinking after midnight" is ambiguous and can be interpreted in four ways. It is not clear whether it is the police or some other people who are to stop drinking, or whether the drinking is to stop after midnight, or if that was when the order was given.

Similarly, the drawing shown in Fig. 7.15b is ambiguous and can be interpreted in three ways: as a cube with a smaller cube removed from one

a b c

FIG. 7.15. Line junctions in line drawings of rectangular objects. Drawing (a) contains a T-junction and is unambiguous (i.e., there is only one credible way of interpreting it as a drawing of a possible object). Drawing (b) is ambiguous and can be interpreted in three ways: as a cube with a smaller cube removed from one corner, as a small cube stuck up into the corner of a ceiling, and as a cube with a smaller cube sticking out at an odd angle. Drawing (c) represents an impossible object. Taken from Willats (1997, Fig. 5.6).

corner, as a small cube stuck up into the corner of a ceiling, and as a cube with a smaller cube sticking out at an odd angle. By an effort of will, these interpretations can be changed from one to the other. Figure 7.15a, however, is unambiguous because the T-junction in the center shows that the front face of the cube must be in front of the concave edge in the center of the drawing. Figure 7.15c represents an impossible object because the combination of the two T-junctions and the arrow-junction on the right of the drawing cannot occur in a projection of a real object.

Projection Systems

Using lines rather than regions as picture primitives is important developmentally because it solves the problem posed by the fold-out drawings. This problem arises because when regions are used to represent the true shapes of faces and more than two faces of a rectangular object are shown, it is impossible to get the corners to join up properly. Figure 7.16 shows three examples of the ways children attempt to overcome this. In Fig. 7.16a four faces have been drawn as true shapes, and then two oblique lines have been added in an attempt to pull the corners together. In Fig. 7.16b the overall shape of the die has been represented by a square, but to get the three visible faces included, the top face has been drawn as a triangle and the other two faces have been distorted. In a last, desperate attempt to preserve at least the right angles in the shapes of the faces, and still get the corners to join up, the outlines of the regions in Fig. 7.16c have been curved. These are just three of the many ways children attempt to solve this problem. Caron-Pargue (1985), Nicholls and Kennedy (1992), and Phillips et al. (1978) give many more examples.

The anomalies in the form of fold-out drawings arise as a result of children using a denotation system in which regions represent faces. By defini-

a b c

FIG. 7.16. Children's attempts to solve the problem posed by fold-out drawings of cubes. (a) The corners at the top are pulled together by lines. (b) The die as a whole is represented by a square but the top face is represented by a triangle. (c) The outlines of two of the regions are curved in an attempt to preserve the right angles at the corners.

FIG. 7.17. A drawing of a cube in oblique projection. The front face of the cube is drawn as a true shape and the oblique lines representing edges in the third dimension are drawn as true lengths.

tion, the shapes of the faces are the scene primitives; therefore, these shapes have to be represented by true shapes in the picture. By using lines as picture primitives this problem can be solved, as Fig. 7.17 shows. Now the shapes of the regions representing faces can be drawn as true views, and the lines representing edges can be drawn as true lengths. This results in the drawing system known as *oblique projection*. Using this system, in which oblique lines are used to represent edges in the third dimension, enables children to draw possible views of rectangular objects.

Oblique projection is a frequently used drawing system in both adult pictures and children's drawings. Nicholls and Kennedy (1992) found that 58% of the adults who were asked to draw cubes produced drawings in oblique projection. If we add drawings in isometric projection (a variant of oblique projection in which all the edges of a cube are represented by oblique lines), the figure rises to 82%. Oblique projection was also the drawing system most commonly used by children over age 8.[4]

[4]As with orthogonal projection and horizontal and vertical oblique projection, oblique projection can be defined in terms of either primary or secondary geometry. In terms of primary geometry, the projection rays are parallel and strike the picture plane at an oblique angle in both the horizontal and vertical directions. Pictures in oblique projection thus correspond to views of scenes taken from a considerable distance but viewed from an oblique angle. In terms of secondary geometry, oblique projection can be defined as the drawing system in which the front faces of objects are drawn as true shapes but the side faces are distorted and edges in the third dimension are represented by parallel oblique lines (the "orthogonals" as they are called). Thus, as with all the other projection systems, definitions given in terms of primary geometry are usually more appropriate for describing picture perception, whereas definitions in terms of secondary geometry are more appropriate for describing picture production (Willats, 2003).

In a replication of Willats (1977a), Jahoda (1981) asked both schooled and unschooled adults in Ghana to draw a table with three objects on it. Like Willats, Jahoda found that the most commonly used system was vertical oblique projection: forty-five of 77 adults produced drawings in this system. Again, as in Willats's experiment, the next most commonly used system was orthogonal projection. However, 7 participants, all but one of them university students, produced drawings in oblique projection; one of these is shown in Fig. 7.18. The orthogonals used to represent the side edges of the table and the two boxes all run in different directions, however, and this suggests that in this drawing the oblique projections are better described in terms of secondary geometry rather than primary geometry.

Court (1992) also replicated Willats's (1977a) experiment, but with rural Kenyan children as participants. Figure 7.19 shows three drawings by a girl age 13. These drawings are in the system known as *inverted perspective* or *divergent perspective* in which the orthogonals diverge, rather than being parallel as they are in oblique projection or converging as they do in normal perspective. Court found that this system was widely used by Kenyan children for drawing tables.

Drawings in inverted perspective cannot provide possible views, but in terms of secondary geometry they can be defined by saying that diverging oblique lines are used to represent edges in the third dimension. In the drawings shown in Fig. 7.19, however, the three objects on the table are rep-

FIG. 7.18. A drawing of a table in oblique projection produced by a university student in Ghana. Taken from Jahoda (1981, Fig. 3b). Reprinted by permission of The Experimental Psychology Society, Taylor and Francis Ltd., http://www.tandf.co.uk/journals, and courtesy of G. Jahoda.

FIG. 7.19. Three drawings of tables in inverted perspective by a Kenyan girl Milka Adhiambo age 13. Taken from Court (1992, Fig. 20). Collection of Elsbeth Court.

resented by separate regions, suggesting that the picture primitives are regions rather than faces. Thus, these drawings can also be thought of as fold-out drawings of a table but with the regions distorted to get the corners of the tabletops to join up properly.

Figure 7.20 shows a drawing that Willats (1977a) classified as being in oblique projection. The oblique lines representing the side edges of the table are more or less parallel, and lines joining the bottom of the table legs would run in the same oblique direction. The mean age of the children who produced drawings in oblique projection was 13 years 7 months.

Figure 7.21 shows an example of a drawing belonging to the system that Dubery and Willats (1972, 1983) called *naive perspective*. In this system the

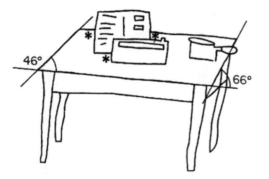

FIG. 7.20. A drawing of a table in oblique projection produced by an English child. The mean age of children who produced drawings in oblique projection was 13 years 7 months. Taken from Willats (1977b, Fig. 5).

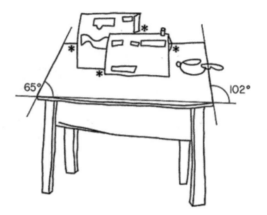

FIG. 7.21. A drawing of a table in naive perspective. Drawings in this system give the impression of being in perspective but are actually made up of combinations of oblique projections. Taken from Willats (1977b, Fig. 6).

orthogonals converge, but not to a regular central vanishing point, so that pictures in this system can be regarded as being made up of combinations of oblique projections. In the drawing of the table shown in Fig. 7.21, for example, the orthogonals on the left are parallel and run up toward the top right, whereas the orthogonals on the right are parallel and run up toward the top left. Thus, although this drawing gives an impression of being in a crude version of perspective, it is actually made up of two versions of oblique projection. The mean age of children who produced drawings in this class in Willats's experiment was 14 years 4 months.

Finally, Fig. 7.22 shows a child's drawing of the table in more or less true perspective. The lines representing the side edges of the tabletop and the lines joining the bottoms of the table legs all converge, if not to a single vanishing point, at least to a relatively small area in the picture. The box, however, might perhaps be better described as being in oblique projection. The surface geometry of the drawings in this class corresponded fairly accurately to the geometry of the children's view of the scene they were asked to represent.

In formal terms, the drawings described in chapters 3 to 7 illustrate a sequence of changes in the mark systems, the denotation systems, and the drawing systems on which they are based. The marks in these drawings are predominantly lines, but the meanings of the marks change during development. At first, these lines form patches of scribble, standing for long or round regions as picture primitives. Then, with the tadpole figures, single

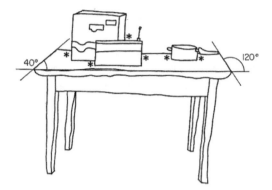

FIG. 7.22. A drawing of the table in perspective. The lines representing the side edges of the table and the lines joining the bottoms of the table legs all converge to a relatively small area on the picture surface. Taken from Willats (1977b, Fig. 7).

lines are used as outlines to define the boundaries of regions. Finally, lines as marks are used to stand for lines as picture primitives.

The denotation systems represented by these marks also change. Throughout most of the developmental sequence the picture primitives are regions. At first these regions stand for whole volumes. Then, in drawings of rectangular objects such as the fold-out drawings, the regions in the picture come to stand for the faces of objects in the scene. Finally, the problems posed by these fold-out drawings is solved by using lines to denote edges and line junctions to denote corners and points of occlusion. In pictures of smooth objects the denotation system in which regions stand for volumes persists for a longer period, but when children connect the lines defining the boundaries of the regions through threading, these drawings come to resemble regions in the visual field. Finally, the lines come to denote the smooth contours of objects, with T-junctions denoting points of occlusion and end-junctions denoting the points where contours end.

In the earliest drawings the spatial relations between objects and parts of objects in the scene are represented using only topological relations such as spatial order, joining, and enclosure. Drawings of rectangular objects in which only one face is represented can approximate to orthogonal projections, and drawings in which two faces are represented can approximate to vertical or horizontal oblique projections. However, the use of genuine projection systems such as oblique projection and perspective is only possible using lines as picture primitives and comes relatively late in the developmental sequence. Representing the foreshortening of smooth objects, and

the occlusion of part of one object by another, also depends on using lines as picture primitives.

Thus, to make sense of children's drawings we have to begin by understanding the complex interplay among the mark, denotation, and drawing systems, and the changes in these systems that take place during development. But describing these changes does not in itself tell us why these changes take place nor how children use these systems in the drawing process. These two topics form the subject of the next two chapters.

Part Two

MENTAL PROCESSES

"Seeing in" and the Mechanism of Development

Hamlet *Do you see yonder cloud that's almost in shape of a camel?*
Polonius *By the mass, and't is like a camel, indeed.*
Hamlet *Methinks it is like a weasel.*
Polonius *It is backed like a weasel.*
Hamlet *Or like a whale?*
Polonius *Very like a whale.*
—William Shakespeare, *Hamlet, Prince of Denmark*

As children get older the drawing, denotation, and mark systems they use in their drawings change. But why do children's drawings change? And what are the mechanisms by which these changes take place?

Figure 8.1 shows examples of children's drawings of a smooth object (people) and Fig. 8.2 shows examples of children's drawings of a rectangular object (a table), both taken from the early, middle, and late stages of drawing development. Looking at these drawings, together with the whole range of drawings illustrated in chapters 3 to 7, it is impossible not to be struck by the fact that the drawings by the older children are in some sense better than the drawings by the younger children. But better in what sense? Better as works of art? Better because they look more like adult pictures? Or better because they look more like the real world? There are difficulties with all these answers, and in this chapter I argue that drawings by older children are better than those by younger children in the sense that they are *more effective as representations*. By more effective as representations, I mean that the objects they are intended to depict can be seen in them, clearly and unambiguously. I also argue that the mechanism of development depends on the interaction

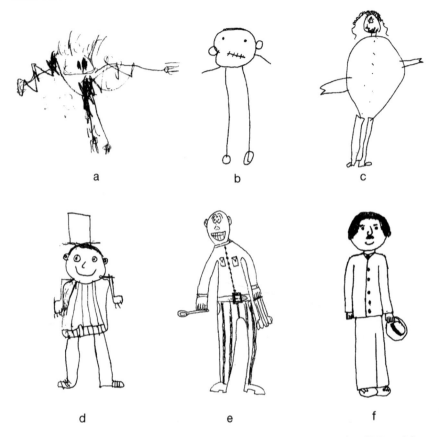

FIG. 8.1. Children's drawings of people. (a) By a girl age 3 years 3 months. (b) By a girl age 6 years 6 months. (c) By a boy age 5 years. (d) By a boy age 6 years 8 months. (e) By a boy age 11 years 3 months. (f) By a boy age 10 years 10 months. (b) Taken from Harris (1963), remainder collection of the author.

between perception and production. The changes that take place at the end of each stage of development come about as the result of attempts by children to solve specific drawing problems, but each attempt brings fresh problems in its wake. For example, children are often satisfied with single-square drawings of objects such as houses or cubes, based on a denotation system in which regions denote faces, but eventually they become dissatisfied because these drawings show only one face. Adding more faces seems a reasonable way of solving this problem but results in the fold-out drawings that look wrong and are ineffective as representations. These drawings do not provide possible views, and the edges and corners cannot be made to join up properly. This mismatch between picture production and picture perception

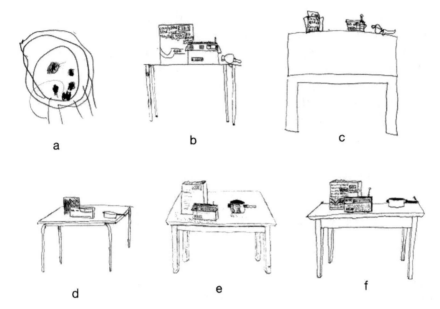

Fig. 8.2. Children's drawings of a table. (a) Girl age 3 years 0 months. Collection of the author. The mean ages were (b) 9 years 8 months, (c) 11 years 11 months, (d) 13 years 7 months, (e) 14 years 4 months, and (f) 13 years 8 months. Taken from Willats (1977b, Figs. 3–7).

spurs children on to find a solution to this problem, which in this case depends on their being able to find a new denotation system: one in which lines denote edges.

The goal of language development is generally regarded as unproblematic. Children's speech is judged to be more developed to the extent that their utterances correspond more closely to those of adults. But the end point of drawing development is by no means unproblematic, and very different views have been entertained as to what constitutes progress. Earlier accounts took it for granted that the end point of drawing development was to be able to produce pictures in perspective, similar to those produced by European artists during the 19th century. More recently, Hagen (1985, 1986) has argued that the superiority of Western art is an ethnic myth and that, judged from this standpoint, there is *no* development in children's drawings. Hagen's argument is that drawings in systems such as orthogonal projection, vertical and horizontal oblique projection, oblique projection, and perspective—used by artists in different periods and cultures and often regarded as characteristic of different developmental stages—are all based on projective geometry and that, as a result, drawings in all these systems pro-

vide possible views. As the purpose of depiction, according to Hagen, is to provide pictures whose geometry corresponds to that in a view of a scene, the differences among these systems are trivial and simply correspond to what she called "cultural canons": more or less arbitrarily different versions of natural perspective that artists in different cultures or periods of art history, or children at different ages, have chosen to adopt. Hagen (1985) acknowledged that "children's fine motor development improves with practice" but argued:

> Neither the mastery of specifically taught canons nor the acquisition of motor skills is reason for the excitement generated by those who espouse the theory that drawing undergoes a developmental progression with ordered stages that differ qualitatively from each other. . . . Is it possible to measure developmental level with a tool that itself shows no development? (p. 76)

In short, according to Hagen, "there is no development in art" either in children's drawings or during the course of art history.

It is tempting to dismiss Hagen's (1985, 1986) thesis out of hand because it outrages our common sense. Whatever the logic of her arguments, the drawings by older children shown in Figs. 8.1 and 8.2 look, at least to adult eyes, more advanced than the drawings by the younger children. But in what way do the drawings by the older children look more advanced, and what is the basis for our intuitions that they do?

Figure 8.3 shows two drawings we have considered earlier, a cube with a smaller cube removed from one corner. In an experiment (Willats, 1981) the mean age of children who produced drawings similar to that shown in Fig. 8.3a was found to be 12 years 2 months, whereas the mean age of children who produced drawings similar to that shown in Fig. 8.3b was 7 years 2

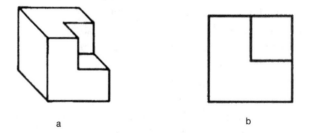

a b

FIG. 8.3. Drawing (a) is in oblique projection and drawing (b) is in orthogonal projection. According to Hagen (1985, 1986) these drawings should be equally good as representations. The mean ages for children producing similar drawings were (a) 12 years 2 months and (b) 7 years 2 months.

months. The drawing systems in both of these drawings can be described in terms of projective geometry: Fig. 8.3a is in oblique projection and Fig. 8.3b is in orthogonal projection. As a result, both drawings provide possible views of this object; therefore, according to Hagen (1985, 1986), they should be equally good as representations, but clearly this is not the case. Figure 8.3a looks much more effective as a representation than Fig. 8.3b, but why do we say this, and what does it mean to be more effective as a representation?

Wollheim (1977, 1998) defined representation in terms of "seeing in." For a picture to be a representation we must be able see in it the object or scene it is intended to represent. Judged by this test, Fig. 8.3a is an effective representation. Even without knowing beforehand what object the draughtsman intended to represent (and this is an unfamiliar object that most people are unlikely to have seen) it is impossible to look at this drawing without seeing in it a cube with a smaller cube removed from one corner. Figure 8.3b, on the other hand, is much less effective as a representation. It provides a possible view of the object shown in Fig. 8.3a, but even if we know that both drawings are intended to represent the same object it is difficult to see that object in it.

The most obvious difference between these two drawings is that Fig. 8.3a looks three-dimensional, whereas Fig. 8.3b looks flat. So far, I have described the spatial systems in pictures in terms of the drawing systems and the denotation systems, saying that the drawing systems map spatial relations in the scene into corresponding spatial relations in the picture, whereas the denotation systems map scene primitives into corresponding picture primitives. But to describe the experience we have in looking at Fig. 8.3a and comparing it with the experience of Fig. 8.3b we have to go beyond this and describe a third domain that I call the *pictorial image.*

When we look at a Canaletto painting of a view of Venice we do not, of course, see a real scene. Nor, unless we are very close to the picture, do we simply see it as a collection of marks on a surface. Instead, we see in it a paradoxical scene that seems to have depth but does not have all the properties of real space. For example, if we move our heads to one side, our view of the depicted scene does not change, as it would do if it were a real scene. Looking at Fig. 8.3a we see depth in it—in fact we cannot help seeing depth in it—but moving to one side does not give us a different view of the object represented. The experience we have in looking at Fig. 8.3b is, however, different. Knowing what object the drawing is intended to represent we can perhaps, by an effort of will, see it as three-dimensional, but the experience is not only fleeting but ambiguous: we are just as likely to see the small square in front of the L-shaped region as behind it. Seeing depth in pictorial

images is a subjective experience but it is not unreal, and Koenderink (1998) has shown that it is possible to measure this perceived depth objectively (see the Appendix).

According to Wollheim (1998), seeing in precedes representation both logically and historically. We not only see objects in pictures, we can also see them in accidental formations such as Leonardo's famous stains on a damp wall, or in clouds, as in the dialogue between Hamlet and Polonius quoted at the beginning of this chapter. Wollheim gave two examples: a photograph by Aaron Siskind of stains on a wall that look like a naked boy, and a photograph by Minor White of an "Empty Head" in the frost on a window pane. Figure 8.4a shows an example taken from my own home, formed by the patches of contact adhesive left on a wall when a mirror was removed.

Figure 8.4a is remarkable because not only can we see a girl in a Hellenistic costume in these accidental patches, but they also resemble the girl in the well-known Hellenistic wall painting shown in Fig. 8.4b. We cannot count Fig. 8.4a as a representation, however, because, unlike the Hellenistic painting it resembles, it has not been produced deliberately but has come about by chance. Thus, to his definition of a representation as "a configuration in which something or other can be seen," Wollheim (1977) added the restriction that the representation must have been *intended*, by whoever made it, to be a configuration in which something or other could be seen, and moreover this someone must have had the required competence to act on this intention (p. 82). If, for example, as Luquet (1927/2001) suggested in his account of fortuitous realism, a child sees something or other in his or her

a b

FIG. 8.4. (a) Patches of contact adhesive left when a mirror was removed from a wall. (b) Wall painting from Stabiae, first century AD of *A Girl Plucking Flowers*.

scribbles and then names it, this is an example of seeing in but not of representation in a true sense. True representation begins only when a child intends to draw something specific and has the competence, however crude, to carry out this intention.

Seeing in, then, is a distinct kind of perception, and what we see in pictures are the pictorial images of objects. Scenes are three-dimensional and pictures are two-dimensional, but pictorial images may have depth to a greater or lesser extent; that is, the pictorial relief we see in pictures may vary from fully three-dimensional to more or less flat. To put this more formally, if we describe scenes as three-dimensional and pictures as two-dimensional, pictorial space is (2+1)-dimensional in the sense that although two of the dimensions describe the visual field and correspond roughly to the geometry of projections on the picture plane, the third, or depth dimension, has different properties. Because no information is available in pictures from binocular disparity or optical flow, this depth dimension is generally thought to be constructed by the brain on the basis of depth cues (such as occlusion and shape from shading), prior information, and the observer's experience of the environment (van Doorn, Koenderink, & Ridder, 2001). As Koenderink (1998) and Koenderink, van Doorn, and Christou (1996) have shown, the value of this depth dimension in picture perception can vary greatly from one viewer to another and according to the depth cues that the picture contains.

In terms of picture production, the depth dimension of the pictorial image produced by different artists varies greatly from one period of art history to another and from one culture to another. Greek vase paintings from the geometric period, for example, which take the form of silhouettes, look much flatter than later paintings in the red-figure style, which take the form of line drawings, and it is in fact these changes in the depth dimension that characterize the development of Greek vase painting. On the other hand, many artists at the beginning of the 20th century deliberately tried to make the picture surface look "flat." Properly speaking, of course, the picture surface can never be anything but flat, and it would be more correct to say that what they were actually trying to do was to reduce or eliminate the depth dimension in the pictorial image (Willats, 1997).

The depth dimension portrayed in children's drawings also varies during the course of development. Intuitively, at least to adult eyes, the degree of pictorial relief is much less in their early drawings than it is in their later drawings. For example, the tadpole figure by a 6-year-old girl shown in Fig. 8.1b looks almost, if not completely, flat, whereas the drawing of a man by a 10-year-old boy shown in Fig. 8.1f has some apparent depth, though not as

much as that in the drawing of a man by the talented 8-year-old girl shown in Fig. 7.9. Similarly, the depth dimension in the drawings of tables by the younger children shown in Fig. 8.2 is much less than it is in the drawings by the older children.

This suggests that one of the things that children are trying to do during the course of drawing development is to enhance the depth dimension in the pictorial image, and that they do this because enhancing the depth dimension results in drawings that are more effective as representations. What pictorial devices do children need to acquire to produce drawings in which the degree of pictorial relief is enhanced?

Hagen (1985, 1986) was correct in saying that if pictures are to function as representations, they must provide possible views. The human visual system is designed to extract information about the shapes of objects from views of scenes, and picture perception works in the same way. But as Fig. 8.3 shows, this is not enough. To be effective as a representation a picture should also provide a general view of an object. A general view of an object is one such that a change in the orientation of the object, or a step to one side on the part of the viewer, does not change "the number of lines in the picture or the configurations in which they come together" (Huffman, 1971, p. 298). This condition is satisfied by Fig. 8.3a but not Fig. 8.3b: a slight change in the position from which Fig. 8.3b is taken would reveal a number of new edges and one or two new sides.

This constraint springs directly from our experience of the real world and is probably built into the human visual system as the result of evolutionary pressures. We do not expect to see objects from a special direction of view in which, for example, the side faces of the object shown in Fig. 8.3b line up directly with the front edges, and when we see this effect in pictures the visual system infers that the picture must be of a flat object or pattern rather than a three-dimensional object, and consequently we see the pictorial image as flat.

The expectation on the part of the visual system that pictures show objects from a general direction of view has far-reaching consequences for depiction. Another example is that we expect the extendedness of objects to be reflected in the extendedness of their images. Round objects such as lumps appear round from whatever direction they are viewed. But long objects such as sticks normally project long images on the retina: only when sticks are viewed from a special direction of view—that is, from end on—will they project round images. Making certain assumptions—for example, that there are about equal numbers of round, long, and flat objects in an ideal universe and that we have no prior knowledge of which of these objects we are likely to encounter—it is possible to work out the probabilities of round and long

regions being representations of lumps, sticks, and slabs in silhouettes. It turns out that the probability of a round region as a view of a lump is about 3 in 5 (i.e., better than evens), and the probability of a long region as view of a stick is about the same, whereas the probability of a round region as a view of a stick is only about 1 in 60 (Willats, 1992b). This suggests that we ought to interpret round regions in silhouettes as views of lumps and long regions as views of sticks, and this agrees with our intuitions.

On the other hand, the probability of a round region being a view of a disk is only about 1 in 3 (i.e., considerably less than evens), and the probability of a long region being a view of a disk is about the same. Consequently, round regions and long regions are possible, but improbable, as views of disks, and this agrees with our intuition that it is difficult to see disks or slabs in silhouettes.

These observations have consequences for both artists' pictures and children's drawings. Figure 8.5 shows Picasso's *Rites of Spring*, a painting in which all the figures except the bird are represented in silhouette. Round regions are used to represent lumps such as the heads of the two human figures, and we can see these objects in the picture. Similarly, long regions are used to represent sticks, such as the body of the figure on the left and the legs of the goat, and again we can see these in the picture. However, there are two regions at the ends of the dancing figure that are difficult to interpret on the basis of

FIG. 8.5. Pablo Picasso, *Rites of Spring*, 1959 © Succession Picasso/DACS 2005.

shape perception alone. Prior knowledge tells us that these are intended to represent tambourines in the form of flat, drum-like disks, because this dancing figure is almost certainly taken from a similar figure in Poussin's *The Triumph of Pan*. Nevertheless, even with this prior knowledge it is difficult to see these regions as representing disks. Even for an accomplished artist like Picasso, it is difficult to represent disks convincingly in silhouettes.

Extendedness is just one example of a whole range of what are called *nonaccidental* shape properties. These include straightness, curvature, symmetry, and parallelism. These properties are called nonaccidental because they are likely to be reflected in images of objects having these properties when they are seen from a general direction of view. For example, each of the regions representing the bodies of the pipes played by the figure on the left in the *Rites of Spring* are straight, and the visual system infers that these regions represent a view of a straight object in the scene rather than a possible, but highly unlikely, view of a curved object seen from a viewpoint lying directly within the plane of curvature. Similarly, if objects such as the goats' horns are pointed in the scene, this property is likely to be reflected in a general view.

One very important nonaccidental shape property concerns variations in surface curvature. Figure 8.6 shows three views of a "peanut" in both full silhouette and outline silhouette. Figure 8.6a, which shows an end view, is clearly ineffective as a representation because it falsifies the extendedness of the peanut, which is long rather than round. We naturally interpret this drawing as a short ellipsoid or an egg (Richards, Koenderink, & Hoffman, 1987). Figure 8.6b, which shows a top view, is also ineffective as a representation because although it reflects the extendedness of the peanut, it does not show the saddle-shaped surface of the underside; therefore, we naturally interpret this as a drawing of a long ellipsoid. Figure 8.6c is much more effective as a representation because it shows both the convex top surface and the saddle-shaped surface at the bottom. As Richards et al. (1987) pointed out, this comes about as the result of an extension of the "general position" restriction defined by Huffman (1971) for line drawings, which requires that the view shown should not be special.

The view shown in Fig. 8.6c is still not completely general because the viewer's line of sight is at right angles to the principal plane of the peanut. However, as Fig. 8.7a shows, turning the peanut through an angle to give a slightly foreshortened view results in a less effective representation in both full and outline silhouette because the shape of the outline suggests that the peanut has a kink at the bottom. In a full line drawing, however, the effectiveness of the representation is much improved, as shown in Fig. 8.7b. Thus, although full line drawings of objects are as a rule more effective as

FIG. 8.6. Three views of a peanut shown in full silhouette and outline silhouette. Drawing (a) is not effective as a representation because it shows neither the extendedness of the peanut nor its surface undulations. Drawing (b) shows the extendedness but not the surface undulations. Drawing (c) is effective as a representation because it shows both the extendedness and the surface undulations. Adapted from Richards et al. (1987) and Willats (1997).

representations if the object is shown in a general position, this is not necessarily true of either full or outline silhouettes, so that for smooth objects there is an interaction between the "general position" restriction and the denotation system used.

Richards et al. (1987) referred to silhouettes that show the surface undulations of a smooth object as "canonical," but this term is used somewhat

FIG. 8.7. The full and outline silhouettes at (a), which show the peanut in a more general position, are less effective than the full and outline silhouettes shown in Fig. 8.12c, which show the peanut in a more special position. However, the full line drawing in (b) is much more effective as a representation.

differently in the context of children's drawings. Cox (1992), for example, used the term *canonical* to describe drawings that include the defining features of objects. In a well-known experiment Freeman (1972) found that the majority of children under age 7 included the handle in their drawings of a cup, even when it was presented to them with the handle turned away so that it was not in sight (Fig. 8.8b). Views of this kind are often described in the literature as canonical.

However, the term *canonical* is also used to describe children's drawings that reflect the extendedness of objects. Ives and Rovet (1979), for example, found that children of all ages nearly always draw horses, boats, and cars from the side rather than from the front, reflecting the fact that such objects are long rather than round. On the other hand, they also found that people and owls were nearly always drawn from the front, although in this case the representation of extendedness is not critical because people and owls look equally long in front and side views. Presumably, with these objects, it was the representation of defining features (such as the eyes and mouth) that was more important (Fig. 8.9). Children attach great importance to the inclusion of defining features in their drawings: a lion has to have a mane and a tail, and a tiger has to have stripes (Freeman, 1972).

Thus, if a drawing is to be effective as a representation—that is, if we are able to see in it the objects that the artist, draughtsman, or child intended to represent—it should not only show the shapes of objects but should also include their defining features. However, the possibility of including such features may depend on the particular mark system and denotation system on which the drawing is based. Figure 8.10 shows drawings of a head based on three different denotation systems: full silhouette, outline silhouette, and full line drawing. Columns a, b, and c show silhouettes of the object taken

a b

FIG. 8.8. (a) An adult's drawing of a cup with its handle turned out of sight. (b) A drawing by Amy, 4 years 11 months, from the same viewpoint. Amy said, "I can't see the handle, but I'm going to draw it anyway. It makes it look better." Taken from Cox (1992, Fig. 6.8). Courtesy of M. Cox.

FIG. 8.9. Horses, boats, and cars are nearly always drawn from the side because this view reflects their extendedness. People and owls, however, are drawn from the front, and with these objects the front and side views reflect their extendedness equally well. In these drawings the choice of a front view is related to the representation of distinctive features. Taken from Cox (1992, Fig. 6.7). Courtesy of M. Cox.

FIG. 8.10. The interactions among the defining features of an object, the direction from which it is viewed, and the use of a particular denotation system.

from different directions of view—face on, from the side, and in a three-quarter view—and column d shows full line drawings.

The top row shows the head in full silhouette. Only the drawing in column b provides an effective representation, and it does so because it not only shows the extendedness of the head as a round volume but also shows its surface undulations; that is, it shows the nose as a convex protrusion with a saddle-shaped surface where it joins the head at the top. It is no coincidence that 18th- and 19th-century silhouettes always show people's faces from the side. The three-quarter view is ineffective as a representation because it does not reveal the shapes of these surfaces.

The middle row shows outline silhouettes in columns a, b, and c, and a full line drawing in column d. Here, the full line drawing showing a three-quarter view is more effective as a shape representation than the side view, but is still not wholly effective as a representation of a head because it lacks two defining features—the eyes and the mouth—that are treated here (as they usually are in young children's drawings) as surface markings.

Finally, the drawings in the bottom row include these defining features. The outline silhouettes in columns a and b are both recognizable as drawings of heads, but neither is as effective as a representation as the full line drawing in column d.

The use of lines as marks in children's drawings is so universal that we take it for granted, but the fact that line drawings can be so effective as representations is astonishing because on the face of it there appears to be no similarity between the array of light coming from a real scene and the array coming from a line drawing of a scene. However, Pearson et al. (1990) have suggested that there is a correspondence between these two arrays and that line drawings are effective as representations because the human visual system is able to pick up this correspondence.

Early attempts in vision science to extract line drawings automatically from full gray-scale images were relatively unsuccessful because they simply substituted lines for abrupt changes of tone in the image, so-called luminance step edges (Marr, 1982, Fig. 2.15). These step edges correspond well to features in the image such as the edges of cast shadows, or changes in tone at the edges of clothing, but not to the light coming from the contours of smooth forms. However, Pearson et al. (1990) suggested that the changes in the array of light coming from the contours of a smooth surface correspond not to luminance steps but to luminance *valleys*: features in the array in which a line of dark elements is surrounded by relatively light elements. These luminance valleys also correspond to the light coming from line drawings, and by using what they called a *cartoon operator* that detected com-

binations of step edges and luminance valleys in the image they were able to produce line drawings that compared well with drawings by a human artist (Fig. 8.11). They concluded that the human visual system might contain a similar cartoon operator designed to pick out contours in real scenes and that this operator responded in the same way to the luminance valleys provided by line drawings.

Pearson et al.'s (1990) results suggest that we would expect the effectiveness of line drawings in representing the contours of smooth surfaces to be common to all periods and cultures and that the effectiveness of line drawings as representations does not depend on learned conventions but is a result of design features in the human visual system. This is supported by evidence from psychological tests. Kennedy and Silvers (1974) analyzed 675 outline drawings found on rock faces and cave walls in Europe, Africa, North America, and Australasia and found that all but 7 of these drawings contained lines standing for the occluding contours of smooth surfaces. A psychologist called Ross lived with a people called the Songe in Papua New Guinea for a year, and during this period none of the Songe possessed any form of picture or was observed so much as to doodle a picture in the earth. Despite their unfamiliarity with pictures, however, the Songe had little difficulty in recognizing objects in outline drawings in which the lines stood for occluding contours. They did, however, have some difficulties with drawings in which the lines stood for the boundaries of different areas of color, such as the markings on a parrot (Kennedy, 1983; Kennedy & Ross, 1975). Finally, and most important for our study, children can recognize objects in line drawings from a very early age, even though they cannot produce such drawings themselves (Hochberg & Brooks, 1962).

a b c

FIG. 8.11. (a) A gray-scale photograph. (b) A drawing by an artist. (c) A computer-generated drawing produced using a cartoon operator. Taken from Pearson et al. (1990, Figs. 3.5 and 3.6). Courtesy of D. Pearson and Cambridge University Press.

If drawings are to be effective as representations they must thus possess the following properties. First, they must show *possible* views of objects. Second, they should show objects from a *general* direction of view, so that important shape properties such as their extendedness and their surface shapes are reflected in the drawing. Third, as Fig. 8.10 suggests, *full line drawings* are more effective than silhouettes. And finally, they should contain representations of *defining features* such the eyes, nose, and mouth. The course of development can be seen in terms of children's successive attempts to include these properties in their drawings.

As we have seen, drawing begins with scribbling, but with some exceptions, children's scribbles are not representations in a true sense because although children can sometimes see objects in them, this resemblance comes about by chance rather than as a result of prior intention. Although the 2-year-old Italian girl cited by Luquet saw a bird in her traces (Fig. 2.6) and Ben, also age 2, saw an aeroplane in a drawing that combined a horizontal arc with a push-pull movement, in neither case was there the intention to draw these objects beforehand. Luquet (1927/2001) called this stage fortuitous realism. Once children notice chance likenesses in their drawings they try to improve them by adding defining features. "A French girl of three-and-a-half, having interpreted one of her traces as a bird, added the beak, the eye, and the legs, and six weeks later when she saw a bear in one of her drawings she completed it with an eye" (Luquet, 1927/2001, p. 89).

Sometimes the subjects of these chance likenesses may be bizarre. Winner (1986), for example, cited a 3-year-old boy who interpreted his scribble as "a pelican kissing a seal" and proceeded to add eyes and freckles to make the seal more recognizable. When children discover that they have produced a recognizable image they are often "filled with intense joy" (Luquet, 1927/2001, p. 88). But as Luquet (1927/2001) observed, "This joy does not last. Since the resemblance was produced fortuitously, this happy coincidence will not immediately occur again, and children are then forced to recognize that it was only by accident that they managed to produce a resemblance" (p. 88). This is especially true in cases where the resemblance is bizarre, as in the case of the pelican kissing the seal, and children are very unlikely to reproduce the original scribble again. But there is one case in which the form of the scribble is likely to reoccur, is easy to remember and easy to reproduce, and in which the resemblance is to a very familiar object: the human figure.

The very earliest scribbles consist only of single isolated units and these may take the form of dots, lines, or circles. Kellogg (1969), for example, listed 20 basic scribbles of this kind, some of which take the form of single

lines and others multiple lines covering more or less solid areas. In the next stage, children begin to combine these marks: Ben's combination of a horizontal arc with a push-pull movement, resulting in the cruciform shape in which he recognized an aeroplane, for example. In this case, the marks were areas filled with lines, and these areas resemble the silhouettes of the fuselage and the wings. But one very common combination is what Matthews (1999) called "core with radials," and as he noted, the marks in these third-generation structures are very often lines rather than areas. Figure 3.5, reproduced here as Fig. 8.12a, shows two examples of these structures. These were no doubt made without any representational intention, but it is easy to see that when only two radial lines have been added to a central core, as shown in Fig. 8.12b, these structures may resemble a person in the form of the ubiquitous tadpole figure.

As with other chance likenesses, children may then go on to enhance the likeness by adding defining features—probably, and most commonly, by adding dots or circles to represent the eyes. The combination of two or more lines with a core circle is likely to occur naturally during the child's exploration of mark structures, is easy to remember, and is easy to reproduce. At the most basic level, a human figure can be seen in this chance combination, and this chance resemblance can easily be enhanced by adding further defining features. Once a child remembers this combination and deliberately reproduces it, true representation begins.

Here we have yet another possible explanation of the puzzle of the tadpole figure. It may not be, as Freeman (1975) suggested, that the child "for-

a b c

FIG. 8.12. (a) Possible precursors of the tadpole figure in the form of core and radial marks. Taken from Matthews (1999, Fig. 8). (b) Two radials added to a core fortuitously resemble a very elemental human figure. (c) Basic tadpole figures, drawn deliberately as part of the teddy bear game. Taken from Matthews (1999, Fig. 12). Courtesy of J. Matthews.

gets" to put in the body as the result of production problems or poor short-term memory, nor, as Arnheim (1974) suggested, that the tadpole figure represents the child's global, undifferentiated conception of the human figure in terms of picture production. The child does not have an internal shape description of the human figure in the form of an undifferentiated head/body, which is then represented by a single closed form. Instead, although the combination of a closed curved form and two radial lines is in fact a poor representation, our disposition to see objects, and especially the human figure, in chance formations is so strong, and the child's joy at this almost magical coincidence so great, that at this stage the proto-tadpole figure, produced by chance, provides a representation that is "good enough." When this figure is reproduced deliberately, as in Fig. 8.12c, representation proper begins.

These tadpole figures possess, in the simplest possible form, the properties necessary for a picture to be, if not an effective representation, at least a tolerable one. If the legs are below the head/body or the arms outstretched, the spatial order of the component parts results in a possible view. Joining the lines to the central core represents the join relation between the arms or legs and the body. In addition, the shapes of these parts reflect the extendedness of the head/body as a round volume and the arms or legs as long volumes. As we have seen, children's early scribbles may take the form of areas filled with lines—in effect, silhouettes—or lines enclosing areas. But as Fig. 8.10 shows, silhouettes have one major drawback: it is impossible to add defining features within the outline because they "won't show up." Thus, although the precursors of the tadpole figures may take the form of both silhouettes and outline drawings, children choose to continue with outline drawings because they can add features such as the eyes, nose, and mouth within their boundaries. Moreover, although these outlines only define the regions they enclose, and have no representational status as picture primitives by themselves, the design features of the human visual system will guarantee that we see them as contours.

Thus, these precursors of the tadpole figures fortuitously provide possible views of the human figure in terms of features such as spatial order, the join relation, and extendedness. In addition, the mark system provides the basis—in terms of picture perception—for a denotation system in which the outlines of the head/body are seen as contours and the lines for the arms or legs are seen as long wire-like forms.

A combination of two round forms for the head and body, two lines for the arms, and two lines for the legs is unlikely to come about by chance. However, once the tadpole figure has been established as a starting point

children begin to elaborate it by adding further defining features, including the body and the missing arms or legs. Cox and Parkin (1986) studied collected drawings from six children showing the transition from tadpole figures to conventional drawings, and Fig. 8.13 shows just one sequence. In the first drawing of the sequence eyes have been added to the basic core and radial figure. In the second drawing zig-zag scribbles have been added to represent the hair and feet. In the third drawing lines representing the nose, mouth, and arms have been added. In the final drawing the body, in the form of a round region, has been added, with a dot to represent the tummy button.

In this case, Amy's tadpole phase unusually lasted only 3 days, but Cox (1992) found that the pattern of development was variable: some children went through a period of some months during which they produced transitional figures and conventional figures as well as tadpole figures. Cox suggested two reasons for this. One is that when such a child draws a tadpole she may sometimes not try very hard and will dash off a shorthand version of a figure. The other reason is that the number of defining features may depend on the context: where the human figure is the main topic of the picture, as it often is in test situations, the child will do the best she can. But where a figure is only incidental to the scene (as it is in Ben's *Round and Round the Garden* shown in Fig. 8.12c, where representing the action is more important than representing the figures), a shorthand version may be "good enough."

Marks in the form of single lines are used in these early drawings to stand for long regions as picture primitives, which in turn denote long volumes such as the arms and legs. This mark system may have its origins in the chance resemblance to the human figure found in the core and radial structures—two lines joined to a round area are far more likely to occur by chance than two long areas joined to a round area. An additional factor may

| 2 June 1984 | 3 June 1984 | 4 June 1984 | 29 July 1984 |

FIG. 8.13. Successive defining features are added to the basic core and radial tadpole figure, finally resulting in a conventional figure. Taken from Cox (1992, Fig. 3.8). Courtesy of M. Cox.

be that at this age children are not confident about being able to distinguish in production between long areas and round areas, and so use a combination of single lines and round areas because this provides the maximum contrast in the representation of extendedness. In terms of picture *perception*, however, single lines are rather unsatisfactory because as representations of long volumes they look too thin, so in the next stage (by the age of about 6 years, according to Cox, 1992) long areas defined by outlines are used instead. These lines can then be seen as representing the contours of solid forms. According to Cox, the legs are usually outlined earlier than the arms.

The mark system also changes in several other ways. The first change, which occurs early on, is that scribbled zig-zag lines or patches of scribble are used to stand for textured features such as smoke, hair or fur. Figure 8.14 shows a drawing by Sally, age 4, of *Mummy in a Black Fur Hat*. Once again, this development comes about as the result of the interaction between production and perception. Initially, the marks in the form of lines that make up patches of scribble have no representational status. Fortuitously, however, closely spaced lines can look like areas of texture because the individual lines look like hairs. Once children begin to see areas of texture within their patches of scribble they go on to use patches of scribble deliberately for this purpose.

Using patches of scribble to represent areas of texture can lead to further changes in the mark systems children use. Scribbled lines forming silhouettes occur early in children's drawings and are used to represent areas of texture. But seeing them used successfully for this purpose may give chil-

FIG. 8.14. Sally Willats, 4 years, *Mummy in a Black Fur Hat*. Scribbled lines are used for hair, the fur hat, and the collar. Drawn lines are used for the pattern on the coat. Collection of the author.

dren the idea that areas of tone or color in silhouette can also be used as a way of differentiating between areas representing different features, such as clothing, within the outlines of the figure as a whole. In Fig. 8.15, for example, the decorated pinafore of the figure on the right, represented by a blank area of the picture surface, is distinguished from the rest of the figure by setting it against the more or less opaque block of color used for the child's dress. In addition, children may come to realize that when they use markers or crayon that give semitransparent areas of color or tone they can add features within them. In Fig. 8.15 translucent areas of colored crayon with lines showing through them are used for the feathers on the hat. Finally, as Fig. 8.15 also shows, lines can be used to represent surface features, such as surface decoration, or the boundaries between different areas of tone or color, as well as to define the boundaries of regions denoting volumes. All these changes can be prompted by the interaction between production and perception. Children make marks in their drawings, either by chance or to serve a particular purpose, and then they see that they can be adapted to serve other purposes.

This drawing also illustrates some of the changes that have taken place in the denotation systems since the tadpole figure stage. Although the representation of extendedness is still very important—the heads are represented by round regions and the arms by long regions—the shapes of the regions

FIG. 8.15. Sally Willats, age unknown, but probably about 7 years, *Lucy Locket Lost Her Pocket*. Collection of the author.

representing the feathers on the hat have been varied by modifiers such as "being pointed" and "being bent." The most important of these modifiers, however, is the one that leads to threading: the arms and body of the figure on the left are no longer represented by separate regions, but instead the transitions between them are represented by smooth lines.

Thus, the changes that separate drawings of this kind from the earlier tadpole figures are of two kinds. The mark system has become much richer, and the earlier denotation system that recognized only the representation of extendedness has become richer through the addition of shape modifiers. But through all these changes the basic denotation system, in which regions denote volumes, has remained the same. However realistic the figures in this drawing look, there is still little or no representation of occlusion: each region preserves its own identity as a picture primitive.

The next major developmental change that takes place is that the lines in the drawing lose their function as merely defining the boundaries of regions and take on the role of lines denoting contours. This change also may be prompted by the recognition of chance resemblances. As I noted in the previous chapter, the convex surfaces of smooth forms project convex contours in the image and saddle-shaped surfaces project concave contours, and in line drawings these contours are represented by convex and concave lines. In Fig. 8.16, drawings of dinosaurs by Joel, a talented 6-year-old boy, there are concave lines where the tails join the bodies. These have almost certainly come about as a result of threading, but nevertheless they give, in terms of picture perception, a convincing impression of the three-dimensional saddle-shaped surfaces that would have been present in the scene.

The second chance resemblance concerns the representation of occlusion. In the two lower figures there are T-junctions where the legs join the bodies. It may be that in the case of this talented 6-year-old these T-junctions were drawn deliberately to represent points of occlusion, but it is more likely that they occurred by chance when the legs were added to the body after the main outline silhouette had been drawn. In either case, the presence of these T-junctions gives a strong impression of the occlusion of one part of the figure by another, and thus of depth. Similar T-junctions are present in Fig. 8.15 where the heads of the two figures join their bodies. In both cases this gives an impression of depth, particularly in the figure on the left in which the two T-junctions may be intended to represent points of occlusion. In the figure on the right, however, it seems likely that these junctions simply represent the join relation.

In individual drawings of this kind it is often difficult to tell whether the T-junctions have come about by chance or are intended to represent points

FIG. 8.16. Joel, 6 years. The concave lines where the tails of the dinosaurs join their bodies fortuitously resemble the contours of smooth saddle-shaped forms, and the T-junctions where the legs join the bodies fortuitously resemble points of occlusion. Taken from Milbrath (1998, Fig. 4.16). Reproduced from *Patterns of Artistic Development in Children* by Constance Milbrath, 1998, Figure 4.16a, New York: Cambridge University Press with author's permission.

of occlusion. However, in a drawing by Joel (Fig. 8.17), produced only 1 year later, we are left in little doubt: the T-junctions denote points of occlusion where one part of a figure disappears behind another, and the end-junctions denote points of occlusion where the internal surface contours end. This change in the denotation system, from the use of regions as picture primitives to a system in which lines denote contours and line junctions denote points of occlusion, allows the representation of both occlusion and foreshortening. Both these features can be seen very clearly in Joel's drawing shown in Fig. 8.17, in which the use of a new denotation system gives a much more convincing impression of depth. In contrast to his earlier drawings shown in Fig. 8.16, which look relatively flat, the third dimension in the pictorial image is fully established and we can see depth in the picture.

Thus, the course of development in children's representation of smooth forms can be seen in terms of a complex interplay among the mark systems, the denotation systems, and the drawing systems, with each system coming to the fore at different times like the instruments in a orchestra. The primary

FIG. 8.17. Joel, 7 years. The T-junctions denote points of occlusion where one body part occludes another, and the end-junctions denote points of occlusion where surface contours end. Taken from Milbrath (1998, Fig. 4.16b). Reproduced from *Patterns of Artistic Development in Children*, 1998, Figure 4.16b, New York: Cambridge University Press with author's permission.

mechanism driving this development depends on the interaction between picture production and picture perception. The same interplay, and the same mechanism of development, can also be seen at work in the development of children's ability to represent rectangular objects such as cubes, houses, and tables.

After the earliest stage in which closed, curved forms are used to represent whole volumes, and in which the only shape feature represented is extendedness, the shape modifier "having straight sides" is introduced to represent the feature "having flat faces." At this stage the regions stand for whole volumes. However, it is possible to see single faces in these drawings, and this prompts the change to a new denotation system in which regions denote faces rather than volumes. Adding extra faces, however, leads to the fold-out drawings that, because they do not provide possible views, do not even satisfy the first and most basic property that a picture must have to be an effective representation. Thus, although such drawings are logical in terms of picture production they are unsatisfactory in terms of picture perception. One solution to this problem is to stop at the right moment when the drawing looks right, resulting in drawings of cubes (Fig. 6.13), tables (Fig. 6.17), and houses (Fig. 6.18) in horizontal or vertical oblique projection.

Developmentally, however, this solution is something of a dead end, and as we have seen, children tinker with their fold-out drawings in many different ways, trying to find a better solution (Fig. 7.16). Many of these attempts result in the introduction of oblique lines, either to pull the corners of the cube together or to distort the regions to get the corners to join up properly. In terms of picture production these oblique lines have no representational status, but their introduction can, fortuitously, give an impression of depth, leading to the establishment of a three-dimensional pictorial image. Seeing this pictorial image in their drawings leads children to use a denotation system based on lines rather than regions as picture primitives, and this in turn opens the way to use projection systems such as oblique projection and perspective that involve the use of oblique lines. Figure 8.18 illustrates the course of this development in a simplified and idealized form.

The mechanism of development described here shares some features with Gombrich's (1988) account of the role of schema and correction in the development of art history. In Gombrich's account of the origins of cave painting, for example, the proto-artist sees a bison in the indeterminate rock formations in a cave and builds on this to produce a picture. In much the same way, I have suggested, a child may see a man in his or her early core and radial mark structures and turn this into a representation by adding defining features. However, in the account of development presented here it is not just the schema for drawing a particular object that changes; instead, it is the representational systems that children use that change during the course of development. These changes are prompted by children's need to acquire

FIG. 8.18. The transition from fold-out drawings of a cube to drawings in oblique projection. The oblique lines in the middle row occur as a result of the child's attempts to join the corners of the cube together. Fortuitously, however, they suggest a pictorial image in which the oblique lines represent edges in the third dimension, and the child can then capitalize on this to produce drawings in oblique projection. Adapted from Willats (1984, Fig. 12).

more effective ways of representing the objects they want to draw, and the mechanism that drives these changes depends on the interplay between production and perception. Moreover, once these new pictorial systems have been acquired they can be applied to the representation of new objects that the child may never have attempted to draw before, so that the drawing process is essentially creative in Chomsky's (1972) sense of making infinite use of finite means.

This account also owes something to Luquet's (1927/2001) theory of fortuitous realism. In Luquet's account, fortuitous realism is the mechanism that starts the development of representation: children see something or other in their scribbles, they repeat the traces that resulted in this something or other, and drawing begins. But in the account given here the interaction between perception and production is not just something that begins the drawing process, but something that continues throughout the whole course of development. Children become dissatisfied with their fold-out drawings because they do not show possible views and seek to correct them in various ways. Here the mechanism of schema and correction acts in response to the perception of what children see to be errors in their drawings. But children can also build on their successes. Most of the attempts children make to correct their fold-out drawings involve the introduction of oblique lines, and fortuitously, these oblique lines begin to look like edges receding in depth. Building on this, children can go on to develop a general drawing rule (Use oblique lines to represent edges in the third dimension) that enables them to produce drawings of all kinds of rectangular objects in oblique projection. Similarly, in threading, children introduce continuous outlines to represent the shape feature "having a smooth continuous surface," but fortuitously, these outlines begin to resemble contours. This prompts a change in the child's denotation system and opens the way to full line drawings and the use of the T-junctions and end-junctions.

In theory, this interaction between production and perception could enable a child working in complete isolation to reach the stage based on full line drawing as a denotation system and oblique projection, or even perspective, as a drawing system. In practice, however, this is unlikely to happen. Children are influenced by the pictures they see around them when these pictures provide them with the solutions to the representational problems they are trying to solve at a particular stage of development. In the very earliest study of children's drawings, Ricci (1887) told the story of how he was led to begin his study by the discovery of some children's drawings on a portico wall in Italy. The drawings by the older children were at a higher level than those by the younger children, and Wilson and Wilson (1982) have ar-

gued that the high percentage of two-eyed profile figures in these drawings (a drawing style that has now virtually disappeared) had come about as the result of the younger children's attempts to copy those of older children. As Fig. 8.10 shows, full-face drawings and profile outline drawings of the head are about equally good as representations, and where a choice among modes of representation exists children are likely to chose models that are already available in their pictorial environment. In addition, children can sometimes be helped in solving their problems by advice from both children and adults. The first figure drawing produced by a little boy called Joe was a conventional one with a head, body, and legs, although it had no facial features and no arms. Joe said proudly, "Alistair showed me [how] to draw giants" (Cox, 1992, p. 46).

At a later stage of development the transition from fold-out drawings to drawings in oblique projection is a complex one involving several transitional stages. Children are unlikely to make this transition unless they are brought up in a pictorially rich environment, or given some teaching, or both.[1] Some years ago my research assistant, Sarah, and I were testing children's ability to draw cubes in a school in East London. We had borrowed the Psychology Department's mobile laboratory for the occasion and were due to return it that evening. We were testing the children individually, but unfortunately we failed to set a time limit for each test. Most of the children completed their drawings within a few minutes, but one little girl, who was trying to solve the problem of the fold-out drawings, would not leave for over an hour. She tried all sorts of solutions and then came back of her own accord to try again at playtime. She knew that there was something about oblique lines that would solve the problem but she didn't know what it was. Eventually, Sarah took pity on her and showed her. "Ah!" she said, "That's how you do it!" To adults this seems such a simple problem to solve, but not only do children have to learn a new denotation system—that you can use edges to stand for lines—and a new drawing system—that you can use

[1]Jahoda (1981), who gave schooled and unschooled adults in Ghana the task of drawing a table, concluded:

> The absence of any significant difference between unschooled and those with only limited schooling, coupled with the significant difference between these two groups and those with secondary schooling, strongly suggests that the boundary between Classes 3 [vertical oblique projection] and 4 [oblique projection] represents a critical divide; in the absence of an environment rich in perspective drawings, it is not crossed. Such an environment is available to all children in Western cultures, but only to secondary pupils in others. (p. 142)

oblique lines to stand for edges in the third dimension—but, and this is probably the most difficult part, they have to let go of an old system in which regions are used to represent the true shapes of faces. To make this kind of transition children may well need the help of adults.

As with language, children may remain satisfied with the drawings they produce and stay with the rules that generate these drawings for some time. As a result, they may be as impervious to adults' attempts to correct their drawings as they are to adults' attempts to correct their speech.[2] But, as with language, once children themselves become dissatisfied with their drawings and are actively seeking a solution to their problems, seeing a single instance of a drawing that contains the solution may be enough to generate a new set of rules.

In language learning, adults, and especially the mother, act as the child's caretakers, and "it appears that in order to learn a language a child must also be able to interact with real people in that language" (Moskowitz, 1978, p. 89). But drawing is a much more solitary activity, and except for children whose parents are artists or designers children do not often watch adults drawing. Thus, although a rich pictorial environment is almost certainly necessary for the full development of drawing, and adult advice, given at the right moment, may be helpful, in learning to draw children often have to act as their own caretakers, or rather, their own drawings have to act as caretakers for them, through the interaction between production and perception.

[2]As Moskowitz (1978) said of language:

> Children do not always understand exactly what it is that the adult is correcting. The information the adult is trying to impart may be at odds with the information in the child's head, namely the rules the child is postulating for producing language. The surface correction of a sentence does not give the child a clue about how to revise the rule that produced the sentence. (pp. 89–90)

The Drawing Process

Current accounts of the ways in which children produce drawings are based on one of two models: the camera or the computer. The camera model is a very old one and is assumed by all earlier writers on children's drawings. In cameras an image is projected onto the film by light rays coming from the scene, and this image is then captured by chemical processes. But the cameras we know today had predecessors, the best known of which is the *camera obscura*, and optical devices of this kind provided the model for early theories of visual perception.[1] Gibson (1971) quoted Sir Isaac Newton's account:

> The Light which comes from the several points of the Object is so refracted as to . . . paint the Picture of the object upon that skin called the Retina. . . . And these Pictures, propagated by motion along the Fibres of the Optick Nerves

[1] In its original form the *camera obscura* consisted of a dark room with a small aperture admitting light from the outside. Light rays from the scene passed through this aperture and formed an (inverted) image of the scene on the far wall. The *camera obscura* was first used for observing eclipses, but Giovanni Baptista della Porta popularized its use as an aid for artists in the mid-16th century (Kemp, 1992). In later versions the "darkened room" took the form of a closed box with a lens at one end and a mirror set at an angle to turn the image the right way up. This image may be projected onto a piece of paper, in which case the artist draws directly on top of it, or onto a ground glass screen, in which case the artist traces around the image on the screen. Many artists used drawing machines of this kind in the succeeding centuries; it seems probable, for example, that Vermeer used a *camera obscura* as a basis for his paintings. Kemp (1992) described a number of variants, many of them developed during the 19th century. William Fox Talbot possessed one of these variants called the *camera lucida*, and it may have been his inability to use it successfully that prompted him to fix the image chemically and thus invent photography.

into the Brain, are the causes of Vision. For accordingly as these Pictures are perfect or imperfect, the Object is seen perfectly or imperfectly. (p. 28)

Against the background of this theory of vision it seemed perfectly natural to writers on children's drawings to assume that the production of pictures by older children and adults could be explained in terms of the transference of views of scenes in the form of "pictures on the retina" to the surface of the paper. Gibson (1978) summed up the copying theory of pictures in this way: "Drawing is always copying. The copying of a perceptual image is drawing from life. The copying of a stored image is drawing from memory. The copying of an image constructed from other memory images is drawing from imagination" (p. 230). Gibson then went on to ask how copying an image was supposed to occur. As he pointed out, we have no means of projecting an image onto the paper in the way that an image in a camera is projected onto a film, but he observed that traditional theories of drawing tried to overcome this objection by saying, "If you cannot trace around the projected mental image at least you can copy it freehand. Perhaps drawing is not exactly like this, they say, but something like this. Otherwise what could it be?" (pp. 230–231).

Gibson (1978) himself rejected the copying theory, but its influence on theories of depiction remains very powerful. The obvious difficulty of using it to explain drawings by young children, however, as the early writers on children's drawings realized, is that their drawings do not look in the least like photographs. There are in fact two difficulties here: explaining why children use lines to represent the outlines of objects (rather than producing gray-scale images like full-tone black-and-white photographs), and explaining why their drawings are not in perspective. Very little attention was paid to the first difficulty; after all, older children and adults also produce line drawings, and the assumption was that these were produced by somehow mentally tracing around the internal perspectival mental images, much as a 19th-century artist might trace around the images produced by a *camera obscura* or *camera lucida*. The great difficulty lay in explaining why young children did not produce pictures in perspective.

Various explanations have been offered, as we have seen in chapter 2, but the earliest and most common explanation was to say that young children draw what they know rather than what they see. This explanation, however, introduced further difficulties, not the least of which lay in defining what children know of objects and scenes as distinct from what they see of them. There were, moreover, other problems with this theory, such as the difficulty of explaining why children draw tadpole figures without bodies and/or

arms or legs, even though they know that people have them. However, new theories of perception developed during the late 1970s and early 1980s, notably by Marr (1982) and his colleagues, seemed to offer a way out of at least some of these difficulties.

Marr's (1982) work on visual perception was strongly influenced by current work in artificial intelligence in which attempts were being made to model mental processes using the computer, and the subtitle of his book on vision—*A Computational Investigation Into the Human Representation and Processing of Visual Information*—reflects this influence. As a result, it is perhaps not surprising that the first suggestion that children's early drawings might be derived from object-centered internal descriptions rather than from perspectival mental images came not from developmental psychologists but from Minsky and Papert (1972) in an Artificial Intelligence report from the Massachusetts Institute of Technology. Commenting on a 5-year-old's fold-out drawing of a cube, they argued that the properties of a real three-dimensional cube are more directly realized in these fold-out drawings than in a "grown-up's pseudo-perspective picture":

> Each face is a square.
> The "typical" face meets four others!
> All angles are right!
> Each typical vertex meets 3 faces.
> Opposite face edges are parallel!
> There are 3 right angles at each vertex! (Memo No. 252, page unnumbered)

Minsky and Papert's (1972) suggestion was that children derive their drawings from object-centered descriptions, much as a computer would do. One advantage of using this computer model of the drawing process is that it could explain why children produce pictures in different drawing systems at different ages because computers are not limited to producing pictures in perspective, although they can do this also. Pictures produced by computers are typically derived from three-dimensional, object-centered descriptions in which spatial relations are described in terms of algebraic Cartesian coordinates. Transformation equations are then applied to these descriptions to produce two-dimensional pictures. By using different equations, pictures can be produced in any of the drawing systems, including not only the projection systems such as orthogonal projection, oblique projection, and perspective, but also pictures, similar to those produced by very young children, that are based on topological rather than projective geometry. In fact, the pictures produced by ROSE illustrated in Figs. 4.10, 4.11, and 4.12 pro-

vide examples of just such pictures. These drawings, which resemble those of 3-year-old children, were produced by a computer program and derived from three-dimensional, object-centered descriptions using transformation equations based on topological geometry.

Another attraction of the computer model is that it might explain why young children find it difficult to represent occlusion. (One object is said to occlude another object if it hides that object from an observer situated at a particular point of view.) In pictures produced by optical machines such as the camera or *camera obscura* the representation of occlusion is carried out automatically: the light rays from those parts of a scene that are hidden from an observer at a particular point of view simply fail to reach the lens and are therefore not represented in the image. But in pictures produced by computers, the occlusion of one object or part of an object by another has to be calculated by the process known as HLE. The position of a notional viewer has to be specified within an object-centered description of the scene, and the points at which edges disappear behind surfaces from this point of view then have to be calculated algebraically and converted into a representation of these points within the picture. Lines representing edges that pass behind surfaces at these points then have to be eliminated from the program. This process is complex and usually forms a large part of drawing programs.

Thus, in theory at least, it seems as if it should be possible to describe the process of picture production in children by analogy with such a program, and in this way it would be possible to account for the whole range of drawings systems used by children from tadpole figures to perspective. Such an account would derive all drawings, including pictures in perspective, from object-centered internal descriptions. However, although Marr (1982) and other writers have argued that we store object-centered descriptions in long-term memory to recognize objects when we see them again from a different direction of view, and this is now generally accepted, we must also be able to construct viewer-centered descriptions to manipulate objects and avoid bumping into things (Sutherland, 1979). Moreover, computer programs may also be used to store views of scenes, as they do when manipulating photographs.

Thus, within the computer model children may derive their drawings from object-centered descriptions or from viewer-centered descriptions, and the suggestion was that young children draw what they know in the sense of deriving their drawings from object-centered descriptions and older children draw what they see in the sense of deriving their drawings directly from views. This account is compatible with the observation that young children have difficulty in representing occlusion and, indeed, seems

to explain why this is the case. If the computation of hidden-line elimination is so complex and difficult for pictures derived from object-centered descriptions in computer programs, and this provides a model for children's drawings, no wonder young children have difficulty with it. But there is a snag with this simple and apparently persuasive account.

Once children begin to represent occlusion in their drawings it would surely be easier for them to derive their drawings from the observation of perspectival views, in which points of occlusion can be seen directly, than to go through the laborious process of deriving them from object-centered descriptions with all that this would involve in a computer model. If this were the case we would expect that children would find it easier to draw from life than from memory and that the production of drawings in perspective would appear fairly early in the developmental sequence. But as we have seen, this does not happen: children are reluctant to draw from life until a relatively late age, and drawings in perspective appear, if they ever do appear, at the end of the developmental sequence. Moreover, once children can represent occlusion they seem to have no difficulty in representing it in systems other than perspective. How then is the representation of occlusion carried out? I suggest that this process is not carried out before drawing begins (as it is in the computer model) but is carried out on the surface of the picture through the interaction between the child's internal representation of the scene and the pictorial image as it emerges during the drawing process.

The process of picture production in both the computer and camera models takes place in one direction only. In the camera model the rays of light form an image on the film but there is no feedback from this image to the scene. In the computer model all the computation necessary to produce a picture is finished within the program before drawing proper begins, and the representation of the picture that forms the end point of the program is realized physically after this computation has been finished. Again, there is no feedback from the physical realization of a picture during the production process. There is thus no equivalent in either the camera or computer models to our human perception of the pictorial image. In the camera model, views of scenes are mapped directly into pictures. In the computer model, algebraic object-centered descriptions of scenes are mapped into pictures by means of transformation equations. But accounts of picture production by both adults and children involve a third domain, that of the pictorial image. This is because we do not just see pictorial images in finished pictures. If the drawing sequence is carried out in an appropriate way, the pictorial image will begin to emerge during the drawing process itself, and it is the perception of this emerging pictorial image that guides picture production.

In the camera and computer models, the nature of the drawing sequence is of little or no importance. In both film and digital cameras all the parts of the image are, of course, captured simultaneously. In the *camera obscura* model, the complete image is thrown onto the paper or the ground glass screen and the artist has to trace around it, but the order in which this tracing is carried out is of little consequence: the artist can start anywhere within the image and either work downward from one end or jump from place to place. In the computer model, the whole picture is realized internally before drawing begins, so that when a picture is displayed on a screen all the parts of the picture will be realized simultaneously. If a printer is used, the top of the picture will be drawn first and the sequence in which the various parts of the picture are drawn has no significance. If, in contrast, occlusion is represented through the interplay among the scene, the picture, and the pictorial image, the sequence in which the various parts of the picture are drawn will play an important part in the drawing process.

Suppose, for example, that an older child wishes to draw a hat, either from life or from memory. The natural way to begin the drawing would be to draw the brim of the hat first, as shown in Fig. 9.1a. At this stage there may no pictorial image, and the region representing the brim of the hat may simply look like a flat ellipse. However, it can, by an effort of will, be made to look like a foreshortened circle and this interpretation can be used to determine, on the paper, the two points at which the line representing the contour of the crown of the hat should end. But once the crown of the hat is added, the interpretation of the elliptical region as a foreshortened circle is strengthened by the presence of the two T-junctions, which we interpret as points of occlusion (Fig. 9.1b). This gives depth to the picture, so that a stronger pictorial image begins to appear in the emerging drawing. Now,

a b c

FIG. 9.1. An appropriate drawing sequence for a human subject to use in drawing a hat. (a) The brim is drawn first as an ellipse. (b) The crown of the hat is added, and the two T-junctions cause the pictorial image to appear within the picture. (c) A line representing the contour of the surface of the brim as it turns into the crown can be added, and the positions of the two end-junctions can be determined within the context of the pictorial image.

guided by the shape perceived in this pictorial image, an experienced or talented child will be able to add the line representing the contour of the surface of the brim as it turns into the crown, using the pictorial image to determine the positions of the two end-junctions (Fig. 9.1c). Thus, even in this simple example the drawing process involves an interplay among the child's knowledge of the three-dimensional shape of the hat, the addition of lines as marks, and the perception of the (2+1)-dimensional pictorial image as the drawing progresses.

Contrast this with the drawing sequence shown in Fig. 9.2. This would be an inappropriate and bizarre sequence for a human subject to use, even if the hat were being drawn from life. But if the drawing were to be produced by tracing around the image on the ground glass screen of a *camera obscura*, it would be perfectly possible to use this sequence.

This example suggests that, whether in drawing from life or from memory, it is desirable to plan the drawing sequence in such a way that a pictorial image appears in the picture as soon as possible as a guide to further action, and in particular to guide the representation of occlusion.

The more complex the object or scene to be drawn, the more carefully the drawing sequence must be planned if errors are to be avoided. Failure to plan the drawing sequence appropriately is likely to result in characteristic errors in the representation of occlusion, and Fig. 9.4 shows one such error. In the experiment described in Willats (1977a, 1977b) children of various ages were asked to draw the scene shown in Fig. 9.3. All the children drew from the same fixed viewpoint, and from this viewpoint there were six points of occlusion in the view they had of the objects on the table.

Figure 9.4 shows one child's drawing of this scene that was classified as being in oblique projection. The mean age for children producing drawings in this class was 13 years 7 months. In this drawing there is a characteristic transparency error where the line representing the far edge of the tabletop

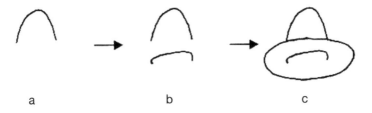

a b c

FIG. 9.2. An inappropriate drawing sequence for a human subject to use when drawing a hat from life or from memory. This sequence would, however, be possible if the drawing had been produced by tracing around the image on the screen of a *camera obscura*.

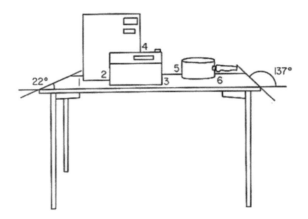

FIG. 9.3. The child's view of the scene to be drawn, including six points of occlusion for the objects on the table. Taken from Willats (1977a, Fig. 1).

FIG. 9.4. A drawing of the scene in oblique projection that includes a transparency error where the far edge of the table can be seen through the box. The child producing this drawing has tried to disguise this error by filling the region representing the box with scribbled lines and has failed to complete the drawing of the box. Taken from Willats (1977b, Fig. 5).

passes behind the box, and the child who produced this drawing has tried to disguise this error by filling in the region representing the box with scribbled lines.

Because the line representing the far edge of the table must have been drawn before the box was added it is possible to construct the probable drawing sequence. Figure 9.5 shows the first three stages in this sequence.

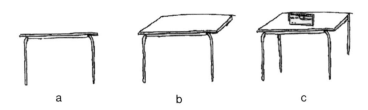

a b c

FIG. 9.5. A reconstruction of the probable drawing sequence employed in producing the first three stages of the drawing shown in Fig. 9.4.

In Fig. 9.5a the front of the table has been drawn as a true shape, and in Fig. 9.5b oblique lines representing the side edges of the table have been added, together with a horizontal line representing the far edge of the table. The pictorial image of the table is now well established, and in Fig. 9.5c the radio has been added, standing on the tabletop. This does not accord with the child's view of the scene, but at this stage the drawing contains no errors of occlusion within its own terms.

Figure 9.6 shows the next three stages. In Fig. 9.6d the saucepan has been added, with the handle filled in to avoid producing a transparency. Now, as shown in Fig. 9.6e, this child has begun to add the box, and this has inevitably produced a transparency. The lower edge of the box has been abandoned and the region representing the box has been filled in with scribble in an attempt to disguise the transparency error. In this case, establishing a complete pictorial image of the table by itself early on in the drawing sequence proved to be counterproductive.

Figure 9.7 shows another drawing of a table, also in oblique projection, in which this problem has been avoided by careful planning. In this drawing four points of occlusion have been correctly represented, but notice that only the three T-junctions marked with an asterisk correspond to the points of occlusion in the child's view of the scene shown in Fig. 9.3. Nevertheless,

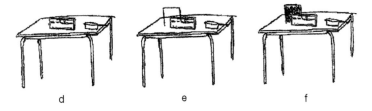

d e f

FIG. 9.6. The final stages in the drawing sequence. Because the line representing the far edge of the table was drawn early in the drawing sequence, it proved impossible to represent the occlusion of part of this edge by the box.

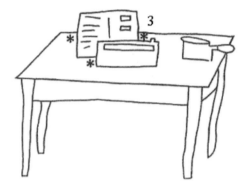

FIG. 9.7. In this drawing, three of the points of occlusion marked with asterisks corre-
spond to those available in the view shown in Fig. 9.3, but in the fourth point marked
with a 3, the line representing the far edge of the table disappears behind the box,
whereas in the child's view the edge of the table disappears behind the radio. Neverthe-
less, all four points of occlusion are correct within the context of the pictorial image.

all four points of occlusion are correct within the context of the pictorial im-
age available in this drawing. The odd man out is the point of occlusion
marked with a 3: in Fig. 9.3 the far edge of the table disappears behind the
radio, whereas in Fig. 9.7 it disappears behind the box.

Figure 9.8 shows the first stages in a probable drawing sequence for this
drawing. In Fig. 9.8b only the side edges of the table have been represented,
so that the pictorial image of the table that is beginning to emerge in the pic-
ture is not as clear as it is in the corresponding stage shown in Fig. 9.5b. But
leaving out the line representing the far edge of the table at this stage is es-
sential if the partial occlusion of this edge by the box is to be correctly repre-
sented in the final drawing.

Figure 9.9 shows the final stages used to complete the drawing. In Fig.
9.9d the saucepan has been added within the context of the pictorial image

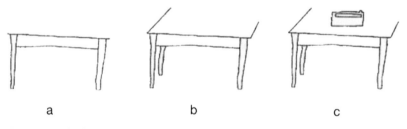

a b c

FIG. 9.8. The first three stages in the drawing sequence. Leaving out the line repre-
senting the far edge of the table at (b) is essential if the partial occlusion of this edge by
the box is to be correctly represented in the final drawing.

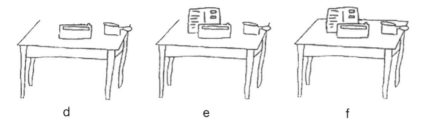

d e f

FIG. 9.9. The final three stages in the drawing sequence. At (d) the saucepan has been added, with the partial occlusion of the side edge of the table by the handle of the saucepan correctly represented. At (e) the box has been added within the context of the pictorial image of the radio and the tabletop. Finally, at (f), a line representing the far edge of the table is drawn in, with the partial occlusion of this edge correctly represented.

established in Figs. 9.9b and c. In Fig. 9.9e the box has been added within the context of the pictorial image of the table and the radio, and in Fig. 9.9f the far edge of the table has been added to complete the drawing within the pictorial image of the table and the box. The occlusion of the handle of the saucepan by the edge of the table in these drawings was not scored in Willats (1977a) because it did not occur in the children's view of the table. However, this occlusion is represented correctly in the drawing shown in Fig. 9.7 within the context of the pictorial image.

The role of the drawing sequence is just as important in drawings of smooth objects as it is in drawings of rectangular objects, and if the sequence is not planned appropriately characteristic errors are likely to occur in the finished drawing. In their tadpole figures children will try to establish at least a two-dimensional pictorial image as early as possible. The top row of Fig. 9.10 shows the drawing sequence in a drawing of a tadpole figure recorded by Goodnow (1977). The head or head/body was drawn first, and then the legs and arms. Once this had been done it is possible to see a man, however imperfectly, in the drawing. Then the eyes were added within the outline of what now represents a head. In contrast, the drawing sequence illustrated in the row below seems most improbable: the eyes, arms, and legs taken together do not establish even a two-dimensional pictorial image.

Drawing the outline of the head in its entirety at an early stage is a perfectly appropriate strategy for these simple figures, but can lead to problems in more complex drawings. Figure 9.11 shows the probable drawing sequence for a detail of the drawing of a man with a hat shown in Fig. 7.8b. (It is often possible to reconstruct the probable drawing sequence in this way because the line representing the occluding contour of a surface at a T-junction is likely to have been drawn before the contour it hides.) In this

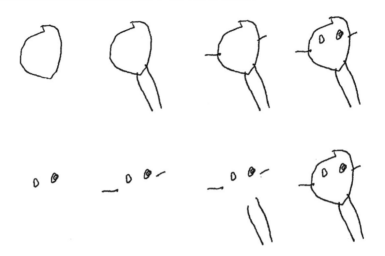

FIG. 9.10. Top row: the drawing sequence in a drawing of a tadpole figure. Adapted from Goodnow (1977, Fig. 4). Courtesy of J. Goodnow. Bottom row: an improbable drawing sequence for the same figure.

a b c

d e f

FIG. 9.11. A detail of a drawing of a man with a hat by a girl, age 10 years 10 months. A reconstruction of the probable drawing sequence. Drawing the entire outline of the head first resulted in transparency errors when the hat was added.

drawing the outline of the head would have been drawn first, as it was in the tadpole figure shown in Fig. 9.10, and then the facial features added within the context of this outline. Unfortunately, drawing the complete head at this early stage has led to a problem, because adding the hat inevitably introduced transparency errors. This is similar to the problem that occurred in the drawing of the table shown in Fig. 9.4, when completing the tabletop at an early stage in the drawing sequence resulted in a transparency error when the box was added. Thus, in order to produce the more complex drawings that occur later in the developmental sequence children not only have to acquire different and more complex drawing and denotation rules, they also have to learn to plan the drawing sequence in a different way. This will probably mean abandoning some of the drawing sequences that have become firmly entrenched during the earlier stages of development.

Figure 9.12 illustrates the drawing sequence that was used in a drawing of a portrait head, which is radically different from that normally used by young children. The nose had to be drawn first because the nose partially occluded one eye. Once this eye had been added, a (2+1)-dimensional pictorial image began to emerge, and the mouth was added within the context of this image. Adding the mouth strengthened the pictorial relief still fur-

FIG. 9.12. John Willats, *John Punshon*, 1963. Ball-point pen on paper, 26 cm × 20.8 cm. Collection of the author. The drawing sequence was governed by the rule that the line representing the contour of the occluding surface at a T-junction must be drawn before the contour it hides.

ther, and the ear and the glasses were then added. The glasses had to be drawn before the contour of the far side of the face because there are two T-junctions close together at the lower edge of the rim of the lens on the right. (The separation between these two T-junctions represents the visual dislocation of the contour of the cheek at this point, caused by the refraction of the light passing through the lens.) Once the contour of the cheek had been added the drawing could be completed.

Thus, the role played by the pictorial image is just as important in the production of individual drawings as it is as a mechanism of development. In the camera and *camera obscura* models occlusion takes place automatically within the image projected from the scene and is then copied onto the film or screen. In the computer model the points of occlusion are computed to form a representation of the picture, and this computation is complete before the process of picture production begins. In human picture production, in contrast, the representation of occlusion is achieved progressively during the process of production, guided by the pictorial image that emerges during the drawing sequence.

I have concentrated on describing the role of the emerging pictorial image in the representation of occlusion because this provides the clearest illustration of the difference between the production process I have described and the camera and computer models. However, this interaction is just as important in establishing the geometry of the drawing systems in a picture. In the camera and computer models this geometry is determined before drawing proper begins. In the camera model the geometry of the drawing system in the picture, which is necessarily that of perspective, is present in the projected image of the scene. In the computer model it is obtained using transformation equations. But in human picture production as I have described it this geometry emerges during the drawing process.

Consider in more detail, for example, the early stages of the drawing sequence the child might have used in producing the drawing of the table shown in Fig. 9.4. To begin with, the front faces of the table are drawn as true shapes (Fig. 9.13a). At this point the pictorial image is purely two-dimensional and there is no representation of depth. But as soon as the oblique line representing the side edge on the left is drawn a $(2+1)$-dimensional pictorial image will begin to emerge (Fig. 9.13b). So far, the two-dimensional geometry of the picture corresponds, more or less, to the geometry of the child's view of the table. In Fig. 9.13c the other side edge of the table has been drawn, but instead of the oblique line representing this edge being drawn in such a way that it converges toward a central vanishing point, it is drawn parallel to the other side edge. This establishes the geome-

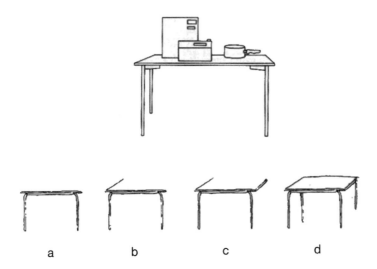

FIG. 9.13. The early stages of the drawing sequence for the child's drawing shown in Fig. 9.7. At (a) and (b) the geometry of the picture corresponds more or less accurately to the child's view of the scene, but at (c) the right-hand edge of the table has been added in oblique projection rather than perspective. At (d) the geometry of the lines representing the table legs is consistent with the pictorial image established at (c).

try of the pictorial image, with the axis of the third dimension running obliquely across the picture surface. In Fig. 9.13d the drawing of the table is completed by drawing the far edge and adding the other two legs, and the placing and geometry of these legs is fully consistent with the geometry of the pictorial image, so that if oblique lines were to be drawn joining the bottoms of the legs they would be parallel to the side edges of the table rather than converging to a vanishing point as they would do in the child's view of the table.

Why, when the geometry of the lines representing the front and left-hand edges of the table in the picture corresponds so closely to that of the corresponding edges in the child's view of the scene, has the line representing the side edge on the right been drawn parallel to the edge on the left rather than converging to a vanishing point? It seems inconceivable that a child who was capable of reproducing the geometry of the view so correctly at stages a and b could make such a gross error in copying the geometry of the view at c. A more plausible explanation is that this child had formed an internal object-centered description of the table and then drew the right-hand edge in accordance with the drawing rule for pictures in oblique projection, that is: Represent edges in the third dimension in the scene by parallel oblique lines in the picture. But drawing this line establishes the geometry of the pictorial

image so clearly that no further computation is needed. The table legs can now be drawn within the context of the three-dimensional pictorial image with almost as much ease as this child could run his or her fingers down the legs of the real table in the scene.

In this example the table was drawn from life, and it is possible that in drawing the front face and the left-hand edge of the table this child was guided by the two-dimensional geometry of his or her perception of a view of the scene. Thereafter, however, this child drew on his or her knowledge of the three-dimensional geometry of the scene in the form of an object-centered description and represented this geometry within the context of the pictorial image. Drawing from memory will follow essentially the same course. A child of a similar age, asked to draw a table from memory, would probably produce a similar drawing. In this case, however, he or she would draw the front face of the table as a true shape taken from an object-centered internal description and add a side edge for the tabletop using the drawing rule: Represent edges in the third dimension by parallel oblique lines. Thereafter, the other side edge might be drawn parallel to the first, resulting in a drawing in oblique projection. Alternatively, another child might draw the other side edge according to the drawing rule: Let lines representing edges in the third dimension converge to a vanishing point, resulting in a drawing in perspective. Subsequent details would then be added within the context of a *perspectival* pictorial image.

Marr's (1982) distinction between object-centered and viewer-centered internal descriptions thus has an important role to play in making sense of children's drawings, but as Costall (2001) has pointed out, there are pitfalls in equating this with Luquet's (1927/2001) distinction between intellectual and visual realism. Some writers have tended to suggest that young children's drawings are in themselves object-centered descriptions, but as Costall rightly said, "It is important to be clear that children's drawings are not—and could not—themselves be object-centered representations in Marr's sense" (note 13, p. xxi). Object-centered descriptions are by definition three-dimensional and cannot be directly transferred onto the picture surface. Pictures can be derived from object-centered descriptions (as they are in computer programs), but this necessarily involves some kind of transformation from three dimensions to two.

Just because a picture provides a view this does not mean that it must have been derived from a view. Traditionally, children's drawings have been classified as being either intellectually or visually realistic on the basis of

whether they do or do not provide possible views, but this is not necessarily any guide to whether they have been derived from views. In fact, the example given earlier and illustrated in Figs. 9.4 and 9.13 suggests that even drawings by older children are predominantly derived from object-centered descriptions, and this seems to be true even for drawings made from life rather than from memory.

Another argument against equating the distinction between drawings derived from object-centered scene descriptions and drawings derived from viewer-centered descriptions with the traditional distinction between what children know and what they see is that the change from intellectual realism to visual realism was supposed to take place at the age of about 8 or 9 (Freeman, 1972). However, the example given earlier shows that drawings in oblique projection, such as this drawing of a table, must be derived, at least in part, from object-centered descriptions, and the mean age of children producing drawings in oblique projection in this experiment was 13 years 7 months. There is also evidence to show that the majority of drawings by naive adults are derived from object-centered descriptions, even when the task is to copy a view in perspective (Freeman, Evans, & Willats, 1988; the results of this experiment are illustrated in Willats, 1997, Fig. 8.9).

Thus, the traditional theory that young children draw what they know and older children draw what they see has little explanatory value, and it cannot be saved by saying that young children's drawings are derived from object-centered descriptions and older children's drawings are derived from viewer-centered descriptions. The evidence suggests that most children's drawings are predominantly derived from object-centered descriptions, and this is perhaps not surprising because the primary function of the human visual system is to extract object-centered descriptions from views.

Because drawings by older children often provide possible views of objects and scenes this does not necessary mean that they draw what they see in the crude sense that their drawings have been derived from views. Instead, what children are doing during the course of drawing development is to discover ways of producing drawings that provide possible views of objects and scenes, and they do this because such drawings are more effective as representations. Some children may be guided, at least in part, by the two-dimensional geometry in their views of scenes, but for the most part children learn to produce effective representations in the form of possible views by applying increasingly complex and powerful transformation rules to internal object-centered descriptions. Moreover, these transformations from

scenes to pictures do not just take place in one direction as they do in cameras and computers. Instead, drawing by even the youngest children involves some feedback from the picture. In humans, in contrast to cameras and computers, producing a drawing depends on a continual interplay among the scene, the picture, and the pictorial image as it emerges during the course of the drawing process.

Part Three

CHILD ART

Children as Artists

Child's play! Those gentlemen, the critics, often say that my pictures resemble the messes and scribbles of children. I hope they do! The pictures that my little boy Felix paints are often better than mine because mine have often been filtered through the brain.
—Paul Klee, quoted in Wiedmann, 1979, p. 224; Wilson, 1992, p. 18

It is often claimed that children are naturally gifted as artists and that their work is free, spontaneous, and creative. R. R. Tomlinson, Senior Inspector of Art to the London County Council, began his book *Children as Artists* (1944) with these words:

> A generation ago, the title of this book would have been considered face-tious. . . . Owing to the courage and tenacity of pioneer teachers, however, and the fuller understanding by the general public of modern developments in painting, all but a few will today accept the title of this book without question. (p. 3)

As Wilson (1992) has pointed out, child art now seems to have lost some of its status as art. It is less often seen to have an affinity with what adult artists do and is less often displayed in the galleries of museums. Nevertheless, the almost obligatory display of children's drawings in doctors' consulting rooms and the thousands of children's drawings attached to refrigerators in kitchens attests to the enduring belief that children's drawings are in some sense works of art. How did this belief come about? In the passage quoted previously Tomlinson (1944) gave two reasons: the efforts of pioneer teachers and the shift in ideas about art on the part of the general public. An addi-

tional reason, however, was that many artists at the beginning of the 20th century became interested in children's pictures and hailed them as works of art. One important factor in this recognition was that children's drawings and paintings and the work of the avant-garde often looked remarkably alike, and in this chapter I concentrate on describing the formal similarities between the art of the avant-garde in the early and middle 20th century and children's drawings and paintings. That these similarities exist is undeniable, but the inference that young children are therefore artists in the way that Klee, Matisse, and Picasso were artists is, I believe, mistaken.

The belief that children are natural, spontaneous, creative artists originated with Franz Cizek in Austria and Marion Richardson in England. Cizek was a student of painting at the Vienna Academy in the 1880s, and it was there that he first became interested in the art of children. What intrigued him was that the drawings children produced on their own were quite different from those that they produced at school. Cizek became a teacher and was given official approval for his private art classes for children in 1897. The year before, Cizek and many of the younger Austrian artists had severed their connections with older artists working along traditional lines and had started the movement known as the *Sezession*, and through Cizek these younger artists became acquainted with paintings and drawings by young children. In 1906 his art classes for children were incorporated into the Vienna Arts and Crafts School, and pictures produced by these children were exhibited at the Kunstschau in 1908. Cizek, together with other artists, served on the committee for this exhibition, which was chaired by Gustave Klimt. In Germany, children's pictures were reproduced alongside paintings by European avant-garde artists in *Der Blaue Reiter*, edited by Wassily Kandinsky and Franz Marc. The Blaue Reiter group, which also included artists such as August Macke and Klee, was founded in 1911 and represented the high point of German Expressionism. In Italy, the Futurist Exhibition in Milan in 1911 also included children's drawings. A number of avant-garde artists, including Kandinsky, Klee, and Joan Miró, made collections of children's drawings and included motifs taken from them in their work (Fineberg, 1997).

Exhibitions of children's work done under the guidance of Cizek were held in London and many other countries, and attracted a great deal of attention. Richardson was a young art teacher at Dudley High School for Girls, and the results of her revolutionary teaching there, inspired by the work of Cizek, were first given publicity by being included in an exhibition of children's drawings held at Roger Fry's Omega Workshops. It seems that Richardson had seen one of Fry's Post-Impressionist Exhibitions; these were

dominated by Picasso and Matisse but also included paintings by Paul Cézanne, Clive Bell, Duncan Grant, and Wyndham Lewis. In 1917 she met Fry for the first time and showed him her children's drawings, which he added to his current exhibition.

Thus, by the early years of the 20th century many European artists of the avant-garde had seen children's paintings and drawings exhibited together with their own work. What was it about these pictures that held their attention? And why was it that art teachers, influenced by the work of Cizek and Richardson, claimed that the children under their care were producing works of art?

The most obvious similarity between children's drawings and the work of the avant-garde artists is their lack of perspective. During the latter half of the 19th century Cézanne had begun to produce pictures in drawing systems that approximated to the parallel systems rather than perspective, and in 1912 the critic Jacques Rivière wrote:

> Perspective is as accidental as lighting. It is the sign, not only of a certain moment in time, but also of a certain position in space. It indicates not the situation of the objects, but that of a certain spectator. . . . A house which has trees put in front of it by perspective can end up as two, disconnected, white triangles. . . . It is true that reality shows us objects mutilated in this way. But in reality we can move around: a step to the right and a step to the left completes our vision. Our knowledge of an object is, as we have said, a complex sum of perceptions. Since the plastic image does not move, the plastic image must be complete within a single glance and so has to renounce perspective. (pp. 392, 393)

Many painters, especially the Cubists, took this program to heart, and the renunciation of perspective is almost the hallmark of painting at the beginning of the 20th century. One reason for this seems to have been the new theory of visual perception developed by the psychologist Herman von Helmholtz in the middle of the 19th century, and it was the influence of this theory on Cézanne that marked the beginning of modern painting. Ever since the Renaissance theories of vision had been based on the laws of optics, and it was these theories that informed the discovery and development of perspective. But Helmholtz began to describe vision in terms, not just of the images projected by light on the retina but also in terms of how these images were processed by the human visual system. Helmholtz called his account of vision *physiological optics*, in contrast to physical optics, and this account was the precursor of the theory of vision developed by Marr (1982) and his colleagues.

Teuber (1980) has described the influence of Helmholtz's theory of vision on Cézanne, and through him on the Cubists, in this way:

> In *Houses at L'Estaque* (1908) Georges Braque rendered his houses in terms of canonical cubes, his trees display basic cylindrical shapes. These ideas were current in France and already advocated by Cézanne when he advised: "Treat nature in terms of the cylinder, the cone, the sphere." It was Helmholtz who had shown in the third part of the *Physiolgical Optics* (French translation, 1867) that we see in each illusionistic or perspective transformation of an object more than the retinal image, that we "add to it," as his followers in France put it (nous ajoutons) the basic form or idea of the object. We see in all perspective renderings and even in the confusing shapes of nature the constant, non-illusionistic forms of cylinder, cube and sphere. (p. 3)

This seems very close to Marr's (1982) account of the computation of permanent object-centered descriptions from retinal images as the primary function of the human visual system.

In pictures in perspective the shapes of the faces of objects are distorted, and as Rivière (1912) said, "It is true that reality shows us objects mutilated in this way" (p. 392). The alternative is to represent these faces as true shapes, and this was the system adopted by many of the Cubist painters. But this is also the system used by many children. Figure 10.1a shows a detail from Braque's *Viaduct and Houses at L'Estaque*, 1908, and Fig. 10.1b shows a drawing of a house by a 9-year-old girl. In both cases the sides of the houses are, as far as possible, drawn as true shapes.

a b

FIG. 10.1. (a) Georges Braque, *L'Estaque: Viaduct and Houses* (detail), 1908 © ADAGP, Paris and DACS, London 2004. Oil on canvas, 72.5 cm × 59 cm. Private collection, Paris. (b) Nine-year-old girl, drawing of a house. Taken from Golomb (1992, Fig. 159). Courtesy of C. Golomb.

Pictures of this kind correspond to either horizontal or vertical oblique projections, and both these systems are common in early Cubist paintings. Nearly 30 years earlier Cézanne had used these systems in his *Still Life With a Commode*, c. 1887–1888: the table in the foreground is in close approximation to vertical oblique projection and the commode behind it is in horizontal oblique projection (Willats, 1997, Fig. 2.7).

The majority of later Cubist paintings were still lifes rather than landscapes, and in these paintings the most commonly used system was vertical oblique projection. Many of these paintings show objects on a table, and the faces of these objects, the tops of the tables, and the front faces of the table are commonly shown as true shapes. Figure 10.2a, for example, shows Picasso's *Still Life With Fruit Dish on a Table*, and here the top and front faces of the table, the top and front views of the wine glass, and the sections of the apple and the pear are all shown as true shapes. For comparison, Fig. 10.2b shows a child's drawing of a table with various objects on it, and here the top and front faces of the table, the faces of the box, and the front face of the radio are also shown as true shapes.

Both these pictures provide approximations to vertical oblique projection, but the similarity between them lies not so much in the drawing systems on which they are based but in the fact that both contain pictorial anomalies. In the Picasso painting most of these anomalies concern the representation of occlusion. The various objects on the fruit dish, for example, are represented in a way that takes little account of whether they could be

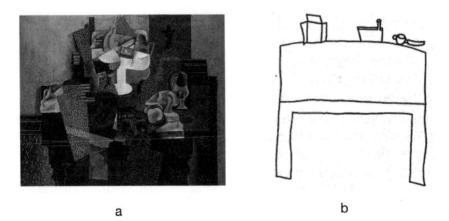

a b

FIG. 10.2. (a) Pablo Picasso, *Still Life With Fruit Dish on a Table*, 1914–1915 © Succession Picasso/DACS 2004. Oil on canvas, 64 cm × 80 cm. Columbus Museum of Art, Ohio. Gift of Ferdinand Howald. (b) A child's drawing of a table, mean age 11 years 11 months. Taken from Willats (1977a, Fig. 9).

seen from a particular point of view. In the child's drawing the objects are lined up on the far edge of the table, and the box is in the form of a fold-out drawing. Moreover, both pictures contain mixtures of drawing systems. The sections of fruit in the Picasso painting and the radio in the child's drawing are represented in orthogonal projection, whereas the tables are in vertical oblique projection. It was the presence of anomalies of this kind that appeared in both children's drawings and the art of avant-garde artists that led early art educators to claim that children were naturally creative. As Cizek put it, "The most wonderful thing is that the more the work of the child is filled with so-called 'faults' the more beautiful it is" (Viola, 1936, p. 24).

There are, unquestionably, similarities between the anomalies in Cubist paintings and children's drawings, but these similarities do not of themselves prove that all children are avant-garde artists. I have argued in previous chapters that drawing systems such as orthogonal projection, vertical and horizontal oblique projection, and the fold-out drawings occur as the result of children applying simple rules (Draw the faces of objects as true shapes, and Join the faces) to internal object-centered descriptions. One of the aims of the Cubists was to depict the basic form or idea of an object, something close to what Marr (1982) meant by an object-centered description. To this extent, the drawing systems found in Cubist paintings and children's drawings spring from similar causes: both are derived, more or less directly, from object-centered descriptions. According to Cooper and Tinterow (1983), "Gris's fundamental pictorial aim was to represent a three-dimensional experience of reality in two-dimensional terms on the surface of the canvas without recourse to illusion, an aim shared with Braque and Picasso" (p. 136). One way of solving this problem was to draw the faces of objects as true shapes. The same solution can be found in children's drawings, but the limitation of this approach, as Costall (2001) pointed out, "is that it is impossible to connect all the parts of an object *to one another*" (p. xvii). Many of the anomalies in children's drawings and Cubist paintings are a consequence of their attempts to solve this problem.

Nevertheless, there are important differences in children's intentions, and the intentions of the artists of the avant-garde. Children aim at realism, and when children become aware of anomalies in their drawings, such as the transparencies arising from their inability to represent occlusion and their failure to get the faces and corners to join up properly in the fold-out drawings, they try to find new ways of representation in which these anomalies can be avoided. I argued in chapter 8 that it was the perception of these anomalies and their attempts to overcome them that provided the driving

force behind drawing development. In contrast, the artists of the avant-garde welcomed these anomalies and used them deliberately: to investigate the nature of depiction, to be expressive, and to flatten the picture surface in the interests of visual delight.

Investigating the Nature of Depiction

One of the most profound changes that took place in painting during the 19th century was that artists became aware that painters in other periods and cultures had used drawing systems that differed from perspective and denotation systems that did not depend on the play of light. Japanese woodblock color prints, for example, became widely known in France from the early 1860s, and their lack of conventional perspective and tonal modeling, and the use of uniform areas of pure color, offered an alternative to the conventions of European painting and a solution to the problem of combining the representation of color with the representation of shape through tonal modeling. In addition, the invention of photography faced artists with a dilemma. The mechanical nature of photography seemed to guarantee its truth, and fitted in perfectly with the discovery of perspective as the basis for Western art, but at the same time it seemed to undermine the status of painters as artists. Moreover, only a few years after photography was invented Helmholtz announced his theory of vision, so that just as it became possible to produce pictures that faithfully capture the light coming from the scene the validity of these pictures as records of what we actually experience in vision was being questioned. All these circumstances challenged current ideas about the nature of depiction, and this led many painters to turn away from depicting objects in the scene and instead to use painting as a way of investigating painting itself (Willats, 1997).

One way of doing this is to turn the normal rules on their heads and see what happens. In the 1950s and 1960s Chomsky (1959, 1965) had used anomalous sentences such as "colorless green ideas sleep furiously" as a way of investigating the rules of language, and in the 1970s Clowes (1971) and Huffman (1971) had used pictures of impossible objects to investigate the rules of line drawing. But long before this, avant-garde painters had been using anomalies to explore the rules of painting. Probably the first painter to do this deliberately and consistently was Juan Gris.

Figure 10.3a shows Gris's *Guitar* drawn in 1913. The table (or what we can see of it) is in vertical oblique projection, and the guitar is in horizontal oblique projection. That is, the front of the guitar is shown as a true shape,

a b

FIG. 10.3. (a) Juan Gris, *Guitar*, 1913 © ADAGP, Paris and DACS, London 2004.
Graphite on paper, 65 cm × 50 cm. Private collection. There are false attachments be-
tween the rim of the glass on the left, and the foot of another glass and a line perhaps
representing the edge of a shadow of the guitar. There are numerous anomalies in the
representation of occlusion. (b, top) An 11-year-old boy's drawing of a table showing a
number of false attachments. (b, bottom) Examples of transparencies, violating the nor-
mal rules of occlusion.

and the side faces are added to it. The glasses are in a mixture of orthogonal
projection and vertical oblique projection. There are, in addition, two
kinds of anomalies in the drawing. At the bottom of the drawing the rim of
one glass is falsely attached to the foot of another on one side and to a line,
perhaps representing the edge of a cast shadow of the body of the guitar, on
the other side. The representation of occlusion is difficult to disentangle,
but there are various anomalies, where, for example, the strings and
sounding board of the guitar are twisted around into the plane of the pic-
ture. On the left, the edge of the body of the guitar is hidden, but on the
right it can be seen through the sounding board as a transparency. The two
children's drawings shown in Fig. 10.3b are also based on a mixture of or-
thogonal projection and vertical oblique projection. In both cases the ta-
bles are drawn in vertical oblique projection (although there is a hint of
perspective in the table at the top), but the box and the radio are drawn in
orthogonal projection. The drawing at the top contains a number of false
attachments among the edges of the table, the box, the radio, and the
saucepan. In the drawing at the bottom there is a false attachment between

the bottom edges of the box and the radio, and in addition there are a number of transparencies where the far edge of the table can be seen through the box, the radio, and the saucepan.

Gris's *Breakfast*, painted a year later in 1914, contains mixtures of drawing systems, reversals of the normal rules of occlusion, false attachments between objects in the picture, false attachments between object in the picture and the frame, reversals of the normal rules for atmospheric perspective, the inclusion of real surfaces such as wallpaper, and the inclusion of lettering (Willats, 1997). With the exception of atmospheric perspective, which children never use, examples of all these anomalies can also be found in children's drawings. Children typically use mixtures of drawing systems in their pictures, and Fig. 10.3b shows examples of both transparencies and false attachments. Children also have no inhibitions about including lettering in their pictures, as Fig. 8.15 shows. Thus, many of the pictorial anomalies found in Gris's paintings and those of the other Cubists can also be found in children's drawings. But the difference is that whereas the Cubists, and Gris especially, used these anomalies deliberately as a way of investigating the nature of depiction, in children's drawings they occur fortuitously. When children become aware of these anomalies they regard them as errors and try to eliminate them from their drawings in the interest of producing more effective representations.

Many of the paintings and drawings that Klee produced toward the end of his life also contain pictorial anomalies, judged by the standards of 19th-century academic painting. Most of these exploit the status of lines, as either marks or picture primitives, and are of a very different kind to the anomalies used by the Cubists. In his *Shipwrecked*, 1938, shown in Fig. 10.4a, although we see the lines as contours, the primitives in this picture are regions rather than lines. As in children's threading drawings, such as the drawings shown in Fig. 10.4b, the main shape property represented is extendedness, but the shapes of the regions are modified by secondary properties that include "being pointed" and "being bent." Thus, the lines as marks only define the outlines of regions, and the detailed shapes of these lines, which in both Klee's drawing and the drawings by the 8-year-old girl shown in Fig. 10.4b are irregular, are not in themselves significant.

The anomalies used in Klee's *With Green Stockings*, painted a year later in 1939, are much more complex (Fig. 10.5a). As in *Shipwrecked*, the marks used are lines, but with the addition of patches of color. However, unlike *Shipwrecked*, the lines stand for different kinds of picture primitives in different parts of the picture, and these lines change their meaning along their length. Figure 10.5b shows a drawing by a 4-year-old girl in which the arms and legs are represented by single lines. In chapter 3 I argued that the lines in

a b

FIG. 10.4. (a) Paul Klee, *Shipwrecked*, 1938, 427 (Z7) © DACS 2004. Crayon, 29.5 cm × 20.3 cm. Klee-Stiftung, Berne. (b) A drawing by Amy, 8 years 7 months. Although lines are used as marks in both these drawings, the picture primitives are regions with the addition of shape modifiers such as "being pointed" and "being bent." Taken from Cox (1992, Fig. 4.4). Courtesy of M. Cox.

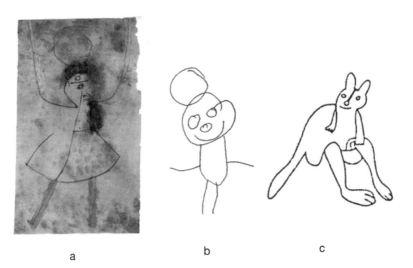

a b c

FIG. 10.5. (a) Paul Klee, *With Green Stockings*, 1939, 1009 (CD9) © DACS 2004. Watercolor and blotting paper, 34.9 cm × 21.0 cm. Felix Klee Collection, Berne. (b) A drawing of a man with a plate by a girl, 4 years 6 months. Taken from Willats (1992a, Fig. 2). (c) A child's drawing of a model kangaroo. Taken from Reith (1988, Fig. 2).

drawings of this kind stand for long regions as picture primitives and that these in turn denote long volumes for the arms and legs. In Klee's painting, also, single lines of this kind are used to stand for the arms and legs. However, instead of ending at the outlines of the body, as they do in the drawing by the 4-year-old, these lines continue into the body of the girl, but in doing so they change their meaning. The line representing the arm at the top left of the painting, for example, changes its meaning at the girl's shoulder and turns into a line representing the contours of the girl's neck, chin, cheek, and head. Similarly, the single line representing the girl's leg on the left changes its meaning as it passes the edge of the skirt, becoming first the contour of a fold within the drapery of the skirt, then the bounding contour of the girl's bodice, and finally the ridge of muscle in the girl's neck.

The lines in drawings by older children do sometimes change their meanings, as Fig. 10.5c shows, but this is very much a transitional stage. As I pointed out in chapter 7, the line at the bottom left of the figure changes its meaning as it moves around the lower part of the body to the leg, with the occluding surface first to the left of this line and then to the right (Fig. 7.6). Similarly, a line at the top of the drawing changes its meaning as it moves from the contour of the head to the contour of the arm where four lines meet. Throughout these changes of meaning, however, all these lines keep their status as lines denoting contours.

But in Klee's painting the changes of meaning that the lines undergo are much more radical. At the bottom right the line denotes the leg as a volume, but as soon as it passes the edge of the skirt it denotes a contour. Klee thus mixes, in a single drawing, denotation systems taken from the extremes of drawing development in children. *With Green Stockings* also contains a number of other anomalies. There is a false attachment between the line representing the leg on the right and the fold of the skirt, and two false attachments between the ends of the lines representing the arms and the top edge of the paper. There are also three false end-junctions: one where the contour of the skirt ends at the middle left of the painting and two resulting from a failure of closure in the representation of the girl's ball. Even young children are normally careful to avoid such failures of closure, and the slight gap in the outline of the plate above the head of the 4-year-old in Fig. 10.5b is no doubt only the result of a slight failure in motor control. (For a more detailed analysis of Klee's *With Green Stockings* see Willats, 2003.)

Changes of meaning in the representational status of lines along their length are rare in children's drawings and where they do occur they are no doubt involuntary. In Fig. 10.5c the changes of meaning have come about as a by-product of this child adding schematic forms to a contour, as Reith

(1988) suggested. At a slightly later stage of development such "faults" have been eliminated (Fig. 7.7b).

In contrast, there is no doubt that Klee used such anomalies deliberately, and similar anomalies appear in a number of paintings and drawings that he produced at this period. In *Oh, but oh!*, 1937, for example, a single line is used, successively, to denote the edges of a bow tie, the contour of a cheek, a patch of tone representing an eyebrow, the ridge of a nose, and a furrow in the upper lip (Willats, 1997). As Klee (1961) said, "I have carried out many experiments with laws and taken them as a foundation. But an artistic step is taken only when a complication arises" (p. 454). But perhaps the strongest evidence that Klee was using the anomalies in *With Green Stockings* deliberately lies in the painting itself. The use of color in this painting, apparently so artless and decorative, is in fact crucial to its meaning. At precisely the points where the lines representing the arms and legs change their meaning these changes are marked by the edges of patches of color: yellow for the arms (unfortunately not visible in this black-and-white reproduction) and green for the legs. Hence, the title of the painting: *With Green Stockings*.

Expression

The primary concern of Gris, Klee, Braque, and Picasso was to find a way of painting, and the anomalies in their paintings and drawings formed part of this research. As Picasso said, "I never do a painting as a work of art. All of them are researches. I search incessantly, and there is a logical sequence to this research" (O'Brian, 2003, p. 81). Other painters of the avant-garde, however, including Chagal, de Chirico, Derain, and Matisse were more concerned with the use of anomalous representational structures as a means of expression. Many of their experiments depended on the use of color, which cannot be reproduced here. However, Fig. 10.6a shows de Chirico's *Mystery and Melancholy of a Street* (painted in 1914, the same year as Gris's *Breakfast*), in which an anomalous mixture of drawing systems is used expressively. The subject matter of this painting is not in itself especially remarkable, although the shadow of the hidden statue thrown across the empty street perhaps conveys a sense of menace. The combination of mystery and melancholy that this painting conveys thus seems to have little to do with its overt subject matter. Instead, de Chirico used the incongruous mixture of drawing systems in this painting as a means of expression. The arcades to either side have different vanishing points and the van is drawn in oblique projection, so that the spatial system in this picture as a whole is in-

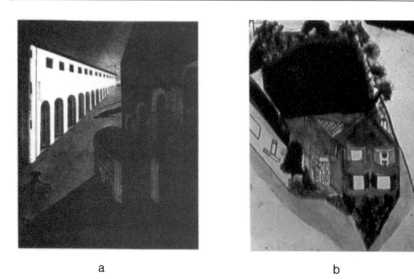

a b

FIG. 10.6. (a) Giorgio de Chirico, *Mystery and Melancholy of a Street*, 1914 © DACS 2004. Oil on canvas, 87.0 cm × 71.0 cm. Private collection. (b) A child's painting of a house, containing a mixture of oblique projection and inverted perspective. Collection of the author.

coherent. The critic James Soby (1966), commenting on the spatial systems in de Chirico's paintings, wrote that "geometry has been wilfully altered for purposes of poetic suggestion" (p. 71).

The child's painting of a house shown in Fig. 10.6b also contains mixtures of drawing systems—in this case, a mixture of oblique projection and inverted perspective—and like the painting by de Chirico this picture seems to have certain expressive qualities. But in this case it seems unlikely that this was intended. Instead, this mixture of systems has almost certainly come about as the result of this child's struggles to master a new drawing system, much as the mixtures of systems in early Italian painting, expressive though they may seem, came about as the result of these painters struggling to master perspective.

Anomaly is not, of course, the only means of expression available. Other means of expression that artists have used include facial expression, posture, eye direction, and composition. All these means of expression, including two kinds of anomalous pictorial structures, have been put to use in the drawing shown in Fig. 10.7. Unlike the other pictures I have discussed, this is not a major work of art but a simple book illustration; nevertheless, it is in its way highly expressive. The drawing illustrates the following passage in Wolf Mankowitz's (1967) *A Kid for Two Farthings*:

FIG. 10.7. James Boswell, "Joe knew that Mrs. Abramowitz meant no harm, but he wished she wouldn't pinch his cheek." Taken from Mankowitz (1967, p. 50).

Whenever it wasn't raining, even in the winter, Mrs Abramowitz, who had a small fancy button shop, used to sit by the open door on a bentwood chair watching people pass. Joe knew that Mrs Abramowitz meant no harm, but he wished she wouldn't pinch his cheek like a hen's bottom, because it made him feel as if he was going to be cooked, and also it hurt. Whenever she called out, "So, my Joe, how is your Mummy?" so that Joe would have to stop and talk to her, he tried to keep out of her way. (pp. 43-44)

In the drawing Mrs. Abramowitz is looking intently at Joe, but Joe is looking slightly away and his expression is more equivocal. Mrs. Abramowitz is sitting four-square, and leaning toward Joe, but Joe is leaning away, balancing on one leg, and is ready to go. On the left, the lines of the doorway behind Mrs. Abramowitz are vertical, and there is a false attachment between the vertical line on the extreme left and the contour of Mrs. Abramowitz's back, anchoring her to her chair. Although Mrs. Abramowitz is leaning forward, and would like to reach Joe's cheek, she is going to stay put. On the right, in contrast, most of the lines are horizontal and run out in the direction in which Joe would like to disappear. Moreover, a number of these lines stop short of the contours of the figure, and parts of the contours of Joe's feet are missing. This gives an effect of impermanence and movement, rather like the semitransparent images in a photograph of a moving object taken with multiple exposures. These suggestions of imminent movement, however, are contradicted by the false attachment between the bottom of Joe's trousers and the line of the skirting behind it. This has the effect of keeping Joe fixed, like the false attachment fixing Mrs. Abramowitz to her chair. In this way the emotional relations between Joe and Mrs.

Abramowitz are expressed in the structural features of the picture. Joe is fixed to the spot by his desire to avoid being rude to Mrs. Abramowitz, but he is nevertheless poised for flight.

Few children are capable of expressive effects of this kind. Even with older children Golomb (1992) found: "In general, it is the head or face that is singled out as the carrier of effective meaning, while body posture remains essentially undifferentiated" (p. 135). The representation of facial expression is limited to showing the mouth as either up-turned, down-turned, or straight, and the representation of expression by posture, where it occurs at all, is even more limited. And because most children are restricted to showing the head either in full face or full profile the representation of expression through eye direction is hardly, if ever, possible.

Figure 10.8, shows a painting of an emotionally highly charged scene by an 11-year-old girl. For a girl of this age this painting is, perhaps, unusually successful in its representation of emotion. The facial expressions of the figures are sad, and the representation of posture, with the boy's arm around the girl and his feet turned in, is quite effective. There is, however, no significance in the representation of eye direction. It is difficult to know whether the sense of chaos resulting from the incoherent use of perspective,

FIG. 10.8. A girl, 11 years, *The Refugees*. Taken from Tomlinson (1944, p. 17).

although it is appropriate enough for the subject of the picture, is deliberate or accidental. The painting contains two false attachments or near false attachments (between the girl's bag and the boy's trouser leg, and between the girl's leg and the patch of shadow), but these seem accidental. Thus, although it is often claimed that children's drawings are expressive, their means of expression seem, for the most part, to be confined to the choice of subject matter and the representation of facial expression. If we compare this painting with *A War Wedding* (Fig. 10.10), although one depicts a sad scene (refugees) and the other a happy scene (a wedding), it would be difficult, without the titles, to identify the differences in emotional content from the ways these pictures are painted.

Visual Delight

I have taken the term *visual delight* from the account that Wollheim (1998) gave of the pleasure we take in painting in his *Painting as an Art*. Wollheim deliberately ignored "the strictly philosophical question, What is visual delight? What is the nature of the pleasure we take in painting?" "Instead," he said, "I shall concentrate on the question . . . What is the source of visual delight. What aspect of painting gives us the pleasure that we characteristically derive from it?" (p. 98). Part of this pleasure, Wollheim suggested, comes from a simple pleasure in subject matter. But in addition we can take pleasure in the contrast between painting and reality, and the contrast between the painting as a depiction and the marks on the surface.

> If the pleasure connected with subject matter is not simple, but depends on a contrast, a fluctuation of interest, between painting and reality, so also, I believe, the pleasure connected with *matière*, with the stuff, rests upon contrast. But this time the contrast occurs within the picture. It occurs between nearer and more distant views of the paint surface. (Wollheim, 1998, p. 99)

To restate this in terms of the account of depiction I have given throughout this book, the contrast between painting and reality lies in the contrast between the pictorial image and the scene, and the "pleasure connected with *matière*, with the stuff" lies in the contrast between the marks and the pictorial image. When we look at a picture, what we see is not a real scene but a pictorial image: a paradoxical scene that shares some of the properties of real scenes but not others. This paradoxical scene appears to have depth, but when we step to one side the scene does not change. There is thus a contrast

between the two domains, and we can take delight in the tension that exists between them. But for the delight to be intense this contrast must be strongly marked. When we look at a trompe l'oeil painting and are deluded into thinking that the scene we see is real, this contrast does not exist, and the only pleasure we can take is in the scene itself. Afterward, of course, if we become aware that it is only a painting, we may take pleasure in the deceit, but this is another kind of pleasure. Conversely, if a painting is very crudely or ineptly painted, the pictorial image as a domain with depth may hardly exist, so that the pleasure we can take in the tension between the two domains may be slight. For this kind of pleasure to be intense, there must be an equal balance between the two domains.[1]

Similarly, for us to take pleasure in the "*matière*, the stuff" there must also be a balance between the domain of the marks and the domain of the pictorial image. There is not much pleasure in looking at an artist's palette, however bright the colors, in which no pictorial image exists, nor is there much pleasure to be gained by looking at the contrast between the depicted scene and the mark system in a photograph because all the balance is on the side of the depicted scene. Again, the greatest pleasure comes when there is an equal balance between the two domains.

One reason much 19th-century painting is so boring is that neither of these contrasts is present, or is only weakly present. One of the great merits of the avant-garde painters of the early 20th century, and the reason their work can give us so much pleasure, is that they restored the tension between the scene and the pictorial image, and the tension between the pictorial image and the marks.

All three factors that can give us visual delight are present in Matisse's *The Painter's Family*, 1911 (Fig. 10.9). We can take pleasure in this intimate portrayal of the painter's own family: his wife on the left, his sons Pierre and Jean at the draughtboard, and his daughter Marguerite in the right. But we can also take pleasure in the fact that this is very obviously a *painting* rather than a real view of a scene. There is depth in the pictorial image, but it is not fully three-

[1]Rawson (1987) made a similar point:

> One final general point remains to be made. It is that in most of the world's best drawings a very large part of their vigour and expression derives from a kind of tension or conflict between the two-dimensional and the three-dimensional. . . . My point here is that in these drawings which are universally recognized as masterpieces there is a vigourous conflict between a highly-developed two-dimensional surface unity, and a highly developed three-dimensional plasticity. The higher the point to which both are developed, the stronger the drawing. (p. 79)

FIG. 10.9. Henri Matisse, *The Painter's Family*, 1911 © Succession H Matisse/DACS 2004. Oil on canvas, 142.9 cm × 194.0 cm. The Hermitage, Saint Petersburg.

dimensional, as it would be in a TV picture. In part, this is the result of the drawing systems and mixtures of drawing systems used in this picture. The carpet is shown almost as a true shape and the mantelpiece is shown in vertical oblique projection. In addition, a comparison between the relative sizes of the depictions of the figures shows that there is little change of scale with distance, as there would be in a view in perspective taken from within the room. Two further factors in the way the drawing systems are used contribute to the relatively shallow pictorial relief. The first is that the picture contains a mixture of drawing systems. Although the scene as a whole is shown in an approximation to vertical oblique projection, the draughtboard is in perspective, the stool on the right is in oblique projection, and the stool on the left is in axonometric projection. As Jacobus (1989) said of this painting, "The overall flatness of the design [is] relieved and contradicted by certain perspective details" (p. 80). Second, the legs of the table supporting the draughtboard and the feet of the figure on the right are falsely attached to the edge of the painting. Although all three paintings are utterly different in style and subject matter, similar false attachments between features of the picture and the frame are present in Gris's *Breakfast* and Klee's *With Green Stockings*. The effect of this device is to flatten the pictorial image and draw attention to the picture as a symbol system rather than a real view of a scene.

The denotation system in this painting is also very different from that which would have been used in 19th-century academic painting. Instead of

using an optical system, in which the picture primitives are derived from tones and colors in the array of light from the scene, this is, in effect, a colored line drawing. Moreover, the colors used are all local colors; that is, they correspond to the true colors of surfaces in the scene, irrespective of lighting or viewpoint. There is thus no representation of tonal modeling or cast shadows, and again this has the effect of reducing the degree of pictorial relief.

Finally, what Wollheim (1998) called the *matière*, the stuff of which the painting is made, is not disguised as it would have been in academic painting but is made apparent. This is partly because the brushwork is deliberately clumsy, partly because the marks are relatively large, partly because the marks are not blended one into another, and partly because some areas of the canvas have been left unpainted. For all these reasons we are very aware of the areas of paint as marks on the surface, heightening the contrast between the mark system and the pictorial image.

Many of the same features that give pictorial delight are also present in *A War Wedding* painted by a 14-year-old girl (Fig. 10.10). We can take pleasure in the subject matter—although the groom does look rather unhappy. However, our main pleasure lies, as it does in *The Painter's Family*, in two sets of contrasts. The degree of pictorial relief seems much the same as it is in Matisse's painting. On the plus side there is some representation of occlusion, both between the individual figures and between the figures and the

FIG. 10.10. Betty Holmes, 14 years, *A War Wedding*. Taken from Tomlinson (1944, p. 21).

gates in the background. There is no true perspective, but the gate on the right and what we can see of the gate on the left are both in oblique projection, leading the eye back into pictorial space. On the other hand, the way the figures are lined up horizontally carries a suggestion of orthogonal projection, although the figures are not standing directly on the bottom edge of the picture as they do in so many children's drawings. These factors contribute to the strong contrast between the pictorial image and the depicted scene, and as in Matisse's painting, there is a strong contrast between the mark system and the pictorial image. The brush marks are large, separate, and clumsy, and (so far as one can judge from a reproduction) some of the areas of the painting have been left bare. All these factors draw attention to the picture surface at the expense of the pictorial image.

These examples show that there are striking formal similarities between children's drawings and paintings and the art of the early 20th-century avant-garde. The most obvious of these is the lack of perspective, but there are many other anomalies that these pictures have in common. These include anomalous drawing systems such as fold-out drawings and the occasional use of inverted perspective, mixtures of drawing systems, transparencies, false attachments, and anomalous denotation systems such as the use of lines or regions to denote volumes rather than edges or contours. The marks in these pictures are often large scale and obtrusive, the handling is often rough and clumsy, and areas of the picture surface are often left bare. These similarities led many early educators to claim that children, and especially young children, are natural artists. How far is this claim justified?

It is not difficult to see why so many of the artists of the avant-garde admired children's drawings and paintings and were fascinated by them, as the quotation cited at the beginning of this chapter testifies. Klee, like many of the avant-garde, was seeking a new pictorial language, he saw children engaged in a similar search, and he found in children's drawings many of the anomalies that he needed in order to explore the languages of depiction. But the difference is that, as Klee said, the way he used these anomalies was "filtered through the brain." Klee's *With Green Stockings* may look artless—the handling is apparently slapdash and the material ground (a torn sheet of blotting paper) would have been despised by the artists of the Renaissance. But what made Klee an artist was the precision of his thinking and the way he used anomalous pictorial devices deliberately to explore the nature of depiction, for expressive purposes, and to give visual delight.

During drawing development children are searching for new and more effective forms of pictorial representation, and the artists of the avant-garde were also seeking for a new pictorial language. There can be no doubt about

the creativity of artists such as Braque, Gris, Klee, and Picasso, and children's attempts to find a language of drawing also demand all their creative powers. As Golomb (1992) rightly said, this attempt is "one of the major achievements of the human mind . . . a truly creative activity of the child, who invents or reinvents in every generation, and across different cultures, a basic vocabulary of meaningful graphic shapes" (p. 2). In both cases this search involves the use of pictorial anomalies, but the difference between these artists and children lies in the different ways these anomalies are used and the motives for using them.

Children's drawings and paintings can also seem expressive, but what we as adults find expressive rarely seems intended by the children themselves. Perhaps the best way of explaining this apparent paradox is to extend Wollheim's (1977, 1998) account of seeing in to cover expression as well as representation. We can see faces in clouds and the man in the moon, and children can and do see recognizable objects in their early scribbles, but these are not true representations in Wollheim's sense. To qualify as true representations the child or artist who produces them must have both the deliberate intention to represent some specific object or scene and the competence necessary to carry out this intention. In the same way, we as adults can see expression in children's drawings, but for the most part this expression lies in the eye of the beholder.

Children can score heavily in providing visual delight, as in this colored drawing by a gifted 7-year-old girl (Fig. 10.11). Free from the constraints of representing three-dimensional space and the difficulties of combining color with chiaroscuro, children can use color and shape in a free and uninhibited way and exploit what often seems to be a natural sense of two-dimensional composition. As Wollheim (1998) has argued, much of this visual delight lies in the tension and contrast between the scene and the pictorial image, and the pictorial image and the marks used to depict it. Children's paintings and drawings are often successful on both counts. The presence of anomalies in their pictures sets up a tension between the scene and the pictorial image, and the clumsiness of the way they handle the media they use sets up a contrast between the mark system and the pictorial image by drawing attention to the picture surface. But in both cases this contrast is fragile. As children become more skilled the tension between the marks and the pictorial image begins to disappear and their paintings and drawings lose much of their charm. And the more able they are to achieve the realism for which they are searching, the less interesting and engaging their pictures become. Mature artists such as Matisse, in contrast, were able to keep these tensions at their highest pitch through the exercise of conscious choice.

FIG. 10.11. Sally Willats, 7 years 6 months, *Formal Suit of the 1st Marquess of Landsdown*, drawn from a figure in the Costume Museum, Bath. Collection of the author.

In terms of the pleasure we can find in children's drawings and paintings perhaps it does not matter much whether we think of children as artists. Nevertheless, the equation between children's pictures and the work of the artists of the early 20th-century avant-garde rested on a number of false premises. This equation, however stimulating it may have been for art education in the short term, had disastrous long-term consequences, consequences that I explore in the next chapter.

Art Education

The hungry sheep look up, and are not fed,
But swoln with wind, and the rank mist they draw,
Rot inwardly, and foul contagion spread.

—John Milton, *Lycidas*

The art educators of the 20th century believed that all children were naturally creative and that if they were protected from the influence of adults this creativity would unfold of its own accord. For Richardson (n.d.), children's drawings "contained the germ of real art . . . buds of the genuine art. It was the seed unfolding." For Cizek, child art, "like a flower, must grow out of its own roots if it is to come to transition" (Wilson, 1921, p. 5). Metaphors of organic growth of this kind were common in the teaching practices proposed by Cizek and Richardson (Malvern, 1988):

> To let children grow, flourish and mature according to their innate laws of development, not haphazardly, is the quintessence of Cizek's views and "method"; if one may use the word "method" in connection with Cizek. To be a gardener, that is all. Can we, by the way, be anything more and better than that for the child? To remove the weeds, tactfully to promote that which is useful for the growth of the child, nothing more. (Viola, 1936, p. 13)

But although this artistic creativity would flourish of its own accord if children were allowed to follow their own natural development, it could be spoiled and corrupted by adult interference. It followed from this that children should be protected from such interference and, especially, from any kind of art teaching:

We have no right to hasten the growth of the child by hot-house culture. It is a crime to bend or break the children according to our own wishes. The result will always be deplorable. (Viola, 1936, p. 13)

Paradoxically, Cizek's method of art teaching was said to be "not to teach." This applied especially to teaching Western conventions of perspective and to teaching any kind of manual skill:

The unspoiled child knows no perspective. Perspective is a matter of geometry, as anatomy is a matter of medical science. Cizek goes so far as to say that he regards perspective in the work of a small child as an unfailing sign of the lack of a gift for drawing. Why does the work of the primitives appear to us so strong, despite the lack of perspective. Why do the works of the ancient Egyptians appear to us so strong? Because they are created according to the same laws as children's drawings. . . . By the way, another opinion of Cizek's is, that there is a relationship, even an absolute parallel, between the art of the ancients and primitives and the art of the child. Only with the ancients and primitives there is no break in creative power at the age of puberty. Cizek believes that the unbroken art of the primitives is due to the fact that they are not spoiled by schools. (Viola, 1936, pp. 24–25)

Skill, too, was suspect, especially skill in copying. "Copying" included copying from exemplars provided in traditional schools, copying adult pictures, and drawing from life, which was also regarded as a kind of copying. Drawing from life was therefore discouraged, and children were encouraged to draw from memory or imagination, sometimes prompted by storytelling. The acquisition of manual dexterity was also discouraged, and when working in a particular medium became too slick and easy Cizek would advise children to try another that provided more difficulties for them. Thus, although children's work should never be ridiculed, and any criticism should always be sympathetic, "care should be taken not to praise skill at the expense of creative ideas" (Tomlinson, 1944, p. 18).

It followed from this that teachers should not only avoid teaching children themselves but also prevent others from influencing them. Cizek said of his Juvenile Art Classes, "I kept the parents away from the children, 'No admittance to grown-ups.' Parents and teachers have formerly suppressed the most essential in children" (Viola, 1936, p. 38). Cizek even preferred to teach children from poorer backgrounds because:

a richer environment is as a rule destructive to what is creative in the child. Too many books, pictures, visits to theatres, cinemas etc. are bad for the child.

The child is so strong and rich in his own imaginative world that he needs little else. A child not yet spoiled by grown-ups once asked him: "What does a meadow look like?" Prof. Cizek answered: "Lie down in it, shut your eyes and live the meadow!" (Viola, 1936, pp. 20–21)

Protecting children from teachers, grown-ups, and seeing too many grown-up pictures was necessary because, in Richardson's (1937) view, children are easily corrupted. The child is "very, very suggestible, and will abandon his own good ways in favour of all sorts of wrong ways that he admires. . . . The teacher must do for the child what good tradition does for the native." Fry (1917) made explicit this affinity between children and what he called "savages," and the consequent need for the teacher to protect the child from corrupting influences: "But both children and savages are so easily impressed by the superior powers of civilised grown-ups that they can with the greatest of ease, be got to abandon their own personal reactions in favour of some accepted conventions" (p. 887).

But although children are creative in the same way that artists and "primitive peoples" are creative, their art is not the same. In spite of its similarities to the art of the avant-garde and primitive art, child art is something apart from these—it is child art, with its own special laws. These laws are universal: "eternal laws perhaps closer to nature than those innumerable compromises, if not illusions, which dominate the world of the adult" (Viola, 1936, p. 10). Moreover, it was no part of Cizek's program, or Richardson's, to produce artists. Instead, their aim was to foster the creativity that the child would subsequently bring to bear on every activity in his or her future life.

Thus, although child art was the paradigm way in which this creativity was to be expressed, the influence of art education was intended to spread beyond the art room. This aim was perhaps most eloquently expressed by Read (1958): "The thesis is this: that art should be the basis of education" (p. 1). The primary purpose of art was self-expression, but "generally speaking, the activity of self-expression cannot be taught. Any application of an external standard, whether of technique or form, immediately induces inhibitions, and frustrates the whole aim. The rôle of the teacher is that of attendant, guide, inspirer, psychic midwife" (Read, 1958, p. 209). A secondary goal was to develop in the child an appreciation for the work of others. This can be taught, but "cannot be expected to show itself much before the age of adolescence. Until then the real problem is to preserve the original intensity of the child's reactions to the sensuous qualities of experience—to colours, surfaces, shapes and rhythms. These are apt to be so infallibly 'right' that the teacher can only stand over them in a kind of protective awe" (p. 209).

Above all, children were to be protected from the teacher's teaching. This included any kind of criticism, and children should not be encouraged to think about their work. For Richardson (1914) a picture was something to be seen and not thought about, and for Cizek (1927) the "longer a child's subconscious creative powers can be kept in the dark, the better. As soon as they are illuminated by reasoning, they generally cease to exist, because the intellect destroys the child's confidence in its abilities" (p. 25). Richardson (1914) wrote:

> No child's drawing is of the slightest value unless it springs from the child's very innermost consciousness. By fairly skilful teaching along certain lines, any results may be obtained or rather results that will deceive all but the real critic. The most elementary and unskilful work is infinitely superior to the most finished and clever, if the latter is in any way a reflection of the teacher and not a direct expression of the child.

Thus, the teacher's only role in teaching is to provide the necessary materials and to shield the child, as far as possible, from adult influences. But this does not mean that the teacher must simply stand aside. "The duty of the teacher is to watch over this organic process—to see that its tempo is not forced, its tender shoots distorted" (Read, 1958, p. 212).

At the time Cizek started his Juvenile Art Class (then a private school) in 1897 his approach was so radically different from the way drawing was taught in schools that it is not surprising his methods were not welcomed by other teachers. At that time children were given books with dotted pages and the dots were to be connected by lines. Older children were given books with the dots farther apart, and later they copied designs from the black-board:

> To draw something from imagination, even to draw from nature, was never thought of. Those over thirteen were expected to copy plaster models and printed designs, the idea being to train the child to copy exactly. It was a training in skill without any regard for creative work. (Viola, 1936, p. 14)

Other drawing teachers ridiculed Cizek's methods, wrote against him in educational journals and the daily press, and sent petitions to the Minister of Education asking him to prevent this "corruption of youth." Nevertheless, it was Cizek's methods that prevailed, and within about 20 years his program had been accepted with enthusiasm by art teachers throughout the world, and especially by art teachers outside Austria. In 1906 his weekend classes for children ages 6 to 14 years were incorporated in the Vienna Arts and

Crafts school and attracted an endless stream of visitors and disciples. Richardson was appointed Art Lecturer at the Institute of Education in the University of London in 1924, and teachers trained by her spread her teaching methods all over England. By the 1930s "the new art teaching" was an established feature of informed educational debate. It was championed in the 1940s by Read in his immensely influential book *Education Through Art* (1958) and became the accepted approach to art teaching throughout the rest of the 20th century.

What were the reasons for this success? It is easy to see the attraction, for the lazy or cynical teacher, of a teaching syllabus that does not involve any kind of teaching, but this would be to belittle the very real dedication and enthusiasm of the pioneers of the new art teaching. For Nan Youngman (1964) one of the new generation of art teachers, "it was a deeply satisfying experience to be teaching them; we were evangelists" (p. 5). Moreover, the formal similarities, at least on a superficial level, between the art of avant-garde and the art of children, and the support of major figures in the art world such as Roger Fry, encouraged teachers to see themselves as an avant-garde in education and thus to ally themselves with avant-garde artists such as Matisse and Picasso.

It might perhaps seem surprising that a teaching program based on the avoidance of teaching, the absence of any kind of criticism, and the rejection of any reasoned approach to the work produced should have persisted for so long, and should indeed still be so influential today. Cizek was clearly a charismatic figure and an able propagandist, and the children in his Juvenile Art Class produced some very remarkable work. Nevertheless, Cizek was perhaps no more than a catalyst for a revolution in art teaching that would have happened anyway. The reasons his methods were adopted with such enthusiasm, and have continued to influence not only art teaching but teaching methods in other subject areas, have their roots in the Romantic movement, the rejection of scientific materialism, and the conjunction of the ideal of the noble savage with that of the untouched innocence of the child.

Paine (1992) traced the history of these ideas back to the 18th-century philosopher Jean-Jacques Rousseau and his account of the development of an imaginary child, "Emile." Although drawing was not accorded much significance in Emile's development it was, like aspects of development, seen as:

> a ripening process, where drawing like any other activity was the manifestation of a particular stage of fruition. It was important, too, as instrumental in the development of the senses, a process which could be facilitated but not

hurried, since an individual must be "ready" to proceed to a further stage. (p. 5)

Wilson (1992) has traced another strand of this history to a Swiss schoolteacher and artist Richard Töpffer, and the painter Gustave Courbet. Töpffer's book *Réflections et Menus Propos d'un Peintre Génevois*, published posthumously in 1848, contained two chapters on child art and made the astonishing claim that there is:

> less difference between Michelangelo "the untutored child artist" and Michelangelo "the-immortal," than between Michelangelo "the immortal" and Michelangelo "the-apprentice." To Töpffer the child's spontaneous graphic inventions were seen as closer to the creative expressions of great artists than were the slick works of those whose art displayed mere conventional skill. (Wilson, 1992, p. 15)

Töpffer's ideas influenced Courbet, whose *The Painter's Studio* (*L'Atelier du Peintre*) was painted between 1854 and 1955. On the left is a group of common people. In the center of the painting is Courbet himself at work, watched by a model and a little boy. On the right are Courbet's friends and colleagues from the artistic and literary world, among them the poet Baudelaire and a "pensive gentleman" at whose feet is another little boy drawing (Wilson, 1992, p. 16). By the end of the 19th century the associations among child art, folk art, the rejection of bourgeois values, and the art of the avant-garde were thus already in place. It was these strands, together with the relationship between child art and primitive and tribal art, that Cizek drew together as the basis for his teaching methods.

The association between child art and the art of primitive and tribal peoples was given scientific authority by what is called the "theory of recapitulation." According to this theory, the development of the embryo in the womb mirrors the course of evolution, and the development of the individual can, by extension, be viewed as recapitulating the history of the species. Although this theory was proposed long before Charles Darwin wrote the *Origin of Species* (1859), Darwin was much influenced by it and believed that embryology provided the most compelling evidence for his theory of evolution. The theory of recapitulation was soon extended to developmental psychology and led many Victorian scientists, including Darwin himself, to investigate the psychology of childhood in the hope that this would reveal the psychological development of the human species. Similarly, although Piaget is best known as a child psychologist, his main goal was what he called "ge-

netic epistemology," a general explanation of human knowledge and development, and he saw his studies of childhood as a convenient, if indirect, route to this larger goal.

Influenced by the obvious structural similarities between primitive art and children's drawings, the early art educators seized on the theory of recapitulation as a justification for teaching programs in which children were to be treated as noble savages and shielded from outside interference.[1] Given all these social, scientific, developmental, and educational factors, together with the formal similarities among primitive art, folk art, children's drawings, and the art of the avant-garde, the case for the new art teaching seemed overwhelming. Moreover, it gave results: a great many of the paintings, drawings, cut-paper work, and linocuts produced by children, especially in the early years, are very attractive—no wonder art teachers adopted these ideas so enthusiastically, and no wonder they have lasted, with some modifications, for so long. But most of these ideas rested on false premises, and in the long run I believe that we have lost as much, or more, than we have gained.

The ideas underlying the new art teaching contained a mass of contradictions, and because these ideas are so contradictory it is difficult to give a coherent account of them. Three strands can, however, be distinguished: the theory of recapitulation, the idea of childhood innocence and the innocent eye, and the apparent conflict between the aims of expression and representation.

The theory of recapitulation was abandoned in embryology before the end of the 19th century but persisted in art education as an explanation for the similarities between child art and the art of primitive peoples at least until the 1940s. The application of this theory to art history seems to reflect a confusion of thought: the original theory had been intended to apply to evolutionary history, not the chronological history of the human race. Moreover, this theory could be, and was, used to support two entirely different

[1]The similarity between the unsophisticated work of children today in all civilised countries and that of primitive people leads to the conclusion that the means and modes of expression in both graphic and plastic forms are inherent in the human race. The recapitulation theory, the belief that the development of the child follows somewhat the same course as the history of the race, may or may not have been conclusively vindicated, but it seems true that in dealing with children we are dealing with little primitive people. . . . A study of the work of primitive people shows that the urge to draw and create is innate. It is vitally important, therefore, that this form of expression should not only be allowed to grow naturally but be encouraged and fostered. (Tomlinson, 1944, pp. 5–6)

accounts of art history. For many art historians in the 19th century the pattern of art history was a simple one: evolutionary progress from savagery to civilization, "savagery" being equated with the art of earlier periods and civilization with the use of perspective and the art of the High Renaissance (Zerffi, 1876). According to this interpretation the course of development was inevitable: "The 'will to form', the *Kunstwollen*, becomes a ghost in the machine, driving the wheels of artistic development according to 'inexorable laws' " (Gombrich, 1988, p. 16). Once it had been discovered and established, perspectival art was assumed to mark the end of development, rather as man was seen as the culmination of evolution.

Progressive art educators, however, stood this interpretation of the theory of recapitulation on its head and saw the drawings of older children and the later stages of art history as representing a decline from an earlier, innocent, golden age. Instead of primitives and children slowly and painfully making their way toward civilization and the ability to use perspective, children and primitive races were seen as able to express themselves in a free, original, and creative way until their work was spoiled by intellectual concepts and socialization. In this interpretation the development of perspective was seen as an aberration, the true culmination of art history being the art of the 20th-century avant-garde. And as with the alternative, perspectival theory of art history, the art of the avant-garde was expected to last indefinitely: "Through the harnessing of individual creative energies art could remain in a perpetual state of renewal, Modernism could last forever, there would be a perennial avant-garde" (Wilson, 1992, p. 19).

These two interpretations of the theory of recapitulation interacted with, and to some extent paralleled, two accounts of childhood innocence: Costall (1997) called these *visionary innocence* and *perceptual innocence*. The first, championed by progressive educationalists, valued child art with all its imperfections because it was natural. The natural expression of the child's creative abilities, fostered by imagination, could, however, be corrupted by exposure to realistic, perspectival art and technical drawing.[2]

[2]It is a fundamental fault of the drawing course that it . . . destroys the golden age by leading the pupil into temptation. The drawing teacher admonishes him: "Open your eyes and see the tree and the fruit thereof, as they really are. Draw the apple exactly as you see it." The pupil does so, and his eyes are opened, and he sees his nakedness, and is filled with shame. The divine gift of artistic illusion vanishes; he awakes to find that he cannot draw. Then follows the curse of all his life long. In sorrow he must draw from the object all the days of his life. Painful copying, spiritless imitation is the start, and unto the same the pupil ever returns. (Lukens, 1899, p. 948, quoted in Costall, 1997, p. 135)

The second, perceptual innocence, was derived from the idea that there exists an internal image of the world that Costall (1997) called the *sensory core* that is necessarily perspectival because it is directly derived from the retinal image. This sensory core is possessed in its original purity by very young children, but by the time drawing begins it has been corrupted by too much intellectual knowledge:

> The child's eye at a surprisingly early period loses its primal "innocence," grows "sophisticated" in the sense that instead of seeing what is really presented it sees, or pretends to see, what knowledge and logic tell it is there. In other words his sense-perceptions have for artistic purposes become corrupted by a too large admixture of intelligence. (Sully, 1895, p. 396, quoted in Costall, 1997, p. 137)

Thus, for Sully, as for other psychologists, children's early drawings with their lack of perspective had come about because the child's early perceptions had been corrupted by adult influences. It was precisely those drawings that were so admired by educationalists such as Cizek and Richardson for their faults, naturalness and visionary innocence.

Although these different accounts of innocence contradict each other, both could be used to support modern painting. Ruskin (1843) used the perceptual theory of the innocent eye to defend Turner's paintings against an unsympathetic public (Gombrich, 1988), whereas Read (1958) used the ideal of visionary innocence to defend both child art and avant-garde painting. In a review of an exhibition of children's work at the Zwemmer Gallery, Read compared the "directness and innocence of the child's vision" with the directness and innocence that artists such Matisse and Picasso had supposedly been able to retain, so that there was "a close resemblance between certain types of modern art and the art of children" (p. 180). Fry managed to invoke both versions of the theory. The aim of the Impressionists was to:

> perceive and record direct optical sense data, or "visual sensations" as they were called, instead of depicting a scene modified and corrected by the intervention of the intellect which gave only a rationally conceived notion of the real world. This explains references among the Impressionists to the desire for the infant's untutored eye. (Anfam et al., 1987, pp. 166–167)

Invoking the theory of perceptual innocence, Fry (1917) hailed Impressionism as its final vindication. But at the same time, in accord with the theory of visionary innocence, his Post-Impressionist Exhibitions celebrated just those "faults" in the form of representational anomalies and a lack of

perspective that characterized both children's art and the art of avant-garde artists such as Matisse and Picasso.

The third strand in this mass of contradictions derives from different ideas on the part of psychologists and art educators of what drawing is for: the difference between children's drawings and child art. For the new art teachers, the primary aim of child art was expression, and in particular self-expression: "the individual's innate need to communicate his thoughts, feelings and emotions to other people" (Read, 1958, p. 208). In contrast, most developmental psychologists assumed that the primary aim of children's drawing was visual realism, exemplified by "proper" drawings in perspective. Although Luquet (1927/2001) had suggested that intellectual realism was an alternative to visual realism and that both were based on conventions, the majority of progressive art teachers and psychologists had this in common: both assumed that visually realistic pictures could only be achieved by some kind of copying. As a result, once children "progressed" from intellectual realism to visual realism, developmental psychologists tended to lose interest in their work. This transition might be the outcome of orthodox art education, or it might be that (for reasons left largely unexplained) children's perceptions had regained their primal innocence, but in either case copying was regarded as a rather low-level activity that stood in no need of explanation. For most psychologists, therefore, the interest in studying children's drawings lay in the difficulty of explaining why children do not draw in perspective.

But although developmental psychologists were simply not interested in copying, progressive educationalists saw it as a positive danger. It was just this mechanical, spiritless copying that destroyed children's natural creativity, and the infliction of copying, whether from life or from other people's pictures, has been compared with child slavery, prostitution, and even murder (Costall, 1997). As a result, one of the most important aims of teachers such as Cizek and Richardson was to prevent children from copying, or even being influenced by, other people's work. How successful were they in this aim?

In his *Child Art and Franz Cizek* Viola (1936) reproduced about 70 pictures produced by pupils of Cizek's Juvenile Art Class. Only two of these (both by a girl between ages 2 and 3) were produced by a child under 8, and these two drawings look very similar to those that children might produce today.[3] Eleven of the rest are the work of children between 8 and 10. These

[3]In his later book *Child Art* (1945) Viola reproduced many more drawings by younger children.

FIG. 11.1. Girl, 8 years. Pen drawing. Taken from Viola (1936, p. 49).

could perhaps have been produced by children today, but their composition is more regular and decorative. Figure 11.1 shows an example by a girl age 8 years. All the rest of the work reproduced by Viola is by children ages 10 to 15, and Figs. 11.2 and 11.3 show representative examples.

As examples of children's drawings these are remarkable by any standards, but rather than reflecting the operation of universal, timeless laws and the child's uncorrupted vision, they clearly demonstrate the influence of

a b

FIG. 11.2. (a) Girl, 11 years. Distemper, homework. (b) Girl, 12 years, *Easter*. Distemper, homework. Taken from Viola (1936, pp. 95, 57).

a b

FIG. 11.3. (a) Girl, 12 years. Paper cut, classwork. (b) Girl, 14 years. Silhouette, home-
work. Taken from Viola (1936, pp. 89, 69).

Austrian folk art and the interaction between the pupils of the Juvenile Art
Class and the Wiener Werkstätte. What actually developed in Cizek's art
classes was a "Cizek child style," which was passed on from one age group to
another. In spite of his protestations, what Cizek was actually promoting
were judgments of taste, and this was achieved in various ways. Although
Cizek claimed that he divided his children into age groups so that the older
children could not influence the younger children, pictures by children of
all ages were constantly on display in the classrooms, and in the group dis-
cussions at the end of the sessions some observers detected a considerable
subconscious transmission of stylistic standards that children were quick to
imitate (Fleming-Williams, 1923). Cizek's task was made easier because he
selected children for his class who were highly motivated, and there were al-
ways more girls than boys in the class. According to Viola (1936) this was be-
cause boys were more interested in technical subjects, but perhaps they were
also less compliant.

The promotion of media such as silhouettes, linocuts, cut paper, embroi-
deries, and woodcuts also influenced the kinds of work that the children
produced. The ostensible reason for using these media was to discourage
children from developing a style that was too slick and easy and to encourage
children who had failed with one medium to try another. But the use of
these media almost inevitably resulted in a flat style that invited comparison
with the art of both primitive peoples and avant-garde artists. The use of cut
paper discourages the development of tonal modeling and cast shadows, and

in linocuts and woodcuts the reversal of the normal direction of tonal con-
trast tends to flatten the picture surface. The use of these media became an
established feature of the new art teaching. Figure 11.4 shows an example of
a linocut by a 13-year-old boy in which the reversal of the normal direction
of tonal contrast (white lines on a dark ground instead of black lines on a
white ground) resembles the mark system used in some kinds of primitive
art and early Greek vase painting.

Paradoxically, the use of these media, which were supposed to discourage
the development of skill rather than creativity, actually resulted in some re-
markably skilled work, as the examples reproduced in Viola's (1936) *Child
Art and Franz Cizek* demonstrate (Fig. 11.3). But in later years the encour-
agement of clumsy brushwork and false naiveté did not always have such
happy results. Tomlinson (1944) showed two pictures side by side that were
intended to demonstrate the superiority of the results of the new method of
teaching compared with the old method, and these are reproduced here as
Fig. 11.5. A dispassionate observer, however, less impressed with the imita-
tion of the surface qualities of a Cézanne still life produced without any un-
derstanding of Cézanne's intentions (Fig. 11.5b), might be forgiven for pre-
ferring the straightforward attempt at representation achieved by the
younger child whose drawing is shown in Fig. 11.5a.

The new art teaching inspired by Cizek and Richardson thus combined
an exasperating mixture of dedication, enthusiasm, and good intentions
with teaching methods that often produced good results but that were based
on a number of ultimately destructive false premises. To begin with, struc-

FIG. 11.4. Boy, 13 years, *Stampede of Elephants*. Linocut. Taken from Tomlinson (1944,
p. 3).

a b

Fig. 11.5. (a) "A typical example of model drawing (old method) by a boy age 12." (b) "A group of models (new method) by Phyllis Harvey, age 15, pupil at a Secondary School." Taken from Tomlinson (1944, pp. 10, 11).

tural similarities between young children's drawings and the art of avant-garde artists led many art educators to assume that their aims and methods were the same. But as I have shown in chapter 10, the work that these artists produced did not arise because they had somehow managed to retain the directness and innocence of the child's vision. On the contrary, Klee, Matisse, and Picasso, together with most other artists of the avant-garde, were professionals who were very conscious of what they were doing and thought and argued a great deal about their work. They were, moreover, highly influenced by the work of other artists, and many of them made copies or transcriptions of paintings by other artists as a way of exploring style.

The early art educators also misunderstood the reasons for the apparent lack of skill in the art of the avant-garde. The lack of skill in children's early drawings is just that: lack of skill. In contrast the apparent lack of skill on the part of artists such as Picasso and Matisse—"clumsy" brushwork, parts of the canvas left unpainted, and irregular outlines in areas of silhouette—was deliberate and served very specific ends: flattening the picture surface, drawing attention to pictures as symbol systems, and emphasizing regions rather than lines as picture primitives.

According to Cizek, "The most wonderful thing is that the more the work of a child is filled with so-called 'faults,' the more beautiful it is. The more a teacher removes these faults from the productions of the child, the more tedious and lacking in individuality they become" (Viola, 1936, p. 24). Cizek and his followers saw these "faults" as an essential part of the child's means to self-expression, so that they were to be encouraged rather than corrected. Many of the artists of the avant-garde used pictorial anomalies

deliberately as a means of expression, but the faults that children make are rarely if ever produced for this reason. Gardner (1980) made this point in relation to children's drawings using an example drawn from children's speech: "Consider a four-year-old youngster who says of the traces left by a skywriting aeroplane, 'Look at that scar in the sky.' We do not wish to credit a preschool child with command of metaphor if he simply uses the word 'scar' inappropriately or if he does not know its precise meaning" (p. 15). As adults, we can be charmed by such speech errors in a 3-year-old as "no, you didn't done it, I done it," but we would not wish to restrict language development for this reason. Cizek and his followers tried to restrict children's drawing development in the interests of creativity, but as Millar (1975) tartly remarked, "this is akin to depriving the child of extensions to his vocabulary in the hope that this will enhance the originality of his essays" (p. 371).

The evidence from children's drawing development suggests that once children become conscious of the representational anomalies in their drawings they try to eliminate them, and in chapter 8 I suggested that it is children's attempts to eliminate these "errors," through the interaction of picture production and perception, that provides the mechanism of development. Although adults may see child's drawings as expressive, it seems doubtful if children themselves see the anomalies in their drawings as a means of expression. What young children mainly aim at in their drawings is realism, and what they want to produce are what I have called "effective representations": pictures in which the objects and scenes they wish to portray can be recognized, clearly and unambiguously. From their point of view, the faults in their drawings, once they recognize them, are just that: faults.

Ultimately, then, Cizek and the children in his Juvenile Art Classes were working at cross-purposes. In the early years children are often satisfied with the pictures they produce, and the children in Cizek's classes were no doubt delighted with the praise they got from teachers and visitors alike. But as children get older they want to produce pictures that are more effective as representations, and a child who wants to draw horses wants, as she gets older, to be able to draw *better* horses. Heidi proudly wrote under one of her drawings, "This is my very best horse and horse head," and this drawing is unquestionably better as a representation of a horse than the drawings she was producing 2 years earlier. The later drawings, in which she has eliminated the faults of the earlier drawings and solved most of the problems of representation, are better still (Fig. 11.6). But Cizek gave children no help in this respect. "To a really creative child who wants to draw a horse and comes to me, I would simply say: 'You know already how you should do it. Just do it and it will be good' " (Viola, 1936, pp. 24, 36).

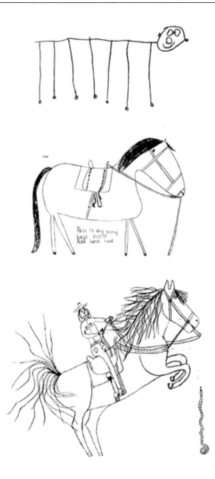

FIG. 11.6. Heidi, ages 4 to 10 years, *Heidi's Horse*. Taken from Fein (1984).

Heidi was exceptionally good at drawing, but most children go through a stage in which their drawings become less visually attractive while they are struggling with the problems of representation. Cizek found to his regret that most children appeared to lose their creative abilities when they reached puberty, but it seems a pity that he was unable to help children to learn how to combine representation with expression and visual delight, as Heidi was able to do. Instead, he saw representation and art as totally opposed. Children who continued to be creative should be left alone. The others, who had begun to "copy," should receive lessons "from an expert," but "the ability to show a carpenter with a few lines, 'I want this chair made so and so' has nothing at all to do with art" (Viola, 1936, p. 30).

Given Cizek's refusal to teach representation it is hardly surprising that the majority of older children, dissatisfied with their drawings and unable to achieve their objective of producing more effective representations, gave up drawing.

Cizek's influence, and that of the new art teachers, persisted throughout the 20th century, although methods of teaching drawing in schools have recently begun to change. Clement (1992) was able to say: "In recent years, there has been a marked increase in the teaching of observational drawing, which is being taught and used well" (p. 129). In spite of this, "The vast majority of teachers encourage children to draw as a form of story telling" (p. 129)—Cizek's own preferred mode of intervention.

With hindsight, the most lasting and damaging influence of the new art teaching may prove to have been its effect on the art schools. When I was at the Royal College of Art as a mature student I was unable to find a single tutor who was able to teach me how to draw. Although the old Beaux Arts ideals were still ostensibly in place there was no explicit teaching. What teaching there was, was by example, and the students learned from each other by a kind of osmosis. By the 1950s the art schools had become out of touch with what painters had been doing since the turn of the century, but when the system collapsed in the 1960s and the plaster casts were thrown out of the window there was little or nothing to take its place. The new theories of visual perception developed by Helmholtz and the Gestalt psychologists that had influenced the artists of the avant-garde were unknown or ignored, and students were left to stumble unaided through a maze of "isms." In the 1980s, when I was working in an art school myself, teaching had degenerated into: "We won't tell you what we want you to do or how to do it. But you do something, and we'll tell you whether we like it or not"—more or less Cizek's method, except that the art schools were awarding graduate and postgraduate degrees on this basis.

Children's art today has little in common with the work of Post-Modern artists. Nevertheless, in their straining after self-expression and their abandonment of skill and reason, the productions of these artists in the form of sharks preserved in formalin, piles of dead rats, and collections of human excreta[4] represent the last poisoned fruits of Cizek's false Garden of Eden.

[4]The Tate Gallery, London recently paid £22,300 for a tin of human excrement (Manzoni, circa 1960, no. 68 of an edition of 90). Spalding (2003).

CHAPTER TWELVE

Summing Up

"This," said Lord Peter Wimsey, "is the proudest moment of my life. At last I re-
ally feel like Sherlock Holmes. A Chief Constable, a Police Inspector, a Police
Sergeant and two constables have appealed to me to decide between their theories,
and with my chest puffed out like a pouter-pigeon, I can lean back in my chair and
say, 'Gentlemen, you are all wrong.' "
"Damn it," said the Chief Constable, "we can't all be wrong."
—Dorothy L. Sayers, Five Red Herrings

All the traditional theories of children's drawing contain weaknesses that
have prevented any of them from being accepted as definitive. The most
popular theory, that young children draw what they know rather than what
they see, has just enough truth in it to be thoroughly misleading. One of the
weaknesses of this theory is that it can be difficult, if not impossible, to sepa-
rate seeing from knowing. Costall, quoting a comment by Arnheim, said:

Arnheim expresses what is wrong with the supposed opposition of seeing and
knowing in a beautifully clear way: "Now knowledge has more than one
meaning. Much picture-making does not in fact rely on what the eyes happen
to see at the moment the picture is produced. Instead the draftsman relies on a
synthesis of his many previous observations of a certain kind of things,
whether horses, trees or human figures. This process can indeed be described
as drawing from knowledge; but it is a knowledge that cannot be taken to be
an alternative to seeing." (Arnheim, 1974, p. 164, quoted in Costall, 2001, note
15, p. xxi)

There are also other weaknesses with this theory. One is that making a
simple distinction between what children know and what they see results in

a two-stage theory of drawing that is far too crude to capture the complex changes in children's drawings that take place during the course of development. Consider, for example, the developmental changes in children's drawings of people illustrated in Fig. 8.1, and their drawings of tables illustrated in Fig. 8.2. Neither of these developmental sequences divides easily into two distinct stages. Similarly, in the sequence of children's drawings of an unfamiliar object illustrated in Fig. 1.5, which covers an age range of 5 to 12 years, drawings showing possible views ("what children see") alternate with drawings showing impossible views ("what children know"). Figure 1.5b, which shows a possible view, is followed by Fig. 1.5c that shows an impossible view. Figure 1.5d, which shows another possible view, is then followed by Fig. 1.5e that shows another impossible view, and finally by Figs. 1.5f and 1.5g that show two more possible views, one ambiguous and one unambiguous. Where does knowing stop and seeing begin in this developmental sequence? The traditional theory of knowing and seeing is utterly inadequate to account for these changes. In contrast, all three sequences can be completely described in terms of the progressive acquisition of increasingly effective representational rules.

Another weakness with this theory is that the expression "what children know" can be, and has been, interpreted in so many different ways. One interpretation is that young children draw the facts about objects rather than their appearances. This was Clark's (1897) explanation for his finding that the younger children in his experiment drew the hatpin clear across the apple rather than stopping it at the edges. Bühler (1930/1949) also believed that "the child draws from its knowledge," but in his account children do not choose to draw the facts about objects or fail to notice how they look from a particular point of view; instead, they have no choice in the matter: they draw what they know because language and conceptual knowledge have corrupted their perception of the appearance of objects.

Another interpretation of the phrase "young children draw what they know" is that young children draw what they know in the sense of knowing *how* to draw an object, rather than *what* they know about it. Young children, for example, may learn how to draw objects by copying the drawings of other children, whereas older children may derive their knowledge of drawing from cartoon books or the popular media. This interpretation also has several variants. In one account, young children draw what they know in the sense of drawing a known stereotype, in the form of an internal image derived from other drawings (Wilson & Wilson, 1977). In Luquet's (1927/2001) account, children develop stereotyped internal images for themselves, derived initially from chance resemblances to familiar objects. In yet an-

other account children may know how to draw an object using what Phillips et al. (1978) called a "graphic motor schema," that is, a series of actions that results in a drawing but that may not necessarily be closely related to any internal representation.

It may be, of course, that one of these possible interpretations of the theory that young children draw what they know and older children draw what they see is correct and all the other interpretations are wrong. But the fact that so many different interpretations of the theory have been offered suggests that this account of young children's drawings is unsatisfactory.

A number of writers have suggested that the distinction between what children know and what they see might be saved by interpreting it in terms of Marr's (1982) distinction between object-centered and viewer-centered descriptions. Clark's (1897) account of the results of his experiment, for example, could be rephrased by saying that the drawings produced by the younger children were derived from object-centered descriptions, whereas the drawings produced by the older children were derived from viewer-centered descriptions. In an object-centered description the spatial relations between the pin and the apple would be given independently of any particular point of view: the pin passes through the apple, and the children draw it so. In a viewer-centered description, on the other hand, the pin is hidden from the viewer and so the older children omit this part of the pin from their drawings.

There are, however, at least three reasons why we should be wary of simply accepting the traditional theory that young children draw what they know but expressing it in a more up-to-date way. The first is that a number of writers have implied that the drawings children produce during the period of intellectual realism *provide* object-centered descriptions, but this cannot be the case. The reason for this is that object-centered descriptions are, by definition, three-dimensional. Children's drawings can, and often are, derived from three-dimensional, object-centered descriptions, but this can only be achieved using representational rules that map three dimensions onto two. For example, the fold-out drawings of houses and cubes that children produce are almost certainly derived from object-centered descriptions, but they do not *provide* object-centered descriptions because they are not three-dimensional, and much of the information they convey—the connections between faces and corners, for example—is incorrect.

The second reason we should be wary of equating this theory with Marr's (1982) distinction between object-centered and viewer-centered descriptions is that because a child's drawing provides a possible view, it does not follow that it must therefore have been *derived* from a view. The fallacy in

making this assumption can be illustrated by comparing children's single-square drawings of cubes with their drawings in oblique projection. Single-square drawings can be produced by reproducing the shape of a single face of a cube in an object-centered description, but they can also be produced by drawing a front view of a cube. Conversely, drawings in oblique projection can be produced by drawing views, but they can equally well be derived from object-centered descriptions, using the rule: Draw the front face as a true shape and draw the other edges using parallel oblique lines. In practice it can be difficult to know, simply by inspection, whether a drawing has been derived from an object-centered description or a viewer-centered description.

The third objection to interpreting the traditional theory of drawing in this way is that the age at which children are supposed to change from drawing what they know to drawing what they see, which is usually put at between 7 and 9 years, does not correspond to the age at which they begin to derive their drawings from viewer-centered descriptions. In an experiment described in chapter 1 children were asked to draw a table with from a fixed point of view, and the results are illustrated in Fig. 1.1. Of the 10 children in the 12-year-old age group, only 1 child produced a drawing in naive perspective, and no child produced a drawing in true perspective. The other 9 children produced drawings in orthogonal projection, vertical oblique projection, or oblique projection, and because the directions of the lines representing the side edges of the table were so different from the directions of those edges in the children's view of the table, it seems almost certain that they were derived from object-centered descriptions using various drawing rules. Similarly, in an experiment in which children were asked to draw a cube presented edge on at eye level, 6 of 10 of the 10-year-olds produced drawings showing three faces of the die, even though the top face could not be seen from the child's viewpoint. The 12-year-olds all produced drawings showing the correct number of faces, but 6 of them produced drawings containing characteristic errors that showed that they were still mainly deriving their drawings from object-centered descriptions (Willats, 1987).

To sum up, the most commonly accepted theory of children's drawings, that young children draw what they know and older children draw what they see, is too crude and too vaguely expressed to capture the complex changes that take place in children's drawings as they get older. In its more modern form, that young children derive their drawings from object-centered descriptions and older children derive their drawings from viewer-centered descriptions, this account may have some merit. However, the experimental evidence suggests that even by the age of 10 or 12 the majority of

children are still largely basing their drawings on object-centered descriptions, and even though drawings by these older children may look like views they are by no means necessarily derived from views. Most of the developmental changes that take place in children's drawings come about as the result of children applying different rules to object-centered descriptions at different ages rather than as the result of changing from object-centered descriptions to viewer-centered descriptions as the basis for their drawings.

Of all the writers on children's drawings it is perhaps Luquet (1927/2001) who came closest to capturing the idea of drawings being derived from object-centered descriptions. His theory of intellectual and visual realism is often equated with the traditional theory that young children draw what they know and older children draw what they see, but this does it an injustice: Luquet's account of drawing is much more complex than this. Once children are past the scribbling stage, Luquet's account of their drawings consists of four stages rather than the traditional two: fortuitous realism, failed realism, intellectual realism, and visual realism. I have already stressed the importance of Luquet's account of fortuitous realism as the origin of representational drawing. In addition, his distinction between intellectual realism, and visual realism is a good deal more complex and interesting than the simple distinction between knowing and seeing. Luquet regarded visual realism and intellectual realism as alternative ways of drawing, analogous to the differences between different languages. He argued that visual realism is no less a convention than intellectual realism and insisted that children have good reasons to have misgivings about it. These misgivings are in fact similar to those held by those held by the Cubists and in this respect can be related to Helmholtz's theory of physiological optics that influenced the Cubists through the work of Cézanne. As Costall (2001) said, "Luquet's first book on children's drawings was published in 1913, the year of the first cubist manifestos, and it is tantalising that even in his later 1927 text he makes no reference to cubism" (p. xv).

During the stage of intellectual realism, according to Luquet (1927/2001), children's drawings are based on what he called the "internal model," but his account of this internal model and the role it plays in drawing is not entirely clear. At times his account of this internal model comes very close to Marr's (1982) definition of object-centered descriptions, and consists of the child's internal representation of the entire object. But Luquet never described how this internal model generates drawings. He simply spoke of the drawings as being translations of the three-dimensional model onto the surface of the paper, but he never explained how this comes about. Elsewhere in his book, however, he seemed to identify

the internal model with what he called "the type," "the way in which any given child represents the same object or motif over a sequence of drawings" (p. 31). But if this is the case, the drawings are simply copies of the internal model, so that, as Costall (2001) pointed out, "the internal model ends up by doing no serious explanatory work at all" (p. xv).

According to another group of theories, children draw things in a different way from adults because they *see* them differently. Here again, it is difficult to do justice to these theories because they are full of internal contradictions. Perhaps the crudest version of this kind of theory is that given by Bühler (1930/1949): "Why does the child draw such curious outlines of things? Surely it sees them differently, or, more correctly, its retinal images are quite different" (p. 113). On the next page, however, Bühler claimed: "The root of the evil reaches far deeper into man's intellectual development. It is the fault of our *mastery of language.* . . . As soon as objects have received their names, the formation of concepts begins, and these take the place of concrete images" (p. 114). Taken together, these two statements seem to suggest that Bühler believed that the acquisition of language corrupted the child's perceptions by changing his or her retinal images, which seems hardly credible.

Piaget's account of drawing seems equally confused. Piaget was not especially interested in drawing for its own sake but only for the light it could throw on the development of the child's conception of space, and although he endorsed Luquet's (1927/2001) theory of intellectual and visual realism, his own account is rather different. In *The Child's Conception of Space* (Piaget & Inhelder, 1956), Piaget suggested that developmental changes in the child's conception of space could be described in terms of a hierarchy of geometries in the following order: topological geometry, projective geometry, affine geometry, and Euclidean-metrical geometry. This suggestion was derived from Jules-Henri Poincaré's account of invariant geometry, in which different kinds of spatial relations remain invariant over transformations from one coordinate system to another. In topological transformations, at one end of the hierarchy, only the most basic spatial relations such as separation and enclosure are preserved, while at the other end Euclidean-metrical relations, such as the true lengths and shapes of objects, remain invariant.

But it is not clear whether Piaget intended his account to apply to changes in the way the children perceive the world at different ages, or to changes in the way they draw it. If he intended it to apply to the way children perceive the world his account seems implausible. If young children can perceive the world only in terms of topological geometry, how can they ever recognize objects or find their way around? Piaget's suggestion that children preserve the

topological relations between objects and parts of objects in their drawing has proved to be valuable, but if his account of the child's conception of space is intended only to apply to drawing it is flawed. Projective transformations in drawing correspond to true perspective, affine transformations to systems such as oblique projection, and Euclidean-metric transformations to orthogonal projection, so that in the later stages of drawing the sequence in which they appear should be, according to Piaget, perspective, oblique projection, and orthogonal projection. In fact, the actual developmental sequence, as shown by the results of numerous experiments, is the reverse of this.

Moreover, in his account of young children's inability to represent foreshortening Piaget did not appeal to the young child's conception of space in terms of topological geometry. Instead, he suggested that children need to become consciously aware of their own viewpoint to draw what they see. "In short, due to a lack of conscious awareness or mental discrimination between different viewpoints, these children are unable to represent perspective and cling to the 'object in itself'" (Piaget & Inhelder, 1956, p. 178). This suggests that Piaget believed that even young children see things in perspective but are unable to represent this in their drawings because they are not consciously aware of their own viewpoints. Finally, Piaget's most famous contribution to psychology, the theory of egocentrism, that young children see everything from their own point of view to the exclusion of everyone else's, suggests that young children, of all people, should draw in perspective.

From a theoretical standpoint the most extreme variation on the theme that young children draw things differently because they see them differently was that advanced by the early art educators, who believed that young children's drawings were creative and expressive because they were derived from a pure and innocent vision of the world that had not yet been corrupted by bourgeois values and the conventions of academic realism. But this leaves unanswered the question of where the "faults" that Cizek so admired come from: it is difficult to believe that they are somehow inherent in the way young children perceive the world. But art educators such as Cizek and his followers were not interested in theoretical questions of this kind. Their primary concern was to free children from what Costall (1997) called "the Gradgrind routine of early art education in the schools, where children were obliged to copy uninspiring objects, or worse still, replicate simple shapes and figures" (p. 134). In this they were successful, at least in the short term. These early art educators took young children's drawings seriously, and their dedication and enthusiasm were reflected in the work produced by the children in their care. But they were seduced into an untenable theory of child art by the misleading resemblance between the anomalies in children's

drawings and similar anomalies in the art of the avant-garde, which they believed stemmed from the innocence and purity of vision that these artists had somehow managed to preserve. In reality, most of the artists of the avant-garde were highly self-conscious about what they were doing, and the anomalies in their work were there either because they could be used as a means of expression or because, in their reversal of the normal rules of depiction, they could be used to investigate the nature of depiction itself. And far from being born of innocence and ignorance, their paintings were strongly influenced by the work of earlier painters. Matisse's paintings, for example, can be seen as continuing the work of earlier painters such as Poussin, Chardin, Watteau, Corbet, Manet, and Cézanne; much the same can be said of most of the major avant-garde painters (Jacobus, 1989).

The new art teachers believed art could remain in a perpetual state of renewal and that there would be a perennial avant-garde (Wilson, 1992). But in reality the art of the avant-garde was relatively short lived, and as the 20th century progressed the similarities between the formal aspects of children's drawings and the work of contemporary painters began to disappear, so that only the more negative aspects of the new art teaching remained. The belief that the only true way to teaching lay in the avoidance of teaching was potentially dangerous and often resulted in lazy teaching. The desire to shield children from the influence of adult artists prevented children from understanding either the work of earlier painters or the reasons painting had changed, and it prevented children from acquiring basic drawing skills. By the end of the century these shortcomings had bred a new generation of art teachers, many of whom were themselves unable to draw and who were incapable of teaching in any coherent way. It is hardly surprising that when the students trained by these teachers became artists they became conceptual artists: a way of practicing as an artist that did not appear to require any ability in drawing.

I have found it difficult to give full justice to all these different theories of children's drawings. Because they contain so many internal contradictions and confusions it is hard to make sense of them, even though many of them contain valuable insights. With hindsight, it is possible to see that most of these contradictions and confusions came about as the result of the all-pervading influence of camera theories of perception allied with copying theories of drawing. In one way or another drawing always consisted of copying two-dimensional mental images onto the picture surface, and because it was difficult to see how these images could be anything but perspectival, a variety of theories was developed to explain why children's drawings were not in perspective.

With the possible exception of Luquet, the only writer who explicitly rejected copying theories of drawing was Arnheim. Arnheim (1974) proposed instead that children learn to draw by discovering or inventing "graphic equivalents" for the objects they want to draw. These are not copies of views, nor are they copies of the objects themselves, or copies of drawings by other people. Instead, their drawings are composed of forms that are related to the shapes of objects in fundamental ways and provide structural equivalents for them but do not depend on or provide a one-to-one correspondence. Instead of seeing drawing as a mechanical process, similar to the production of pictures by photography, Arnheim saw drawing as a graphic language, and his account of the creative nature of drawing comes close to Chomsky's account of the creative nature of verbal language.

Although Arnheim's (1974) account of children's drawings has been very influential, there are two reasons it has not been more widely accepted. The first is that his theory of pictures was derived from Gestalt psychology. Gestalt psychology was an important stage in the history of theories of visual perception, and in some respects provided a stepping stone between earlier, optical theories of vision and present-day accounts. In the first part of the 20th century, Gestalt psychology dominated theories of visual perception and influenced the work of a number of artists including Kandinsky and Klee. Gestalt psychologists were invited to lecture at the Bauhaus when Kandinsky and Klee were teaching there in the 1920s, and in the 1930s the Bauhaus offered an entire course in psychology, with an emphasis on Gestalt psychology, as part of the regular curriculum. However, Gestalt psychology was based on a crude and untenable "magnetic" theory of the physiology of brain function, that has now been superseded. The main problem with Arnheim's theory of depiction, however, is that he was never able to give any detailed account of how children's drawings provide graphic equivalents for objects. This was because the vocabulary for describing the relations between scenes and pictures, derived from modern theories of vision and related work in artificial intelligence, was simply not available to Arnheim at the time he was writing.

Thanks to recent work in the fields of visual perception and artificial intelligence, and especially the work of Marr, a vocabulary for describing the rules governing the spatial relations between scenes and pictures, and the relations among marks, picture primitives, and scene primitives is now available. My main object in writing this book has been to describe these rules by using this vocabulary, to show how children use these rules in their drawings, and to show how they invent and discover new and increasingly effective rules of representation during the course of drawing development.

Children can be creative in the way they use these rules, just as they can be creative in way they use the rules of language. But their creativity is the creativity of children, not the creativity of adult artists. The structural similarities between children's drawings and the art of the 20th-century avant-garde misled art teachers into believing that children are creative artists in the sense that Klee, Mattisse, and Picasso were artists, and their mistaken belief that children's creativity depends on their remaining in a state of perceptual innocence led them to withdraw any kind of teaching. Unfortunately this led, in the long run, to the result they were trying to avoid. By the time they reach puberty most children have lost interest in drawing because without adult help they are unable to make further progress. Children need help from adults, but to give this help effectively we need to understand what it is that children are trying to do when they are learning to draw and how they are trying to do it.

Appendix

Seeing depth in pictures is a subjective experience but it is not unreal, and Koenderink (1998) has shown that it is possible to measure the depth of pictorial space objectively. Koenderink did this by showing subjects a picture on a computer screen together with what he called a "gauge figure," which consists of a representation of a circle with a short axis running through it. The tilt and slant of this gauge figure can be adjusted on screen, and viewers are invited to adjust the gauge figure until it seems to lie on the surface of the viewed object. When they have done this (which normally takes only a few seconds) a new gauge figure appears on the screen at a different (randomly selected) location and the operation is repeated. Figure A.1a shows a typical example of a photograph used in this experiment, and Fig. A.1b shows the tilts and slants of the gauge figure selected by a subject for the lower left half of the photograph.

When this operation has been repeated a few hundred times the tilts and slants of the gauge figures are integrated, and this gives a measure of the shape of the surface seen by the subject in the picture. Koenderink (1998) called the shape dimension of this surface "pictorial relief." Figure A.2 shows a three-dimensional rendering of the pictorial relief seen by one subject in the photograph shown in Fig. A.1a.

Koenderink et al. (1996) also measured the perception of pictorial relief in line drawings and silhouettes. Figure A.3a shows a silhouette of the smooth solid object shown in Fig. A.1a, and Fig. A.3b shows a line drawing derived from the same photograph. Their results showed that the perception of pictorial relief in the silhouette was poor for naive observers and was reasonably articulated but inaccurate for an observer familiar with both the real object and the gray-scale photographs. The perception of pictorial relief in the line drawing, however, was as good as it was for the photograph.

a b

FIG. A.1. (a) A photograph of a three-dimensional object displayed on the computer screen. (b) The tilts and slants of the gauge figure selected by the subject to fit the apparent tilts and slants of the lower left hand of the surface represented in the photograph. Adapted from Koenderink (1998, Figs. 1a and 2a). Courtesy of J. Koenderink.

FIG. A.2. A three-dimensional rendering of the pictorial relief seen by one subject in the photographs shown in Fig. 8.4a. Taken from Koenderink (1998, Fig. 2c). Courtesy of J. Koenderink.

a b

FIG. A.3. (a) A silhouette of the smooth solid object shown in Fig. 8.4a. (b) A line drawing taken from the same photograph. Adapted from Koenderink et al. (1996, Fig. 1). Courtesy of J. Koenderink.

These results agree with our intuition that it is difficult to see shape in silhouettes but easy to see shape in line drawings. Koenderink et al.'s findings also agree with the results of experiments that have shown that the recognition of objects in line drawings is just as good as, or in some cases better than, the recognition of the same objects in full color photographs. Koenderink's findings support Wollheim's (1977, 1998) definition of representation in terms of seeing in and confirm our intuition that some kinds of pictures are less effective as representations than others: silhouettes, for example, are less effective than either line drawings or photographs.

Glossary

Accidental alignment The accidental alignment of unrelated features in a view of a scene resulting from the choice of a particular viewpoint as when, for example, two corners, separated in the scene, happen to occupy the same position in a view.

Arrow-junction A line junction in the form of an arrow, normally representing the corner of an object with plane faces.

Competence The underlying knowledge of a representational system possessed by an adult or child, unaffected by performance factors and usually operating at an unconscious level.

Contours The outlines of a smooth object, made up of the points where the line of sight just grazes the surface of the object.

Coordinate system The frame of reference used to define the spatial relations between scene or picture primitives. Coordinate systems may be based on numbers, as in the (x,y,z) coordinates in a Cartesian coordinate system, but they need not be. For example, the legs of a table might be described as being *below* the corners of the tabletop and *joined* to the corners at one end. Coordinate systems may be object-centered or viewer-centered.

Denotation systems The representational systems that map scene primitives into corresponding picture primitives. In line drawings, for example, the denotation system maps edges and contours in the scene into lines in the picture.

Disk A scene primitive that is saliently extended in two directions but not the third.

Domain The scope of a representation. Three main kinds of domains are normally considered in the analysis of pictures: scenes, pictures, and pictorial images.

Drawing systems The representational systems that map spatial relations in the scene into corresponding spatial relations in the picture. Most of the drawing systems (excluding those based on topological geometry) can be de-

fined in terms of either primary or secondary geometry. Perspective, for example, can be defined in terms of the geometry of the projection of light rays from the scene. Alternatively, it can be defined as the system in which the orthogonals (lines in the picture representing edges in the third dimension of the scene) converge to a vanishing point.

Edges Surface discontinuities such as the edges of cubes and the projections of such features in the frontal plane.

End-junctions The points in line drawings where lines representing contours end.

Extendedness The extendedness of a scene or picture primitive specifies its relative extensions in different directions. Objects in scenes can be round, long, or flat and can be described as lumps, sticks, or disks. The extendedness of an object is independent of its surface shape so that, in terms of their extendedness, balls, potatoes, and cubes can all be described as lumps. Regions in pictures can be round or long, and their extendedness is independent of the shapes of their outlines.

False attachment False attachments in pictures represent accidental alignments in views of scenes, for example, a line junction representing two otherwise unrelated corners of an object that happen to occur at the same point in a view of the object.

Fold-out drawings Drawings in which the faces of objects are shown folded down onto the picture surface regardless of their orientations in the scene.

Foreshortening If an object is turned so that one or more of its axes appears to be reduced in length relative to the viewer it is said to be foreshortened.

Frontal plane The plane lying perpendicular to the viewer's line of sight.

General position A position for the viewer in which accidental alignments are avoided.

Line A one-dimensional mark or a one-dimensional picture primitive.

Line junction The point where a line representing a contour ends, or the point where two or more lines meet.

L-junction A line junction in the shape of the letter *L*.

Local tone The term used to describe the intrinsic tone of a surface, irrespective of the lighting conditions.

Lump An informal name for a scene primitive that is about equally extended in all three dimensions.

Marks The actual physical entities, such as blobs of paint or pigment, used to represent picture primitives.

Object-centered description A shape description of an object given relative to the principal axes of the object itself rather than to the position of the viewer.

Occluding contours A term used to distinguish the outlines of an object from its surface contours.

Occlusion If an object is hidden by another object relative to a particular viewpoint, it is said to be occluded by it.

Orthogonals The lines in a picture that represent edges in the scene that lie perpendicular to the picture plane.

Outline A line defining the boundaries of a region, or a line in a line drawing representing the occluding contours of an object.

Performance The actual use of a representational system in concrete situations.

Pictorial image The paradoxical scene that we see in pictures. Pictorial images are normally three-dimensional, but the degree of relief we see in pictorial images may be less than that in the real or imaginary scenes they represent.

Picture A two-dimensional representation of a three-dimensional object or scene.

Picture plane Pictures based on one or other of the projection systems are imagined as resulting from the intersection of light rays from the scene and a plane known as the picture plane that lies between the scene and the viewer.

Picture primitives The smallest meaningful units in a picture. Picture primitives may be zero-dimensional (points or line junctions), one-dimensional (lines), or two-dimensional (regions).

Point of occlusion The point in a view of a scene where an edge or contour disappears behind a surface.

Primary geometry The three-dimensional geometry of the projection of light rays from objects in the scene and their intersection with the picture plane to form an image.

Primitives The smallest units of meaning available in a representation or description.

Rabattement Luquet's (1927/2001) term for folding out.

Recapitulation According to the theory of recapitulation, the development of an individual repeats the evolutionary history of the species. In the late 19th and early 20th centuries it was thought that children's drawing development recapitulated the history of art.

Regions The term used to describe both two-dimensional shape primitives in views of scenes and two-dimensional primitives in pictures. The regions in pictures are represented by areas, which may be defined by their outlines or filled in with paint or pigment, as they are in silhouettes.

Representation A formal scheme for representing a set of primitives and their spatial relations.

Saliency A primitive is said to be saliently extended in a given direction if its extension in that direction is significantly greater than that in some other direction.

Scene A three-dimensional representation of the shapes of real or imaginary objects.

Scene primitives The smallest meaningful units in a scene. Scene primitives may be zero-dimensional (the corners of a object or the intercepts of small bundles of light rays), one-dimensional (the edges or contours of an object), two-dimensional (the faces of an object or regions in the frontal plane), or three-dimensional (lumps, sticks, or disks).

Secondary geometry The two-dimensional geometry defining the spatial relations between picture primitives on the surface of the picture.

Secondary shape properties Shape properties of scene primitives that are less elementary than their extendedness (e.g., "being pointed" or "having flat faces").

Shape The geometry of a scene or picture primitive.

Shape modifier A means of representing secondary shape properties added to a picture primitive to modify its extendedness (e.g., using straight lines in the outlines of a region to represent the property "having flat faces").

Smooth object An object whose surface is without edges, creases, or other abrupt discontinuities.

Stick The informal name for a volumetric scene primitive that is saliently extended in only one direction.

Surface contours One-dimensional shape features on the surface of an object.

Tadpole figures Children's early figure drawings that lack a trunk or in which the trunk is amalgamated with the head.

T-junction A line junction in the form of the letter T, normally representing a point of occlusion.

Tonal modeling The apparent changes in the illumination of the surfaces of objects, according to the angle they make with the light source. The representation of tonal modeling in pictures can provide information about the shapes of objects.

Transparency The result of including in a drawing those details of objects that would otherwise be hidden. Transparency may result from including objects hidden inside other objects (such as a bird in an egg) or objects hidden behind other objects from a particular point of view.

View The projection of a scene in the frontal plane.

Viewer-centered description A shape description of a scene given relative to the viewer.

Viewpoint The notional position occupied by a monocular viewer in relation to a scene or a picture showing a view of a scene.

Visual field A term used by Gibson (1950) to describe the introspective experience of seeing the world as a perspective projection.

Volumetric primitive A three-dimensional scene primitive such as a lump, stick, or disk.

Y-junction A line junction in the shape of the letter *Y*.

References

Adams, K. I., & Conklin, N. F. (1973). Towards a theory of natural classification. *Papers from the Ninth Regional Meeting, Chicago Linguistic Society*, 1–10.

Anfam, D. A., Beal, M., Bowes, E., Callen, A., Chandler, D., Collins, J., Hackney, S., Meredith, C., McCleery, J., Perry, R., Villers, C., Watkins, N., & Welchman, J. (1987). *Techniques of the Great Masters*. Secaucus, NJ: Chartwell.

Arnheim, R. (1956). *Art and Visual Perception: A Psychology of the Creative Eye*. London: Faber & Faber.

Arnheim, R. (1974). *Art and Visual Perception: A Psychology of the Creative Eye. The New Version*. Berkeley and Los Angeles: University of California Press.

Barnes, E. (1894). The art of little children. *Pedagogical Seminary, 3*, 302–307.

Biederman, I. (1987). Recognition by components: a theory of human image understanding. *Psychological Review, 94*, 115–147.

Bloomfield, L. (1933). *Language*. London: Allen & Unwin.

Bühler, K. (1949). *The Mental Development of the Child*. London: Routledge & Kegan Paul. (Original work published 1930)

Burton, E. (1997). Artificial innocence: interactions between the study of children's drawing and artificial intelligence. *Leonardo, 30*(4), 301–309.

Caron-Pargue, J. (1985). *Le dessin du cube chez l'enfant*. Berne, Switzerland: Editions Peter Lang.

Chomsky, N. (1959). Review of *Verbal Behavior* by B. F. Skinner. *Language, 35*, 26–58.

Chomsky, N. (1965). *Aspects of the Theory of Syntax*. Cambridge, MA: MIT Press.

Chomsky, N. (1972). *Language and Mind*. New York: Harcourt Brace Jovanovich.

Cizek, F. (1927). *Children's Coloured Paper Work*. Vienna: Schroll. (Trans. of *Papier-Schneide-und-Klearbeiten*, 1914)

Clark, A. B. (1897, July). The child's attitude towards perspective problems. *Studies in Education*, 283–294.

Clark, E. V. (1976). Universal categories: on the semantics of classifiers and children's early word meanings. In A. Juilland (Ed.), *Linguistic Studies Offered to Joseph Greenberg on the Occasion of his Sixtieth Birthday* (Vol. 1, pp. 449–462). Saratoga, CA: Anma Libri.

Clement, R. (1992). The classroom reality of teaching. In D. Thistlewood (Ed.), *Drawing Research and Development* (pp. 121–129). Harlow, England: Longmans.

Clowes, M. B. (1971). On seeing things. *Artificial Intelligence, 2*, 79–116.

Cooper, D., & Tinterow, G. (1983). *The Essential Cubism*. London: Tate Gallery.

Costall, A. (1993). Beyond linear perspective: a cubist manifesto for visual science. *Image and Vision Computing, 11*, 334–341.

Costall, A. (1994). The myth of the sensory core: the traditional versus the ecological approach to children's drawings. In C. Lange-Kuettner & G. V. Thomas (Eds.), *Drawing and looking: Theoretical Approaches to Pictorial Representation in Children* (pp. 16–26). Hemel Hempstead, England: Harvester.

Costall, A. (1997). Innocence and corruption: conflicting images of child art. *Human Development, 40*, 133–144.

Costall, A. (2001). Introduction, A closer look at Luquet, to Luquet (1927). In *Children's Drawings (Le Dessin Enfantin)* (pp. vii–xxiv). London: Free Association Books.

Court, E. (1992). Researching social influences in the drawings of rural Kenyan children. In D. Thistlewood (Ed.), *Drawing Research and Development* (pp. 51–67). Harlow, England: Longmans.

Cox, M. V. (1985). One object behind another: young children's use of array-specific or view-specific representations. In N. H. Freeman & M. V. Cox (Eds.), *Visual Order: The Nature and Development of Pictorial Representation* (pp. 188–201). Cambridge, England: Cambridge University Press.

Cox, M. V. (1992). *Children's Drawings*. London: Penguin.

Cox, M. V., & Parkin, C. E. (1986). Young children's human figure drawing: cross-sectional and longitudinal studies. *Educational Psychology, 6*, 353–368.

Cromer, R. F. (1974). The development of language and cognition: The cognition hypothesis. In B. Foss (Ed.), *New Perspectives in Child Development* (pp. 184–252). Harmondsworth, England: Penguin.

Crook, C. (1985). Knowledge and appearance. In N. H. Freeman & M. V. Cox (Eds.), *Visual Order: The Nature and Development of Pictorial Representation* (pp. 248–265). Cambridge, England: Cambridge University Press.

Darwin, C. (1859). *The Origin of Species*. London: John Murray.

Denny, P. J. (1978). The "extendedness" variable in noun classifier semantics: universal features and cultural variation. In M. Mathiot (Ed.), *Ethnolinguistics: Boas, Saphir and Whorf Revisited* (pp. 97–119). The Hague, Netherlands: Mouton.

Denny, P. J. (1979a). Semantic analysis of selected Japanese numeral classifiers for units. *Linguistics, 17*, 317–335.

Denny, P. J. (1979b). Roots for rounded shapes. *Algonquian Linguistics, 4*, 26–27.

Dubery, F., & Willats, J. (1972). *Drawing Systems*. London: StudioVista; New York: Van Nostrand Reinhold.

Dubery, F., & Willats, J. (1983). *Perspective and Other Drawing Systems*. London: Herbert Press; New York: Van Nostrand Reinhold.

Eng, H. (1931). *The Psychology of Children's Drawings*. London: Routledge & Kegan Paul.

Fein, S. (1984). *Heidi's Horse*. Pleasant Hill, CA: Exelrod Press.

Fineberg, J. (1997). *The Innocent Eye: Children's Art and the Modern Artist*. Princeton, NJ: Princeton University Press.

Flemming-Williams, C. (1923). Abstract art for children: an experiment. *New Era, 4*, 14.

Freeman, N. H. (1972). Process and product in children's drawing. *Perception, 1*, 123–140.

Freeman, N. H. (1975). Do children draw men with arms coming out of the head? *Nature, 254*(5499), 416–417.

Freeman, N. H. (1987). Current problems in the development of representational picture-production. *Archives de Psychologie, 55*, 127–152.

Freeman, N. H., Evans, D., & Willats, J. (1988, June). *Symposium overview: The computational approach to projection drawing-systems.* Paper given at the Third European Conference on Developmental Psychology, Budapest.

Freeman, N. H., & Janikoun, R. (1972). Intellectual realism in children's drawings of a familiar object with distinctive features. *Child Development, 43,* 1116–1121.

Fry, R. (1917, September 12). Teaching art. *The Atheneum,* pp. 887–888.

Gardner, H. (1980). *Artful Scribbles: The Significance of Children's Drawings.* New York: Basic Books.

Gibson, J. J. (1950). *The Perception of the Visual World.* Boston: Houghton Mifflin.

Gibson, J. J. (1971). The information available in pictures. *Leonardo, 4,* 27–35.

Gibson, J. J. (1978). The ecological approach to the visual perception of pictures. *Leonardo, 11,* 227–235.

Golomb, C. (1992). *The Child's Creation of a Pictorial World.* Berkeley: University of California Press.

Gombrich, E. H. (1988). *Art and Illusion: A Study in the Psychology of Visual Representation.* Oxford, England: Phaidon Press.

Goodenough, F. L. (1926). *Measurement of Intelligence by Drawings.* New York: Harcourt, Brace & World.

Goodnow, J. (1977). *Children's Drawing.* Cambridge, MA: Harvard University Press.

Hagen, M. (1985). There is no development in art. In N. H. Freeman & M. V. Cox (Eds.), *Visual Order: The Nature and Development of Pictorial Representation* (pp. 59–77). Cambridge, England: Cambridge University Press.

Hagen, M. (1986). *Varieties of Realism: Geometries of Representational Art.* Cambridge, England: Cambridge University Press.

Harris, D. B. (1963). *Children's Drawings as Measures of Intellectual Maturity.* New York: Harcourt, Brace & World.

Hayes, J. (1978). Children's visual descriptions. *Cognitive Science, 2,* 1–15.

Hochberg, J., & Brooks, V. (1962). Pictorial recognition as an unlearned ability in a study of one child's performance. *American Journal of Psychology, 75,* 624–628.

Hollerbach, J. M. (1975). *Hierarchical shape description of objects by selection and modification of prototypes* (MIT Artificial Intelligence Laboratory Technical Report No. 346). Cambridge, MA: MIT Press.

Huffman, D. A. (1971). Impossible objects as nonsense sentences. In B. Meltzer & D. Mitchie (Eds.), *Machine Intelligence* (Vol. 6, pp. 295–323). Edinburgh, Scotland: Edinburgh University Press.

Ives, W., & Rovert, J. (1979). The role of graphic orientations in children's drawings of familiar and novel objects at rest and in motion. *Merrill-Palmer Quarterly, 25,* 281–292.

Jacobus, J. (1989). *Matisse.* London: Thames & Hudson.

Jahoda, G. (1981). Drawing styles of schooled and unschooled adults: a study in Ghana. *Quarterly Journal of Experimental Psychology, 33A,* 133–143.

Kahnweiler, D. H. (1969). *Gris.* London: Thames & Hudson.

Kellogg, R. (1969). *Analyzing Children's Art.* Palo Alto, CA: National Press Books.

Kemp, M. (1992). *The Science of Art: Optical Themes in Western Art from Brunelleschi to Seurat.* New Haven, CT and London: Yale University Press.

Kennedy, J. M. (1974). *A Psychology of Picture Perception.* San Francisco: Jossey-Bass.

Kennedy, J. M. (1983). What can we learn about pictures from the blind? *American Scientist, 71,* 19–26.

Kennedy, J. M., & Ross, A. S. (1975). Outline picture perception by the Songe of Papua. *Perception, 4,* 391–406.

Kennedy, J. M., & Silvers, J. (1974). The surrogate functions of lines in visual perception: evidence from antipodal rock and cave artwork sources. *Perception, 3,* 313–322.

Kerschensteiner, G. (1905). *Die Entwicklung der zeichnerischen Begabung.* Munich, Germany: Gerber.

Klee, P. (1961). *Notebooks (The Thinking Eye). Vol. 1* (J. Spiller, Ed.). London: Lund Humphries.

Koenderink, J. J. (1984). What does the occluding contour tell us about solid shape? *Perception, 13,* 321–330.

Koenderink, J. J. (1998). Pictorial relief. *Philosophical Transactions of the Royal Society of London, A, 356,* 1071–1086.

Koenderink, J. J., van Doorn, A. J., & Christou, C. (1996). Shape constancy in pictorial relief. *Perception, 25,* 155–164.

Land, M. (1990). Vision in other animals. In H. Barlow, C. Blakemore, & M. Weston-Smith (Eds.), *Images and Understanding* (pp. 197–212). Cambridge, England: Cambridge University Press.

Light, P. H. (1985). The development of view-specific representation considered from a socio-cognitive standpoint. In N. H. Freeman & M. V. Cox (Eds.), *Visual order: The Nature and Development of Pictorial Representation* (pp. 214–230). Cambridge, England: Cambridge University Press.

Light, P. H., & Humphreys, J. (1981). Internal spatial relationships in young children's drawings. *Journal of Experimental Child Psychology, 31,* 521–530.

Light, P., & Macintosh, E. (1980). Depth relationships in young children's drawings. *Journal of Experimental Child Psychology, 30,* 79–87.

Luquet, G.-H. (1913). *Les dessins d'un enfant: thèse pour la doctorat presenté à la faculté des lettres de l'université de lille.* Paris: Libraire Félix Alcan.

Luquet, G.-H. (1927/2001). *Le Dessin Enfantin* [Children's Drawings]. Paris: Alcan. Trans. Costall (2001). London: Free Association Books.

Lukens, H. T. (1899). Drawings in the early years. *Proceedings of the National Educational Association, 945–951.*

Malvern, S. (1988). *Modernism and the child: innovation in art and art education and the teaching of Marion Richardson and Franz Cizek.* Unpublished manuscript.

Malvern, S. (1994). Recapping on recapitulation, or how to primitivize the child. *Third Text. Third World Perspectives on Contemporary Art and Culture, 27,* 21–30.

Malvern, S. (1995). Inventing "child art": Franz Cizek and modernism. *British Journal of Aesthetics, 35,* 262–272.

Malvern, S. (1997). Nan Youngman: artist and educator. In J. Rea (Ed.), *Nan Youngman 1906–1995* (pp. 25–29). London: Julia Rea.

Mankowitz, W. (1967). *A Kid for Two Farthings.* London: Deutsch.

Marr, D. (1982). *Vision: A Computational Investigation into the Human Representation and Processing of Visual Information.* San Francisco: Freeman.

Marr, D., & Nishihara, H. K. (1978). Representation and recognition of the spatial organization of three-dimensional shapes. *Proceedings of the Royal Society of London, Series B, 200,* 269–294.

Matthews, J. (1984). Children drawing: are young children really scribbling? *Early Child Development and Care, 18,* 1–39.

Matthews, J. (1992). The genesis of aesthetic sensibility. In D. Thistlewood (Ed.), *Drawing Research and Development* (pp. 26–39). Harlow, England: Longmans.

Matthews, J. (1999). *The Art of Childhood and Adolescence*. London: Falmer Press.

Matthews, J. (2003). *Drawing and Painting: Children and Visual Representation*. London: Chapman.

Milbrath, C. (1998). *Patterns of Artistic Development in Children: Comparative Studies of Talent.* Cambridge, England: Cambridge University Press.

Millar, S. (1975). Visual experience or translation rules: drawing the human figure by blind and sighted children. *Perception, 4*, 363–371.

Minsky, M., & Papert, S. A. (1972). *Artificial intelligence report* (Artificial Intelligence Memo No. 252). Cambridge, MA: MIT Press.

Moore, V. (1986). The use of a colouring task to elucidate children's drawings of a solid cube. *British Journal of Developmental Psychology, 4*, 335–340.

Morss, J. (1987). The construction of perspectives: Piaget's alternative to spatial egocentrism. *International Journal of Behavioral Development, 10*, 263–279.

Moskowitz, B. A. (1978). The acquisition of language. *Scientific American, 239*, 82–96.

Nicholls, A. L., & Kennedy, J. (1992). Drawing development: from similarity of features to direction. *Child Development, 63*, 227–241.

O'Brian, P. (2003). *Picasso*. London: HarperCollins.

Paine, S. (1992). Conflicting paradigms of vision in drawing development research. In D. Thistlewood (Ed.), *Drawing Research and Development* (pp. 1–13). Harlow, England: Longmans.

Palmer, S. E. (1999). *Vision Science: Photons to Phenomenology*. Cambridge, MA: MIT Press.

Pearson, D., Hanna, E., & Martinez, K. (1990). Computer generated cartoons. In H. Barlow, C. Blakemore, & M. Weston-Smith (Eds.), *Images and Understanding* (pp. 46–60). Cambridge, England: Cambridge University Press.

Phillips, W. A., Hobbs, S. B., & Pratt, F. R. (1978). Intellectual realism in children's drawings of cubes. *Cognition, 6*, 15–33.

Piaget, J., & Inhelder, B. (1956). *The Child's Conception of Space*. London: Routledge & Kegan Paul.

Rawson, P. (1987). *Drawing*. Philadelphia: University of Pennsylvania Press.

Read, H. (1931, October 21). From the first stroke. *The Listener*, pp. 693–694.

Read, H. (1938, February 26). The art of children. *The Listener*, p. 180.

Read, H. (1958). *Education Through Art*. London: Faber & Faber.

Reith, E. (1988). The development of use of contour lines in children's drawings of figurative and non-figurative three-dimensional models. *Archives de Psychologie, 56*, 83–103.

Ricci, C. (1887). *L'arte dei bambini*. Bologna, Italy: Zanichelli.

Richards, W., Koenderink, J. J., & Hoffman, D. D. (1987). Inferring three-dimensional shapes from two-dimensional silhouettes. *Journal of the Optical Society of America, A, 4*, 1168–1175.

Richardson, M. (n.d.). Unnumbered, unpaginated notebook. Marion Richardson Archives, University of Birmingham.

Richardson, M. (1914, October 23). Unnumbered early writings. Marion Richardson Archives, University of Birmingham.

Richardson, M. (1937). *Lecture to the Royal Society of Arts* (Item No. 3047). Marion Richardson Archives, University of Birmingham.

Rivière, J. (1912). Sur les tendances actuelles de la peinture. *Revue d'Europe et d'Amérique, 1*, 384–406. Trans. A. Costall (1999) unpublished.

Rosch, E. (1973). On the internal structure of perceptual and semantic categories. In T. E. Moore (Ed.), *Cognitive Development and the Acquisition of Language* (pp. 111–144). New York: Academic Press.

Ruskin, J. (1843). *Modern Painters: their superiority in the art of landscape painting to all the Ancient Masters proved by examples of the True, the Beautiful, and the Intellectual from the works of modern artists, especially from those of J. M. W. Turner Esq., R.A.* London: Smith, Elder & Co.

Selfe, L. (1977). *Nadia: A Case of Extraordinary Drawing Ability in an Autistic Child.* London: Academic Press.

Soby, J. T. (1966). *Giorgio de Chirico.* New York: Museum of Modern Art.

Spalding, J. (2003). *The Eclipse of Art.* Munich, Berlin, London, and New York: Prestel.

Stern, W. (1930). *Psychology of Early Childhood.* London: Allen & Unwin.

Sully, J. (1895). *Studies of Childhood.* London: Longmans, Green.

Sutherland, N. S. (1979). The representation of three-dimensional objects. *Nature, 278,* 395–398.

Teuber, M. (1976). *Blue Night* by Paul Klee. In M. Henle (Ed.), *Vision and Artifact* (pp. 131–151). New York: Springer-Verlag.

Teuber, M. (1980, June). Paul Klee—Between art and visual science. Presented at the 12th annual meeting of the Cheiron Society, Bowdoin College, Maine.

Thorndike, E. L. (1913). The measurement of achievement in drawing. *Teacher's College Record, 14.*

Tomlinson, R. R. (1944). *Children as Artists.* Harmondsworth, England: Penguin.

Töpffer, R. (1948). *Réflections et Menus Propos d'un Peintre Génevois.* Genève: n.p.

van Doorn, A. J., Koenderink, J. J., & de Ridder, H. (2001). Pictorial space correspondence in photographs of an object in different poses. In B. E. Rogowitz & T. N. Pappas (Eds.), *Human Vision and Electronic Imaging VI* (pp. 321–329). Washington, DC: SPIE–The International Society for Optical Engineering.

Verworn, M. (1917). *Zur Psycholgie der primitiven Kunst.* Jena, Germany: Fischer.

Viola, W. (1936). *Child Art and Franz Cizek.* Vienna: Austrian Junior Red Cross.

Viola, W. (1945). *Child Art.* Bickley, England: University of London Press.

Wiedmann, A. K. (1979). *Romantic Roots in Modern Art.* Surrey, England: Gresham.

Willats, J. (1977a). How children learn to draw realistic pictures. *Quarterly Journal of Experimental Psychology, 29,* 367–382.

Willats, J. (1977b). How children learn to represent three-dimensional space in drawings. In G. Butterworth (Ed.), *The Child's Representation of the World* (pp. 189–202). London: Plenum Press.

Willats, J. (1981). *Formal Structures in Drawing and Painting.* Unpublished Ph.D. thesis, Council for National Academic Awards.

Willats, J. (1984). Getting the drawing to look right as well as to be right: the interaction between production and perception as a mechanism of development. In W. R. Crozier & A. J. Chapman (Eds.), *Cognitive Processes in the Perception of Art* (pp. 111–125). Amsterdam: North-Holland.

Willats, J. (1985). Drawing systems revisited: the role of denotation systems in children's figure drawings. In N. H. Freeman & M. V. Cox (Eds.), *Visual Order: The Nature and Development of Pictorial Representation* (pp. 78–100). Cambridge, England: Cambridge University Press.

Willats, J. (1987). Marr and pictures: an information-processing account of children's drawings. *Archives de Psychologie, 55,* 105–125.

Willats, J. (1991). The draughtsman's contract: creating an image. In H. Barlow, C. Blakemore, & M. Weston-Smith (Eds.), *Images and Understanding* (pp. 235–254). Cambridge, England: Cambridge University Press.

Willats, J. (1992a). The representation of extendedness in children's drawings of sticks and discs. *Child Development, 63*, 692–710.

Willats, J. (1992b). Seeing lumps, sticks and discs in silhouettes. *Perception, 21*, 481–496.

Willats, J. (1992c). What is the matter with Mary Jane's drawing? In D. Thistlewood (Ed.), *Drawing Research and Development* (pp. 141–152). Harlow, England: Longmans.

Willats, J. (1997). *Art and Representation: New Principles in the Analysis of Pictures.* Princeton, NJ: Princeton University Press.

Willats, J. (2003). Optical laws or symbolic rules? The dual nature of pictorial systems. In H. Hecht, R. Schwartz, & M. Atherton (Eds.), *Looking into Pictures: An Interdisciplinary Approach to Pictorial Space* (pp. 125–143). Cambridge, MA: MIT Press.

Wilson, B. (1992). Primitivism, the avant-garde and the art of little children. In D. Thistlewood (Ed.), *Drawing Research and Development* (pp. 14–25). Harlow, England: Longmans.

Wilson, B., & Wilson, M. (1977). An iconoclastic view of the imagery sources in the drawings of young people. *Art Education, 31,* 3, 37–38.

Wilson, B., & Wilson, M. (1982). The case of the disappearing two-eyed profile: or little children influence the drawings of little children. *Review of Research in Visual Arts Education, 15,* 1–18.

Wilson, F. (1921). *Education, considered as growth and self-fulfilment* (Lecture by Cizek). Children's Art Education Fund.

Wilson, F. (1922). *Christmas Pictures by Children.* London: Dent & Sons; Vienna: Burgverlag, Richter & Zöllner.

Winner, E. (1986). Where pelicans kiss seals. *Psychology Today, 20,* 8, 24–35.

Wollheim, R. (1977). Representation: The philosophical contribution to psychology. In G. Butterworth (Ed.), *The Child's Representation of the World* (pp. 173–188). London: Plenum Press.

Wollheim, R. (1998). *Painting as an Art.* London: Thames & Hudson.

Youngman, N. (1964). *Recent changes in art education* (Transcript of a lecture in Sheffield). Collection of Nan Youngman.

Zerffi, G. G. (1876). *A Manual of the Historical Development of Art.* London: Hardwicke & Bogue.

Index

(Figures in italics refer to the page numbers of reproductions of artists' pictures.)

academic painting, 3, 201, 209, 210, 238
action representations, 47–49, 53
adult help, 18, 171–172, 241
ambiguities, 135, 149
anomaly, 2, 3, 17, 18, 39–40, 129, 197–198,
 200–201, 205, 212–213, 223
apples, drawings of, 23–26, 89, 117, 134
areas
 See mark systems
Arnheim, Rudolf, 39–40, 42, 59, 61, 76, 114,
 162, 232, 240
art teaching, 36, 215–219, 231, 239, chap. 11
 passim
 See also new art teaching
attention span, 30, 37
avant-garde artists, 3, 17, 39, 194–199, 204,
 219, 220, 222, 226, 239, chap. 10 *pas-
 sim*

Bauhaus, 39, 240
bourgeois values, 3, 220, 238
Braque, Georges, 39, 196, 198, 204
 Houses at L'Estaque, 196
 L'Estaque: Viaduct and Houses, 196
Bühler, Karl, 26–29, 40, 233, 237

camera model, 173, 178, 186
 See also drawing process *and* drawing, theo-
 ries of
camera obscura, 173–174, 176, 178, 179, 186
camera theory of perception
 See perception
canonical views
 See views, canonical
caretaking, 172
cartoon operator, 66, 159

Cézanne, Paul, 195–197, 227, 236, 239
 Still Life with a Commode, 197
Chirico, Giorgio de, 18, 204
 Mystery and Melancholy of a Street, 204–205,
 205
Chomsky, Noam, 8, 18, 78, 170, 199, 240
Cizek, Franz, 3, 17–18, 194–195, 215–218,
 224–226, 229–231, 238
Clark, Arthur B., 3, 23–26, 41, 89, 134,
 233–234
color, 10, 14, 43, 66, 69, 159, 199, 201, 204,
 211, 213, 244
competence, 37–38, 59, 77, 150–151
computer model, 173, 175–177, 186
 See also drawing process *and* drawing, theo-
 ries of contours
 See scene primitives
conventional figures, 37, 163
copying, 8, 3, 39, 42, 83, 85, 106, 174, 187,
 216, 218, 222, 224–226, 239–240
 See also drawing, theories of
core and radial structures, 47
Costall, Alan, 188,198, 232, 236, 237, 238
Courbet, Gustave, 220
 The Painter's Studio, 220
creativity, 3, 8, 15, 18, 40, 77, 170, 198, 213,
 215, 229–230, 238, 240–241
cubes, drawings of, 8–9, 16–17, 67, 71, 90,
 136–137
Cubism, 195–199, 201, 236
cultural canons, 148

Darwin, Charles, 220
defining features
 See distinctive features

denotation systems, 10–12, 43–44, 55, 77, 90,
 92, 97, 107, 140–142, 156–158,
 201–203, 210
 line drawing, 123, 158–159, 201–203, 244,
 chap. 7 *passim*
 optical systems, 10, 211
 region-based systems, 62, 64, 70–77, 107,
 119, chap. 6 *passim*
 See also cartoon operator *and* line junctions
depth in pictures, 149–152, 242
 See also Appendix *passim,* pictorial image,
 and pictorial relief
development, end point of, 14, 147
developmental sequence, 5–7, 10–11, 14–15,
 41, 90, 100, 103–104, 121–124,
 140–142, 145–147, 167–169, 177, 233
dice, drawings of, 8–9, 71, 92–94, 100,
 105–107, 136
dictated drawings, 50, 58
disks, 79–82, 94–95, 119–120, 153–154
 See also extendedness
distinctive features, 33, 61, 56–58, 74,
 156–158, 160–163
drawing process, chap. 9 *passim*
drawing rules, 1, 5–7, 10, 12, 19, 89, 170,
 189, 199, 236, 240
drawing sequence, 41, 178–186
drawing systems, 5–7, 10, 44, 55, 90, 97, 103,
 107, 140–142, 175, 186–188, 204–205,
 210
 horizontal oblique projection, 109–112, 197
 inverted perspective, 138–139, 212
 naïve perspective, 6, 139–140
 oblique projection, 6, 7, 17, 124, 137–140,
 148, 187
 orthogonal projection, 6, 101–104, 148,
 198, 200
 perspective, 2, 6, 124, 140, 186–187, 195,
 199, 207, 212, 216
 topological systems, 34, 41, 55, 73, 85, 98,
 175, 237
 vertical oblique projection, 6, 109–112, 197,
 200
drawing, theories of, 2–4, 23–26, 29, 39, 41,
 58–59, 174, 188–189, 232–239, chaps.
 2 and 12 *passim*

edges
 See scene primitives
effective representation, 7, 14–16, 80, 145,
 149–156, 159–160, 229, 244
egocentrism, 42, 238

enclosure, 34, 53, 55, 73, 97
equivalents, 39, 42, 73, 84, 85, 114, 240
 See also Arnheim
errors, 8–10, 15, 170, 179–181, 183, 201, 229
exemplarity, 31, 35
 See also Luquet
expression, 17–18, 204–208, 213, 221, 238
extendedness, 49, 68–70, 77, 79, 152, 156
eye direction, 205–207

faces
 See scene primitives
facial expression, 205–207
failed realism, 29
 See also Luquet
false attachment, 109, 129, 200–201, 203,
 206–208, 210
faults, 2–3, 18, 198, 223, 228–229, 238
 See also anomalies
feedback from the pictorial image, 177, 190
 See also pictorial image
figure drawings, 50–52, 65, 77, 80, 88,
 113–115, 130, 131, 145–146, 164, 214
 See also conventional figures *and* tadpole
 figures
fold-out drawings, 16, 104–108, 110–111, 119,
 136, 169, 175
 See also anomalies
forbidden configurations, 128, 136
foreshortening, 2, 23–25, 33, 35, 80, 94–95,
 118–120, 131–134, 167, 238
fortuitious realism, 29, 46, 150, 160, 170
 See also Luquet
Freeman, Norman, 36–39, 59–60, 161, 189
Fry, Roger, 194–195, 217, 219, 223

general views
 See views, general
Gestalt psychology, 39, 42, 231, 240
Gibson, J. J., 2, 66, 173–174
Gombrich, Ernst, 35, 169, 223
Gris, Juan, 198–201, 204
 Breakfast, 201, 210
 Guitar, 200

Helmholtz, Herman von, 195–196, 231, 236
hidden line elimination or HLE, 101,
 176–177
horizontal oblique projection
 See drawing systems
horses, drawings of, 27, 32, 53–54, 73, 91–92,
 116, 133, 157, 229

houses, drawings of, 32, 50–52, 67, 71, 74, 84, 85–86, 196, 102, 107–108, 112

impossible objects, drawings of, 127, 199
Impressionism, 12, 121, 223
innocence, perceptual, 222–223, 228
innocence, visionary, 222
innocent eye, 2, 3, 26–29, 221, 239
intellectual and visual realism, 4, 29, 30, 34, 236
 See also Luquet *and* drawing, theories of
interaction between production and perception
 See mechanism of development
internal model, 33, 236–237
 See also Luquet
inverted perspective
 See drawing systems

Japanese woodblock prints, 199
join relation, 53, 55, 86, 97, 107, 162
jumping spiders, 43

Kandinsky, Wassily, 39, 194, 240
kangaroo model, drawings of, 86, 124–126, 128–129
Klee, Paul, 11, 18, 39, 193, 194, 201, 240
 Oh, but oh!, 204
 Shipwrecked, 201, *202*
 With Green Stockings, 201–204, *202*, 210, 212

language and drawing, 1, 8–9, 10–14, 18, 26, 37, 45, 56, 63, 68–69, 77, 88, 127, 135, 147, 172, 199, 229, 236, 237, 240
line drawing
 See denotation systems
line drawings, perception of, 158–160, 244
line junctions, 123, 126, chap. 7 *passim*
 arrow-junctions, 135
 end-junctions, 129–130, 134, 167, 179, 203
 L-junctions, 135
 merge-junctions, 127, 129, 131
 T-junctions, 110, 129, 130, 134, 135, 166–167, 178, 181, 183
 Y-junctions, 104, 135
Luquet, Georges-Henri, 23, 29–34, 40–41, 59, 76, 108 150, 160, 170, 188, 233, 236
mark systems, 12–13, 45–50, 63–68, 77, 96, 121–122, 140–142, 161–162, 163–165, 208, 212
 areas, 49, 57, 122

outlines, 49, 62, 64, 67–68, 114–117, 124–125
 patches, 46–55, 122
 scribbles, 45–55, 65–68, 122, 164
 single lines, 49, 57, 62, 163–164, 201–203
 See also core and radial structures *and* texture
Mankowitz, Wolf,
 illustration from *A Kid for Two Farthings*, 205–207, *206*
Marr, David, 2, 4, 43–44, 66, 175–176, 188, 195–198, 234, 240
 See also perception, theories of
matière, 208–209, 211, 213
Matisse, Henri, 11, 17, 18, 64, 194, 195, 204, 209, 213, 239
 The Painter's Family, 209–211, *210*
mechanism of development, 165–172, chap. 8 *passim*
 See also picture production and perception
merge-junctions
 See line junctions
movement, representations of
 See action representations

Nadia, 27, 133
naïve perspective
 See drawing systems
natural symbols, 68, 80
new art teaching, 3, 219, 221, 224, 227, 231, 238–239
nonaccidental shape properties, 87, 154
 See also secondary shape properties

object-centered descriptions, 4–5, 33, 43, 70–76, 92–95, 175–176, 188–189, 198, 234
oblique projection
 See drawing systems
occlusion, 31, 88, 103–104, 119, 167, 176–186
 errors in the representation of, 176, 178–179, 183–185
 See also transparency
optical systems
 See denotation systems
orthogonal projection
 See drawing systems
orthogonals, 5–7, 137–138
outlines
 See mark systems

patches
 See mark systems
people, drawings of
 See figure drawings *and* tadpole figures
perception
 picture, as an innate ability, 13, 159
 theories of, 1–3, 42–44, 175, 239
 See also Marr, David
performance, 37–38, 59, 68, 77
perspective
 See drawing systems
physiological optics, 195–196, 236
Piaget, Jean, 34–35, 41–42, 94, 120, 220, 237–238
Picasso, Pablo, 11, 13, 18, 193, 195, 197–198, 204
 Rites of Spring, 153
 Still life with Fruit Dish on a Table, 197
pictorial environment, influence of, 91, 171–172, 216
pictorial image, 16–17, 149–151, 167–169, 178–188, 208–209
 feedback from during production, 177–190
 perceived depth in, 150, 242–243
 role in the drawing systems, 186–188
pictorial relief, 151, 185, 211, 242
 See also pictorial image
picture primitives, 63–64, 121
 See also denotation systems *and* line junctions
picture production and perception, 13–14, 17–18, 65, 101, 146, 164–165, 168, 170, 172, 177, 190
 See also chaps. 8 and 9 *passim*
place holders, 50
Pointillism, 43, 64
points of occlusion
 See scene primitives
popular media, influence of, 35, 36, 41, 233
possible views
 See views, possible
Post-Modern artists, 231
posture, 205–207
Poussin, Nicholas, 239
 The Triumph of Pan, 154
primary geometry, 101–102, 109–110, 137
primitive and tribal artists, 27, 29, 216–217, 220–222, 226, 227
production problems, 60, 162
projection systems, 136–141
 See also drawing systems

projective geometry, 147
 See also drawing systems

rabattement, 31, 108, 110
 See also fold-out drawings, *and* Luquet
Read, Herbert, 217, 218, 219, 223–224
real categories, 69
recapitulation, theory of, 28, 29, 220–222
rectangular objects, 99, 122, 135–141
regions
 See denotation systems
representation, 149
 role of competence in, 150–151
 role of intention in, 149–150
 See also competence, effective representation, seeing in, *and* Wollheim
Richardson, Marion, 3, 17, 194–195, 215, 217–218
Rivière, Jacques, 195–196, 219
Romantic movement, 219
ROSE, 72–75, 175
Rousseau, Jean-Jacques, 219
rules
 See drawing rules
Ruskin, John, 223

scene primitives
 contours, 10, 62, 65–66, 114–117, 123, 125, 134, 159, 162, 203
 edges, 101, 113, 119, 123, 126
 faces, 99–112
 points of occlusion, 103, 123, 166–167, 180–183
 volumes, 70–77, 85, 92, 203
 See also denotation systems
scribbles
 See mark systems
secondary geometry, 101, 137–138
secondary shape properties, 70, 84
 See also nonaccidental shape properties
seeing in, 14–16, 149–150, 161–163, 213, 244, chap. 8 *passim*
self-expression, 217, 224, 228, 231
sensory core, 29, 223
serial order hypothesis, 38, 60
 See also tadpole figures
shape modifiers, 82–92, 122, 134, 201
silhouettes, 44, 64, 66–67, 116–118, 122, 124–126, 153, 156–158, 226, 244
single lines
 See mark systems

single-square drawings, 100–104
See also drawing systems, orthogonal projection
skill, 37, 148, 216, 218, 220, 228, 231
slabs
 See disks
smooth edges, 126
smooth objects, 86, 98–99, 113, 122–123, 126
spatial direction, 53–55
spatial order, 34, 51–52, 55
stereotypes, 36, 41, 76, 89, 90, 107, 111, 233–234
surface curvature, 112–113, 115–117, 130, 134, 154, 158, 166

tables, drawings of, 5–7, 32, 51–52, 81, 90, 101, 110–111, 138–141, 145–147, 180–183, 187, 197
tadpole figures, 12, 30, 37–39, 45, 49, 53–54, 57, 75–76, 161–164, 183–184
 absence of body in, 37, 39, 57–62, 76
 origin of, 161–163
talented children, 27, 130, 133, 166, 213
teddy bear game, 48–49, 53
texture, 67, 164
theories of drawing
 See drawing, theories of
threading, 99, 112–116, 123, 166
3-D model, 44, 73
T-junctions
 See line junctions
tonal modelling, 121, 199, 211, 226
Töpffer, Richard, 220
topology
 See drawing systems, topological systems

transparency, 2, 31, 34, 73, 108, 179–181, 183–185, 200–201
 See also anomalies
two-eyed profile, 35
two-square drawings, 109, 123
 See also drawing systems, horizontal oblique projection, *and* vertical oblique projection
type, 41, 76, 237
 See also Luquet

unfamiliar object, drawings of, 14–15, 89, 90–91, 106, 109–110, 135, 148

vertical oblique projection
 See drawing systems
viewer-centered descriptions, 4–5, 43, 72, 176, 234
views
 canonical, 155–156
 drawings of, derived from object-centered or viewer-centered descriptions, 188–189, 234
 general, 152, 154–155, 160
 possible, 84, 107, 112, 116, 137, 148–149, 152, 160, 162, 189
visual delight, 208–213
visual realism, 29
 See also Luquet
volumes
 See scene primitives

Wilson, Brent and Marjorie, 35–36, 41, 90, 170, 233
Wollheim, Richard, 14, 149–150, 208, 244